THE OIL PAINTER'S
ULTIMATE

FLOWER &
PORTRAIT
COMPANION

by Patricia Moran

international
artist

International Artist Publishing, Inc
2775 Old Highway 40
PO Box 1450
Verdi, Nevada 89439

Edited by Terri Dodd
Design by Vincent Miller
Photography and illustrations by Patricia Moran
Typeset by Andrew Forbes

Printed in Hong Kong
First printing in hardcover 1999
Second printing in softcover 2000

03 02 01 00 5 4 3 2

National Library of Congress
Cataloging in Publication Data

Moran, Patricia
The Oil Painter's Flower and Portrait Companion

ISBN NO: 1-929834-03-9

Distributed to the trade and art markets in North America by
North Light Books,
an imprint of F&W Publications, Inc.
1507 Dana Avenue
Cincinnati, OH 45207
(800) 289-0963

About the Author

Patricia Moran was born in Melbourne, Victoria, Australia and still
lives and works there. After winning numerous major awards and
working as a tutor of portraiture at the Victorian Artists' Society,
she began to write instructive magazine articles. These were
followed by her first book, *Painting the Beauty of Flowers with Oils*,
which was published in 1991.

Pat exhibits regularly in Australia and London and her
paintings are sought internationally. Her books are used by
students and teachers alike.

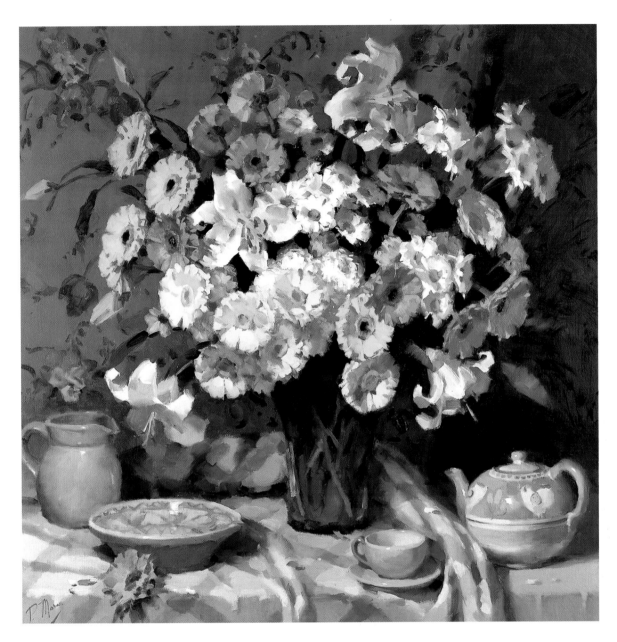

Preface

You don't have to be a genius to appreciate a painting, you only have to look at it to make an assessment. That is why I have made this book as visual as possible so anyone can see the construction of a painting and watch its development, after all, you don't have to be a mechanic to drive a car, (thank goodness).

As readers of my first book know, this is not MY theory on how to paint. I did not invent it. I am only explaining it, and even if you don't paint, a glimpse into the construction of painting can increase your enjoyment of observing any picture.

Oil painting is here to stay, and more people than ever are taking it up. This book is for those who want to know how it is done, even if you choose to paint another way, you will still need the basic handbook on the shelf somewhere.

I hope this book will be of help to those who paint, and enjoyable for those who don't.

CONTENTS

Introduction

"Painting is a science and should be pursued
as an enquiry into the Laws of Nature"

— *John Constable (1776-1837)*

Anyone who read my first book, *Painting the Beauty of Flowers with Oils,* will already know that the theory of tonal painting is not my own, and I would like to reiterate that in this book. What I am endeavouring to explain is one of the Laws of Nature. No matter how fashion changes, the human eye still observes the same way, it cannot do otherwise. It is the observation of the "visual truth" established simply and directly onto the canvas, without drawing first, which produces the character and atmosphere of the moment. Fine details and top polish mean nothing if the underlying truth is not there.

Included in this book are several demonstrations of certain flowers which many artists are wary of attempting, either because they are unappealing or look too difficult. But there is a reason for everything, and perhaps by observing the development of these flowers they may glean some information which will help them overcome a difficult hurdle. Agapanthus, bearded iris, chrysanthemums, delphiniums, the stiff tulip and, of course, the world's favourite flower, the rose, are examined. If these are objectively viewed as different arrangements of tonal values, lost and found edges and proportion they become just another still life, to be handled in the usual way.

The establishment of tonal masses rather than drawing first is not new. Artists such as Corot (1796-1875) and Sir Henry Raeburn (1756-1823) and John Singer Sargent (1856-1925) are on record as working this way, and it doesn't matter whether it is a still life, landscape or a portrait, the approach is still the same. However, out of these subjects, it is the portrait which seems to scare painters the most, but I can assure you that all is required is a nudge in the right direction to get you over the bumpy parts and you will be unstoppable!

The transition from a still life to a portrait is seamless — if you can set up a still life you can set up a self portrait, if you can do a self portrait, a portrait can be easier by comparison.

As with anything that is attempted in any field of endeavour, it is experience, experience, experience which irons out the deficiencies. So for any subject, be it still life, landscape or portrait, if you work on the basics, it is then a matter of PRACTICE WITH PURPOSE, and I would recommend plenty of it.

Keep away from interesting techniques and try to portray the "visual truth" on the canvas because this will set you up for handling any subject.

As for portraits, the words given to me after I won the Alice Bale Overseas Travelling Scholarship were — GO OUT AND PAINT A THOUSAND PORTRAITS.

Part I The Golden Rules of Tonal Painting

A tonal painting
Floral painting, portrait, still life or landscape, you can paint them all using the tonal painting approach. All you have to do is develop the ability to recognise tonal values, and follow the golden rules — then you can paint any subject.

Tonal values revealed
Every colour has a degree of lightness or darkness in it, this is called the "tonal value" and a black and white picture is a "tonal picture", there is no colour, only the lightness and darkness of those colours. By observing the tonal value and not the colours, you get to the core of what makes a subject truthful and interesting, and further on in this book you will see how to set up a subject and to light it so that you obtain the best "tonal value design" that makes a subject interesting.

Part II The Golden Rules of Flower Painting

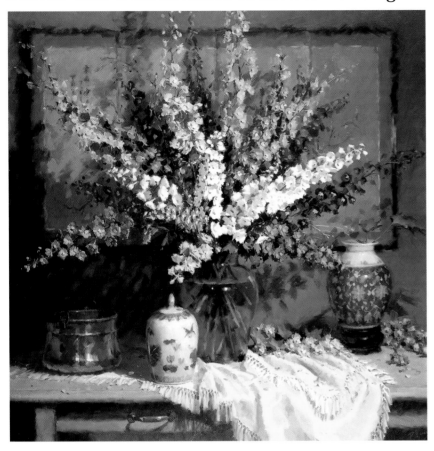

Painting flowers like this requires a standard approach

In this section we discover that no flowers are the same, but the approach to placing them on the canvas is ALWAYS the same.

I'll explain the Golden Rules and then demonstrate how they apply to a series of flower demonstrations:
- Agapanthus and hydrangea
- Chrysanthemums
- Bearded iris
- Delphiniums
- Calendulas
- Roses

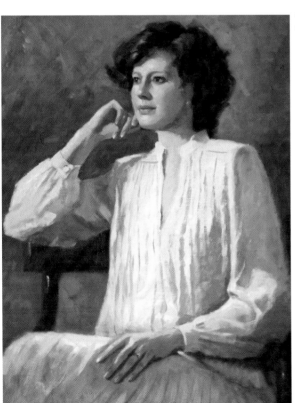

Part III The Golden Rules of Portrait Painting

A portrait is just a still life using different colours

You don't believe me? To prove it, in this section I do a simultaneous demonstration of both!

Part IV The Self Portrait

Then we try a self portrait, after all, the most accessible subject you'll ever have is your own amazing face!

Part V The Floral Portrait

I'll show you what to do when flowers and faces combine.

Part VI Drapery, cloth and clothing

Learning to handle cloth with all its colour and variety.

Floral painting, portrait, still life or landscape — you can paint them all using the tonal painting approach. All you have to do is develop the ability to recognise tonal values, and follow the golden rules — then you can paint any subject.

The golden rules of tonal painting

1. Think tone before colour
A black and white photograph is a tonal picture. There is no colour just tone. Tone, the relative value of light against dark and dark against light, is number one in producing a representation of objects and atmosphere. The art term for this is chiaroscuro, which means putting a strong emphasis on the change from light to dark in a painting. Think TONE before COLOUR.

A black and white photograph is an arrangement of tonal values, which happens to form a picture. Every colour has a tonal value, that is, a depth of lightness or darkness ranging from the lightest light to the darkest dark. It is very hard to judge whereabouts on the scale of lightness and darkness these colours fit, but by squinting your eyes to eliminate all but the lightest light, you can begin to evaluate the tonal value of the "local colour".

The local colour of a lemon is lemon yellow. The local colour of a red vase is red, and so on. A red vase with the light hitting one side could contain around five depths of red on the tonal scale from the light side to the dark side. (Compare this to a piano scale with depths of A or C in different octaves from high to low.)

Once you understand the process, then you can use the tonal painting approach to paint anything.

5. Measure, measure, measure
A well measured painting looks more professional and has more authority than a carelessly placed one. It's important you learn to measure then do it until your arm nearly falls off.

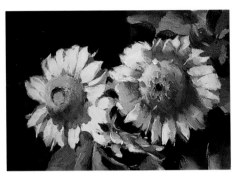

2. Don't paint what you know, paint what you observe to be there

Paint what you see means looking carefully at the subject without relying on previous knowledge. This is difficult, of course, and when asked to paint a jug most people would look at the edges or"known" boundaries and draw the outlines of a jug, rather than the surface tonal values which produce the painted jug.

Never make anything up. Just observe the shapes and tonal values in front of you rather than trying to paint what is not in front of you.

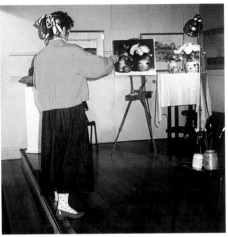

3. Always work from a standpoint

In order to see what you are painting, and paint what you are seeing, you need to establish a standpoint from which to work. Mark a spot ten to twelve paces back from your canvas so you can see the canvas and the subject equally. Make sure that you return to that spot for every evaluation. As there is "more look than put" in painting, you will be spending more time at your standpoint that at the canvas. When you are at your canvas you only paint. You do not look or "peep" at the subject at all. You paint only what you have evaluated from your standpoint.

This photo was taken during a demonstration in 1988.

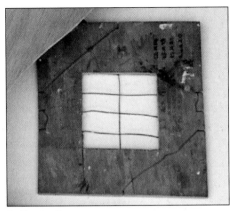

4. Use a viewer

Cut a rectangle, approximately 3 x 4cm, from a small piece of cardboard. Use this to select the exact area of the subject you are about to paint by simply holding it up and observing the subject through it. The viewer eliminates the surrounding, distracting, areas and you can see right from the start exactly the way you want the finished painting to be placed on the canvas. The shape of the viewer should exactly match the shape of the canvas.

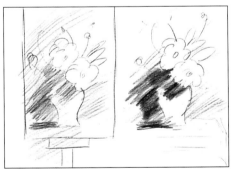

6. Know the difference between sight size and life size

Sight size is painting your canvas the same size that your subject appears. If your canvas is right next to your subject, you will paint it roughly actual size. In this case, sight size will equal life size. If you move your canvas away from the subject and appropriately move your standpoint back, you still paint sight size — the subject will appear smaller and much more of the background will be included in the painting.

Paint flowers as close to life size as possible because they will look more true to life.

When you paint portraits, either paint the heads life size or paint them much smaller. If you paint them just slightly smaller than life size, your subject will look as if they have a monkey head! So if you must go smaller, go very much smaller.

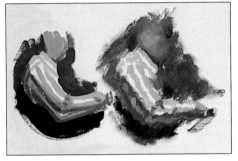

7. Understand brushstrokes and edges

Brushstrokes are important because how you use them shows that you are observing the subject as a whole unit, not just dealing with "known boundaries". In the same way you must understand "lost" and "found" edges because this is how the eye and brain registers what is before it. You only need to suggest or define a certain area and the brain does the rest. It takes courage to loosen up, but it can be done.

Painting against the form gives your work that "painterly" look — It's not what you paint, but HOW you paint that counts. Working your brush in all directions helps keep your paintings as SOFT AS YOU CAN, AS NEUTRAL AS YOU CAN, FOR AS LONG AS YOU CAN, until you are ready to place

those few hard or "found" edges which bring the softness into focus.

No painting should have all hard edges or all soft edges, but a balance of both, and certainly far less hard edges than you would think. PAINT THE MAXIMUM BY MEANS OF THE MINIMUM and keep away from hard edges for as long as you can.

SLEEVE LEFT: This is what is called "painting with the form", too many hard edges too soon and confusing to the eye. When painting with the form there is a tendency to sail right past the intended stop point, throwing all good measurements out the window and the appearance looks slick and amateurish.

SLEEVE RIGHT: Keep your brushstrokes going in all directions. These pink and white stripes have all been painted AGAINST THE FORM — they have been worked sideways with a ROUND brush. At any time during the painting of these stripes it is possible to stop and reassess how you are going, and decide exactly where or if any, the final brushstrokes WITH THE FORM will go.

Materials you will need

The best advice I can give you in regard to materials is to be well organised and have everything you need on hand because this will reduce distractions which saves wasting time and energy. Squeeze out plenty of paint and make generous mixes so that you don't have to stop right in the middle of a sequence.

1. Round hog hair brushes
Not the bushy ones, but the ones that come to a point, in a variety from size 2 to size 10, and at least a couple of each. Why round? Flat brushes tend to give a slick look. It is better to train yourself to use round brushes, they will serve you best in the long run.

2. Small sable brushes, size 2 or 3
Make sure you have the long-handled ones to fit in with the hog hair brushes when you are holding them. The ones with short handles are for watercolour, and will drop out of the bunch and put paint over the handles of the others.

3. Large palette, curved and NOT WHITE
Natural timber, which will oil to a neutral mid tone, will help you to judge your tonal values.

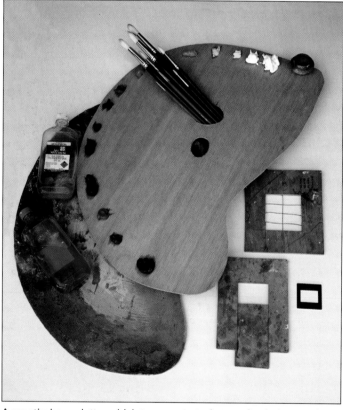

A raw timber palette, which turns a neutral grey after being used a few times is excellent for judging tonal values, DO NOT USE A WHITE PALETTE, as it is difficult to judge tonal values and colours. Turpentine and stand oil on the left, and viewers to help you select your subject matter.

4. Mineral turpentine
Use as a medium to begin a painting, and can be used for washing brushes.

5. Stand oil or oil painting medium
To bind the oil paint and make it permanent.

6. Dipper
I use two, I like to have turpentine in one and a turpentine and stand oil mix in the other.

7. Viewer (see page 11)

8. Spotlight
A 150 watt globe in a photographer's lamp on a stand so that it is moveable. Otherwise you could use an outdoor 150 watt spotlight hung on a nail on the wall, and you can swivel the head around to focus light where it is needed. Natural daylight, although desirable, is not always practical when painting flowers for instance. Flowers won't wait for the sun to come up so you can paint them. They droop or just drop off in a shower of petals when it suits them — usually at the worst time. To keep it simple, only have one light source. If possible, the same light should be on both the subject and the canvas.

9. Drop sheet
To protect the floor and surrounding furnishings.

10. Canvas
I use a double primed linen canvas, as I like to begin on white. Don't use a canvas that is too coarse, because it tends to make the brushstrokes more interesting than the subject. A medium to fine weave is best, especially for portraits, you don't want big lumps of canvas appearing on a face!

View the whole subject as one tonal unit

As there is not a lot of "LOCAL COLOUR" in this painting called, "Cool Beauty", 137 x 122cm (54 x 48''). The tonal values are easier to evaluate. The lightest and largest area is the hydrangea, the blue and white chintz material which is out of the main spotlight is quite a way down the tonal scale. If you were just looking at the cloth and not taking the whole subject in as one tonal unit, it would be easy to paint it much lighter than it is.

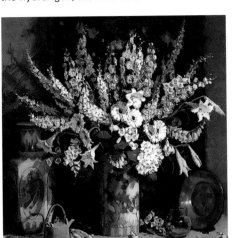

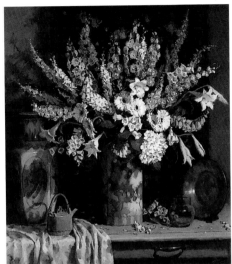

The same picture printed in black and white

This mono version may help you to see what I mean when I talk about tones.

11 colours

I have a favourite brand, but any type will do. Set them out tonally from the medium dipper, beginning with white, because that is the most used

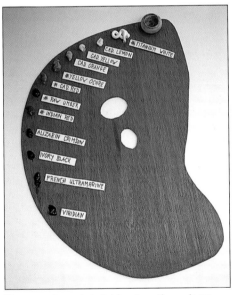

Here are the paints laid out on the palette (see text) and the colours with the asterisk show the colours used to make flesh tones.

Titanium White

Cadmium Lemon

Cadmium Yellow

Cadmium Orange

*Yellow Ochre

*Cadmium Red

*Raw Umber (this is only placed on the palette if I am doing a portrait)

Indian Red

Alizarin Crimson

Ivory Black

French Ultramarine

Viridian Green

*basic flesh colours

As a student I used three pieces of smoked perspex screwed together. Looking through all three pieces of perspex shows only the lightest tones, looking through two pieces shows the next lightest tones and looking through one piece shows the mid-tones.

Underexposed transparencies make handy viewers to help you identify tones.

Above all, think tone before colour

Exploring the Golden Rules

If you are working in black and white or "light and dark" and the edge of an object, (for example, a vase, arm or chair), is beside an area of the same tonal value, regardless of colour, the edge is lost into a block of tone. This happens even though this "known edge" is clearly visible when you focus on it with your eyes wide open.

Therefore, when the edge of the object with an edge is surrounded by the same or similar tonal value, it will become a "lost or soft" edge.

If the object sits against an area of a completely different tonal value, for example, where the lightest light sits against the darkest dark, and a division of tonal value is clearly visible with the eyes

still squinted, an edge will be produced naturally by the light effect and this becomes a "found" or "hard" edge.

So by establishing blocks of lights and darks on the canvas you by-pass the drawing of "known boundaries" and build the painting by breaking down and measuring these masses against each other until all the "visual problems" have been solved. The whole canvas becomes one unit of tone, with edges and proportion all measured against and relating to each other.

This is relatively easy to work on if you are painting in black and white, but when moving into colour it becomes more difficult to judge the "local colour" and tonal boundaries, so tools which aid the judgement can be used. Look through smoky glass, dark, under-exposed transparencies or a picture frame with black paper instead of the picture under the glass, and you will be able to identify the tones of light and dark more easily. No matter what the colour, think TONE

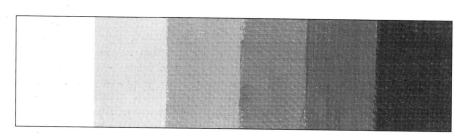

Every colour has a tonal value
Here is tonal scale showing degrees from white through grey to black . Beneath it is a scale showing varying degrees of tone in a colour from the lightest shade to the darkest shade of that colour. Squint your eyes and you can see the direct relationship between the degrees of tone in both mono and colour.

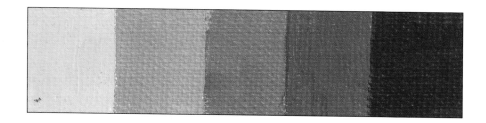

Local colour

The "local colour" is the actual colour of an object. A blue vase, for example, may appear a different colour or tonal value when observed as part of a still life arrangement, when every tone and colour is relevant to everything else. If you are observing the "appearance" of the whole subject as opposed to what you KNOW to be there, the blue vase can appear a completely different colour if it is placed next to something bluer, or if it is in shadow. "Think tone" before painting the "local colour".

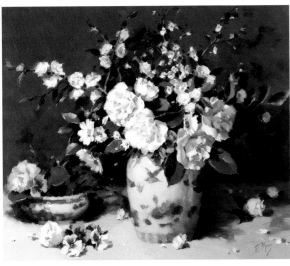

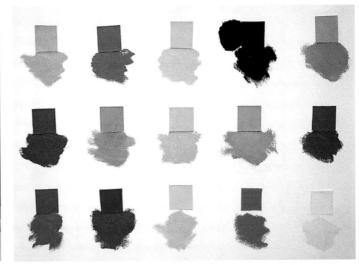

A subtle range of lights
Painting white is always a good exercise in judging tonal values, WORK BACK FROM YOUR LIGHTEST LIGHT. You cannot go lighter than white, so every tonal value must relate to that tone.

This painting, "Pastel and Porcelain", 61 x 71cm (24 x 28''), of white flowers in a white vase, creates a very close and subtle range of lights for the artist to analyse.

A colour matching exercise

Before I began painting, I used to wonder how artists got the colour right and put it in the right place. Working from a standpoint, squinting your eyes at the subject and evaluating the tonal patches is one thing, but then you have to mix the exact tone/colour and that was more difficult than it looks. When my teacher gave a demonstration I was forever asking, "What did you use to get that colour?" He was quite happy to tell me the main two or three colours he used, but then he'd say, " . . . and a bit of everything else on the palette".

Well, of course, it was the bit of everything else that made the difference. Sometimes you can get the local colour right, but it might be too light in tonal value, then you try to darken it and it goes dirty, or lighten it and it goes blue instead of green. Mixing colours and tonal values only improves with experience.

The puddle on the palette always grows in size when you keep adding more colours to get it right, but with experience the puddles become more manageable.

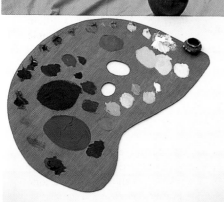

Use a lot of brushes
Use one brush for each tone/colour puddle. As you work just reach for the brush with the colour you want on it. There is no time to wash and use the same brush every time. If you think BIG BRUSH BIG AREA, SMALL BRUSH SMALL AREA it will help you find the brush you want in the bunch. Also, because the palette is set out tonally from light to dark, the light colours are up one end and the dark colours down the dark end. This is how the palette starts out but it's not how it finishes of course, but if you begin with good intentions it will get you further than if you don't. The white dobs are right next to the dipper because it is the colour most used. View it as time and motion to save time and energy.

On a couple of occasions when I have been painting very large colourful canvases, I have had two palettes going at the same time.

Exercise: See how colours on your palette work for you
Obtain some paint colour charts, or swatches from a hardware shop. Select and cut out a variety of patches and stick them down on a canvas board. Space them well enough so that there is enough room for you to paint a matching puddle, and maybe enough room for a second go, or a bigger patch.

Matching these patches is exactly what you have to do when you have follow-up portrait sittings, and you have to remix every tone/colour puddle that you mixed and used at the previous sitting. It is so much harder to mix and match the second time than it was the first time when it just flew out of your head.

When I was a student we were often given the exercise of painting a still life subject with just a few colours on the palette. One colour combination we used frequently when graduating from black and white into colour was Raw Umber, Yellow Ochre and white — nothing else. The still life turned out like a lovely old sepia photograph. Then the next time we would add a little red jug or a mustard jar with a red medallion or red label, and we added Cadmium Red to the Raw Umber, Yellow Ochre and white. Of course, these are the basic flesh colours, and this exercise just showed how far the properties of these colours could go when you weren't allowed to use anything else.

Another time we were only allowed Alizarin Crimson, Viridian Green and Cadmium Yellow and white on the palette while we painted a still life and, amazingly, if you worked at it you could get out everything that was needed.

It is experience you need, not an extensive palette with ready mixed colours on it. Try the exercise and see what you can come up with.

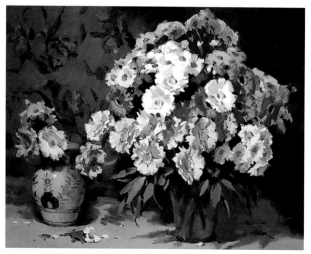

Don't let local colour throw you
It is when you are painting bright colours like this that you really have to "THINK TONE" because it is so easy to let the "LOCAL COLOUR" overtake your judgment. Keep those eyes screwed up, and use the smoked glass viewing aid to help you make your judgments on the tonal values.

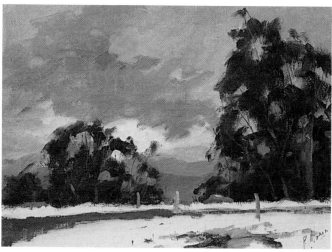

High contrast
There is very strong contrast of tonal value here, almost black against white. The background hills are just steps back in a tonal value chart. The picture is "Icy Winds", 31.5 x 40.5cm (12 x 16'').

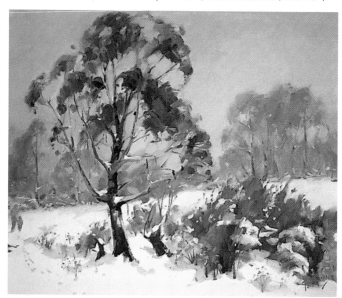

Painting snow is a good exercise
There is nothing like painting a snow subject as a good exercise on how to judge tonal values. Unlike the bright colours portrayed in the tourist pictures, I usually find
the snowfields to be just varying shades of grey. In this picture, "Snow Landscape", 51 x 61cm (20 x 24''), the white primed canvas represents the lightest tonal value on the canvas and is mostly left bare of paint. I worked the mid-tones back from that.

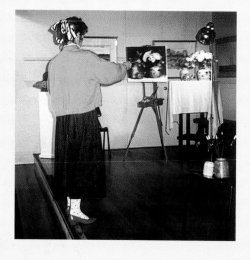

Always work from a standpoint

At my standpoint
I gave this demonstration in January 1986 when I was teaching at the Victorian Artists Society, you can see here that:

- The canvas is beside the subject.
- I am at my standpoint, several paces back observing both the subject and the canvas together.
- I am carrying my palette and brushes so that I can evaluate the subject and mix the paints from my standpoint.
- The spotlight is on both the subject and the canvas. This is not always possible, in fact I usually prefer my canvas out of the spotlight and in the shade when I am painting landscapes.
- I am painting "life size", that is, the head measures approximately 9''.

How to find the golden mean

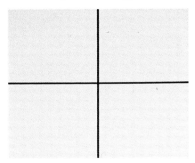

Step 1. Begin with a cross in the middle.

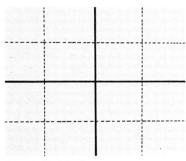

Step 2. Divide the quarter s into quarters.

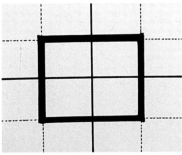

Step 3. This dark square is the golden mean.

Using a viewer

As a general rule you do not put the point of interest near the edge of the canvas, keep anything of great interest away from the edge.

A good guide is to keep the most interesting areas of the subject within the "golden mean" or within the $\frac{3}{8}$ths, $\frac{5}{8}$ths mark. Keep your main point of interest within this area for a balanced painting. Exceptions can occur, but to be safe stick close to this area for a better chance of success.

To make a viewer

Cut a rectangle, approximately 3 x 4cm, from a small piece of cardboard. Use this to select the exact area of the subject you are about to paint by simply holding it up and observing the subject through it. The viewer eliminates the surrounding, distracting, areas and you can see right from the start exactly the way you want the finished painting to be placed on the canvas. The shape of the viewer should exactly match the shape of the canvas.

"There's no drawing with tonal painting."

I've looked . . .

. . . now I'm putting
I have now stepped forward to the canvas to place what I have mixed from the standpoint. You do NOT peep at the subject while you're at the canvas, but paint only what you have evaluated from the standpoint. I will return to the standpoint to judge whether the painted marks were accurate.

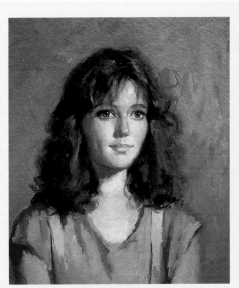

One more sitting would finish it off
My demonstration picture "Lauren", 61 x 51cm (24 x 20''). After the demonstration we decided to have another sitting to finish off the portrait.

15

The easiest way to explain direct tonal painting is to demonstrate a painting in stages, beginning in black or white or brown and white.

Working with tones

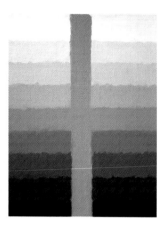

This demonstration explains that you're observing areas of light and dark through squinted eyes (to eliminate distracting details), and these areas often override known boundaries, or the edges that would normally be drawn in first.

Refer to the expanded description of edges in Chapter 5 again to reinforce the information shown in the following demonstration.

Tonal division chart

This chart, painted in Raw Umber and white, has been graded in nine tonal divisions from white (lightest light) at the top to Raw Umber (darkest dark) at the bottom. The middle tone which is halfway between the top and bottom has been painted as a cross in the middle. It appears graded, but this is the natural optical illusion — it looks dark against the light end of the chart and light against the dark end of the chart. All tonal values are relative to each other.

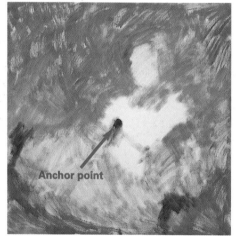

First I establish an anchor point

This demonstration was worked in Raw Umber and white to begin with and the colour brought in later. To begin I squinted my eyes up so much that only the lightest light could be seen, the rest of the area became one mass of mid-tone. I viewed the subject through a viewer with cross hairs, and established a dark area as an anchor point right in the centre of the canvas. I relate all other points to this.

The anchor point doesn't necessarily have to be in the middle as this one is, it could be anywhere on the canvas.

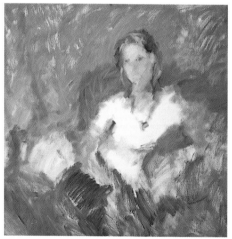

The light effect comes in to play

I was still working in Raw Umber and white. The large masses of mid-tone were broken up with a slightly darker mid-tone. As you can see this is not a drawing, there are no hard edges of known boundaries, but an evaluation of tonal masses which cross the known boundaries. I was in fact establishing "a light effect" on a subject and not delineating the subject itself.

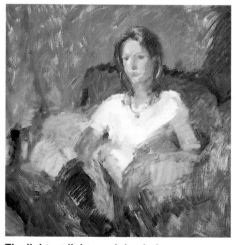

The lightest lights and the darkest darks in place

I established the darkest tones within mid-tone masses and at this stage the full tonal range was established — the lightest light through to the darkest dark. The lightest light is just the raw white primed canvas, I did not put white paint on it at all. You cannot go lighter and whiter than this, and you have to work your tones back from this. In other words nature, and the subject you are looking at, is much lighter, brighter and richer than the paints and canvas with which you are working. Be careful that the mid-tones are not too light, or the whites will lose their brightness.

This painting could be continued and brought forward in Raw Umber and white, but let us now see how the tones become colour.

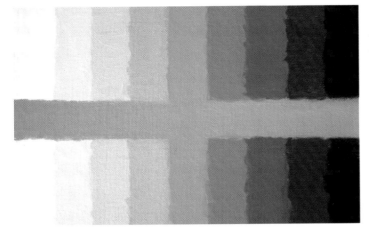

Everything on the dark side is darker

Look at this sideways tonal chart as if you were painting a face lit from the left, and the middle band is the eye area. It is easy to see the tonal values going from light to dark around the face, but the mid-tone centre band looks dark against the light and light against the dark.

Therefore, you cannot paint the eyes or mouth with the same tonal value, it will look the same as this horizontal band — you need to keep your dark brushes for the dark side and the light brushes for the light side.

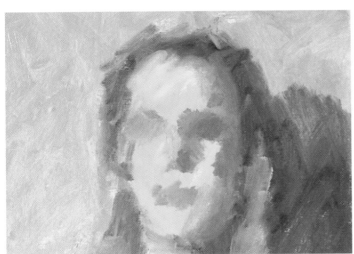

Now compare with this face block-in

Notice the eye area, the eye socket on the left side which is the light side has been painted a lighter tonal value than the eye socket on the right — the dark side. EVERYTHING ON THE DARK SIDE IS DARKER and EVERYTHING ON THE LIGHT SIDE IS LIGHTER. The mouth, the hair, the eyes, the neck — everything that is lit from one side, will have a dark side and a light side.

Of course, there will be exceptions, but be aware and observe the tonal values.

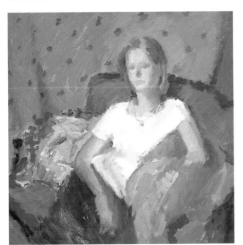

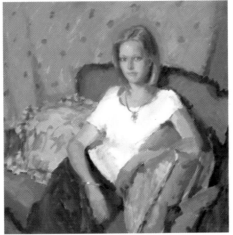

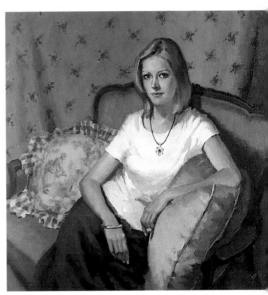

Now we continue in colour

The colour was brought in gently, and the tonal value of the local colour was evaluated. Remember that a colour in the light will be a different tonal value to the same colour in the dark. The dark anchor point had not drifted off its mark in the centre of the canvas, I was still measuring from it.

Establishing the darkest darks

It was time to go darker. I added stand oil to the turpentine which enriches the darks, and binds the oil paints. The darkest darks were established and although the white canvas near the centre of the canvas still did not have any paint on it at this stage, it was beginning to look whiter in relation to the tonal values which were surrounding it.

The subject appears

The tonal masses had been broken up and the subject appeared. With a portrait you do not aim for a likeness, aim to establish accurately what you see and the likeness will take care of itself. The finished painting is called "Susie", 91 x 91cm (36 x 36")

*Most students resist measuring, but if you want accuracy
it is the only procedure that is guaranteed to work.*

Do you measure up?

A well measured painting looks more professional and has more authority than a carelessly placed one. The eye becomes accustomed to the well drafted painting, and you begin to observe more accurately, which saves time and energy.

There are two main types of measuring. The direction and relationship measurement — which I call directional measurement for short. This is the, "as-the-crow-flies", approach. Then there is the multiple, "how-many-times-does-this-go-into-that?", measurement.

Directional measurement
This is the measurement I use the most.

Go to your standpoint, then with a straight arm and swivelling your brush around so you use the full length of the brush, measure the direction of a side flower from the base of the vase. On a model, measure the edge of the hat brim to the chin. DON'T POINT, and don't think you can memorise the angle of the brush, you can't. I suggest if you are not used to measuring, don't just stand on your standpoint and measure the angle of the subject, then swing across to your canvas. I suggest that you follow the next diagrams, and take every measurement right up to the canvas and GET IT RIGHT. THE MORE YOU MEASURE, THE MORE YOU WON'T HAVE TO MEASURE.

How-many-times-into measurement
How many vase-lengths go into the flower arrangement, or tree-lengths into the hill, or heads into the pose? It is easy if the portrait subject is standing — eight lengths go into the body ($7\frac{1}{2}$ is often used, but eight is easier — see diagram on page 101), but in a seated arrangement which could have some foreshortening, the head-lengths could land anywhere on the pose.

The "how-many-times-into" type of measuring shown in the accompanying charts can be used sideways, up and down or any way you like — but just as long as you keep measuring. Keep going until your arm nearly falls off!

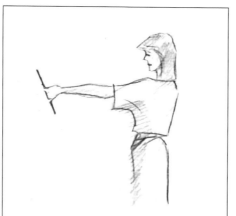

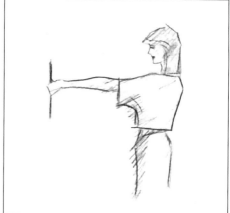

First of all, learn HOW to measure!
Stand on your standpoint and observe both the subject and the canvas. Use your paintbrush as a guide, the most important thing is HOW you hold the brush.

WRONG — do NOT point the brush at your subject. This needs to be checked continually as it is easy to drift into this incorrect habit, especially if the subject being measured is a receding book or chair.

RIGHT — no matter how you swivel the brush around to measure the exact direction of the subject, the brush must be parallel to your body. Don't drift into the habit of pointing at the subject or you will never get the measurement correct.

Directional measurement

 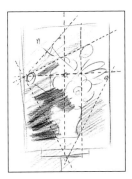

Step 1

From your standpoint (several paces back from the canvas), use the full length of the brush and measure the EXACT direction from one point of your subject to the other — not the length, THE DIRECTION. Loosen up and swivel the brush parallel to the body, DON'T POINT. The example here uses the farthermost point of one rose to the farthermost point of another.

Step 2

Now freeze your arm at the angle that you have judged to be correct, and walk right up to your canvas and lay that brush against your painted farthermost points of the same two roses. The angle should be the same regardless of whether you are painting life-size or sight-size. If it isn't the same, fix it.

Step 3

Now go back to your standpoint and measure the direction and the relationships of every landmark, one to the other on your subject and on the canvas. Keep on cross measuring and tighten all of this up at the block-in stage, get as much of the groundwork established correctly as you can, so you can build on a strong foundation.

Measure for example, the leaf on the left as an anchor and fan out; then go cross-country and see if these points relate to each other. Unfortunately, when you correct one it usually throws all the others out, which can really knock the love-light right out of your eyes. However, just do your best and very soon your eye will become honed, and as I have said, the more you measure and correct, the less measuring you will have to do.

The "how-many-times-into" measurement

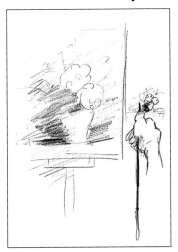 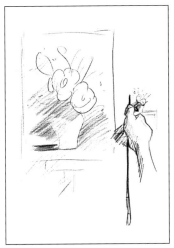

To make a sight-size to life-size measurement proceed as follows:

Step 1

From your standpoint (several paces back from the canvas) use the end of the brush to get the exact length of the vase — DON'T POINT, hold parallel.

Step 2

Don't move from your standpoint and don't move your thumb on the brush, and keep your arm straight. Now, move your arm up slightly and observe the brush end that corresponded with the vase length against the flowers and see where one vase length lands. In a standing portrait, one head length goes down to the breast, but in most cases (but not all) the floral arrangement is bigger than the vase, so count how many times the vase-length goes into the arrangement, In this case, it is about one-and-one-quarter).

Step 3

Leave your standpoint and go right up to the canvas, and you can take your thumb mark off the brush. Lay your brush on the canvas (well as close as you can without getting too much paint on you) and measure the length of the vase you are painting and mark it with your thumb. (If it is a big vase it could use the full length of the brush, if bigger, you will have to use a stick).

Step 4

Don't move away from the canvas and hold your thumb on the vase-length measurement. Move your arm up and see if your painted flowers have the same amount of vase-lengths in ratio as there were on the sight-size subject which you have already measured. In the illustration, the life size canvas shows the flowers to be one-and-one-quarter vase lengths.

If your measurements are incorrect, don't think that near enough will do, it won't, so fix it and train your eye to observe more accurately.

Sight Size and Life Size

Sight size

If you are working in awkward surroundings, and not able to place your canvas next to the subject (or sitter) and you want to paint life size, and not the sight size before you, which would include more of the surroundings than you desire, then measure the vase or head, and roughly block in that measurement on the canvas.

The adult human head measures approximately 23cm (9''). Do some rough marks for the head and then relate every other part of the subject to that head size. (See adjacent set of illustrations for how to do this.)

If it is a vase of flowers you wish to make life-size, then go right up to the vase and either stand a ruler beside it, or just the paintbrush and mark with your thumb the vase length, and establish some marks on the canvas, or a rough block-in that size, and then measure everything else against that measurement, as in the adjacent illustration.

Life size.

It makes the job so much easier if you place the canvas right beside the subject and stand back about six to eight paces and observe your work developing right beside the set-up. You can squint your eyes and look quickly across and back and the differences in tonal values show up well, and it is easy to see if you vase is too tall or too wide.

How I would go about measuring a subject like this.

1. (a) I always like to get the vases settled down early in the proceedings, I hate things floating around. Something as visually important as the little French cachet pot (or planter) and teapot would be measured as soon as the first marks are on the canvas. I measure the direction of the base of the cachet pot in relation to the dark toned glass vase, then
(b) the direction of the cachet pot to the base of the teapot.

2. Holding my brush horizontally I observe that the base of the teapot runs through to the tip of the design on the cachet pot.

3. Still holding my brush horizontally but moving up a step I observe that the top of the flower on the teapot is the same level as the top of the cachet pot.

4. Going up another step I measure the angle of the teapot handle in relation to the spout. It is very important when painting anything with a handle that pours, that the handle is lined up with the spout, or that a jug handle is set directly behind the dip that pours. If you tried to pour from a teapot and the spout was off to one side, well, it would be very awkward wouldn't it?

5. With the brush vertically against the neck of the teapot I observe that the base of the teapot is directly in line, and I also look at the shape of the teapot bulge OUTSIDE the vertical line.

6. Still vertically, I go straight up the front of the cachet pot and observe which flowers fall, or part fall, either side of the line, which happens to be the centre of the canvas.

7. Now I move to the other side of the planter and see what falls, or part falls either side of the line.

8. I hold my brush horizontally across the centre of the canvas and observe what falls above and below it.

9. I check the exact angle of the tulip to the very left, to the tulip on the very right.

10. Then go back from the tulip on the very left and see how it relates to the base of the vase base.

I don't do this once and just leave it, it is worked at and tidied up continually as the whole canvas is worked upon. NEVER WORK ON THE ONE SPOT TOO LONG or it can "drift" off its mark and throw out the direction and relationship of the canvas and create a badly placed subject, and in fact some areas may drift off the canvas altogether.

20

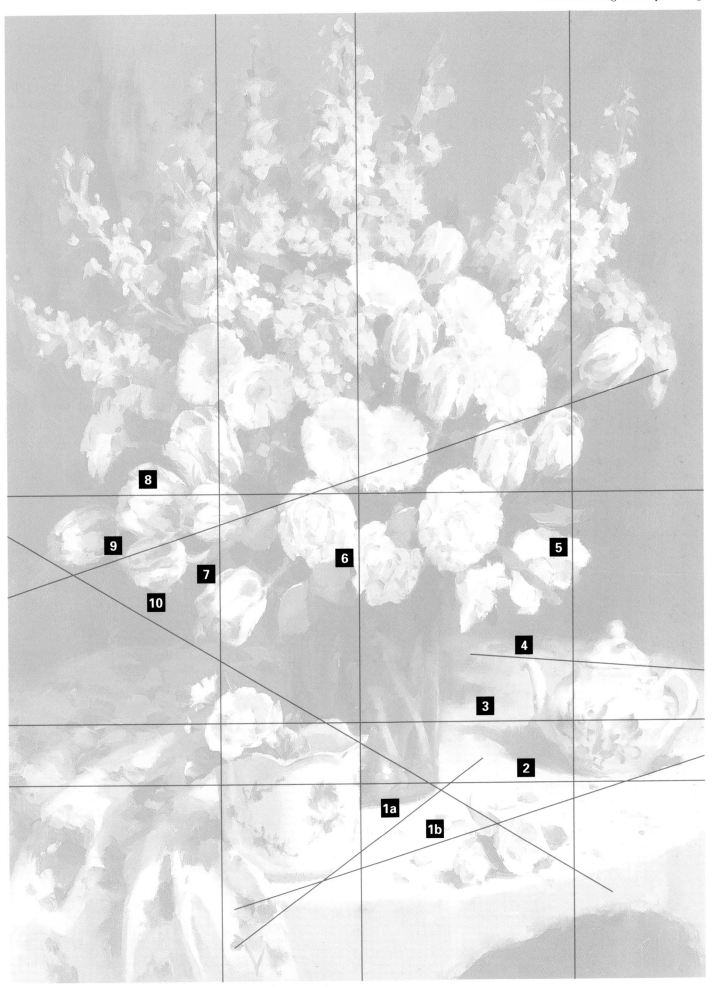

Painting with the form and painting against the form — what do these terms mean, and what have they got to do with edges?

Brushstrokes and edges

In a tonal painting keep your brushstrokes as soft as you can, AS NEUTRAL AS YOU CAN FOR AS LONG AS YOU CAN. Then, when everything is placed and the point of interest is being brought to a conclusion, some hard edges can be brought in.

You may have encountered the terms "painting with the form" and "painting against the form". This cameo painting of pairs of camellias will explain what these terms mean.

Painting with the form — looks unpainterly
The top pair of camellias have been painted "with the form" which means the artist has drawn with the brush all around the edges and whichever direction the bits and pieces are going. This looks unpainterly and shows that the artist is not observing the subject as a whole unit, but is detailing all the "known boundaries". This is just an enumeration of objects, and the eye does not know where to go.

Painting against the form — almost right
The middle flowers have been blocked in "against the form" which looks good and painterly, but the brushstrokes are all going in the one direction. This is almost right, but the brakes need to be put on very soon or the eye will sail out of the canvas forever. This can be a good basis for a soft beginning before the areas begin to be more developed, but the brushstrokes need to go in ALL DIRECTIONS.

Lost and found edges
The bottom flowers have a variety of "lost and found edges". You do this by keeping your brushstrokes as soft as you can, AS NEUTRAL AS YOU CAN FOR AS LONG AS YOU CAN. Then, when everything is placed and the point of interest is being brought to a conclusion, some hard edges can be brought in.

In this example, the hard edges are in the area between the two flowers, that is the area of focus and everything else is out of focus. THE EYE CAN ONLY FOCUS ON ONE THING AT A TIME.

This is just a small cameo, but in a large painting, a whole centre bunch of flowers may be the developed area, the whole canvas cannot be in focus, the greater area of the canvas will be painted softly AGAINST THE FORM, and only a SMALL percentage of the canvas will be painted WITH THE FORM.

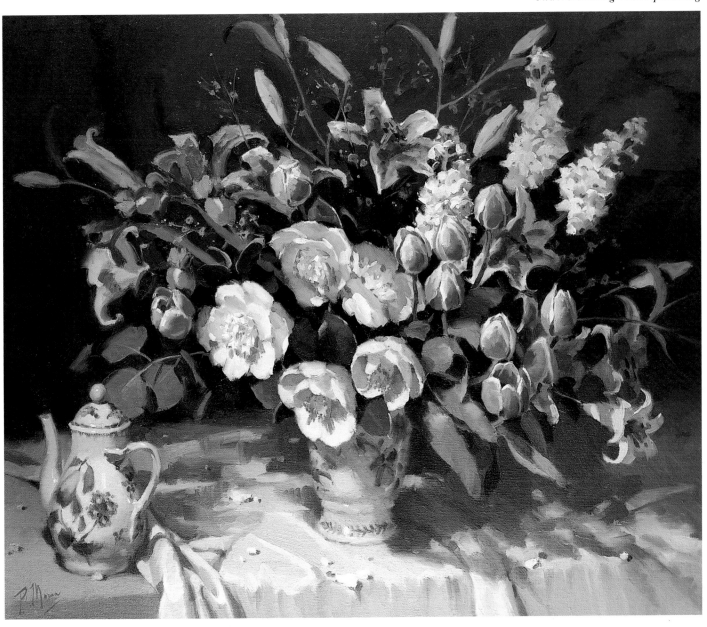

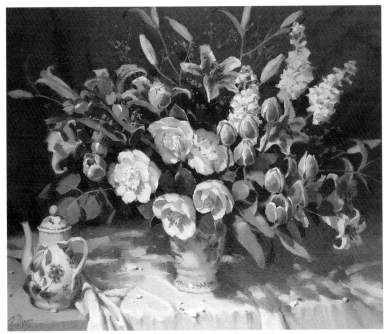

"Spring Sparkle", 76 x 91cm (30 x 36")
Examine this painting and see if you can identify
the lost and found edges. Then compare it with the black
and white version and you will clearly see the painting as
a pattern of tonal shapes.

Can you see the tonal value shapes?
Once the colour has been removed, you can see how the basic
tonal value and the lost and found edges create the "point-of-
interest" and the neutral areas.

The three front camellias are the centre of interest, being
the largest area of lightest tonal value against the darkest
dark, combined with the sharpest edges.

The vase directly underneath the main camellias has no
sharp edges, and the pattern on it is "lost". The two middle
camellias and the lillies, are a combination of "lost" and "found"
edges, and the side lilies in the background, are just mid-tone
shapes surrounded by similar mid-tones (or "half-tones"). Their
"lost" edges and mid-tone value sets them well back from the
point of interest, but there is enough information there to
explain what they are when the eye eventually wanders around
there. How would it look if all these shapes had hard edges? I
would suggest they would look unnatural and disturbing. Keep
your paintings a combination of "hard" and "soft" edges and
create a visual waltz that the eye can become lost within.

More about losing edges

As in all stages of a painting's development there is a pendulum swing, and as you begin to let go and loosen those edges, there may be a phase where all the edges are overly lost, and you have to evaluate which edges can stay lost and which ones you should sharpen up.

When you are painting eliminate one problem at a time.

The first problem is training the eye to assess tonal values correctly, and in the beginning of my career I found this a very lengthy challenge. I just kept at it until someone said the right word at the right time and I hit a major breakthrough.

The next biggest problem is LOSING THE EDGES.

A painting is made up of "lost" and "found" edges because this is how the eye and brain registers what is before it. You only need to suggest or define a certain area, and the brain does the rest. Losing the edges is much harder than you might imagine, after all, if you blur them too much you have a subject out of focus. The edges have to be lost in just the right way and place so that the area is still explained.

Evaluate how much edges need to be lost from the standpoint, and not up close, because what looks lost from a few centimetres away doesn't look lost from a couple of metres back.

This job of losing edges seems so much harder for someone who has a background of drawing or linear rendering than for someone who begins to paint without any previous experience. When someone says "I could never learn to paint because I can't draw a straight line", they don't realise what a good position they are in.

Clear divisions of tonal value

If an object sits against an area of a completely different tonal value, for example the blue and white vase below, which is the lightest light against the darkest dark, and a division of tonal value is clearly visible with the eyes squinted, an edge will be produced naturally by the light effect. This becomes the "hard" or "found" edge.

The other side of the blue and white vase with an edge surrounded by the same or similar tonal values will become a "lost or soft" edge."

This painting is "Still Life with Blue Gum Leaves", 76 x 91.5cm (30 x 36'').

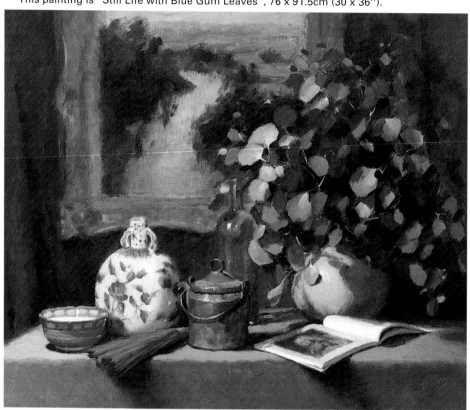

The mechanics of focus

If you focus on the brush the background will be blurred
If you hold up your brush and focus on it, the surrounding areas will be out of focus. The same occurs when you are reading these words — you cannot look properly at the picture above these words. You will have to move your eyes from one area to the other. THE EYE CAN ONLY FOCUS ON ONE THING AT A TIME.

If you focus on the background — the brush will be blurred
Without moving the brush you are holding, move your eyes to the background, now the brush will be out of focus. So it is with a painting, there can be only one main area of focus or the eye and brain become confused. You need to learn to loosen up those edges.

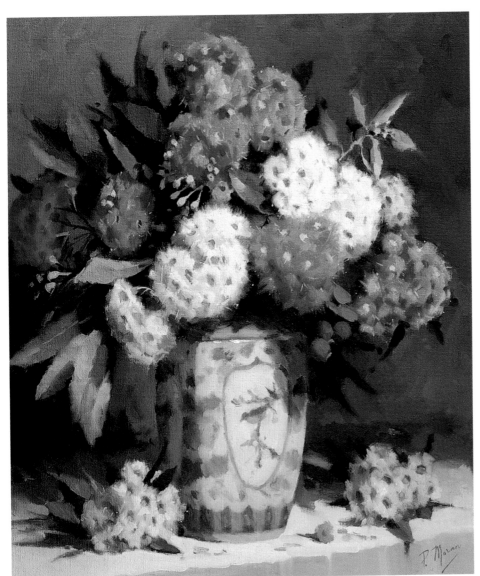

Don't force edges
There is a natural "hard" edge on the lower right-hand side of the vase, but it is not the lightest tone on the canvas. The flowers are the lightest light. Don't ever force an edge to create your own focus — there is always a natural one.
 "Australian Flowering Gums", 76 x 61cm (30 x 24'').

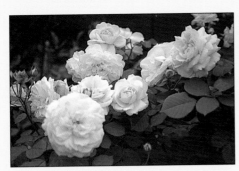

I photographed these roses with a deliberate focus on the centre flower. and the other roses are out of focus which is how the human eye observes the subject. The human eye has to flit from one rose to the other to see them all in focus one by one, it cannot see them all in focus at one time.

If it's not the focal point — there's no detail
In the large painting of "Delphiniums" on page 65 the cloth with a fringe goes right along the 153cm base of the painting. Here you can see that because the fringe is not the point of interest, there is no detail at all.

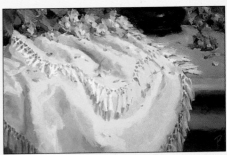

But here is detail
At this side of the painting, where the cloth is attracting the eye, the fringe is in full detail.

The block-in
This is a 61 x 51cm (24 x 20'') canvas and at this stage a thin block-in has been established using turpentine as a medium.

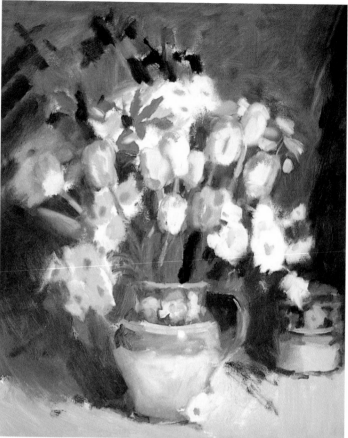

No edges yet
Now move in on the main area and see how the "lost" and "found" edges are developed. At this stage there are no edges, everything is fluffy and moveable. With tulips, which are rather stiff looking flowers, keep away from edges as long as you can.

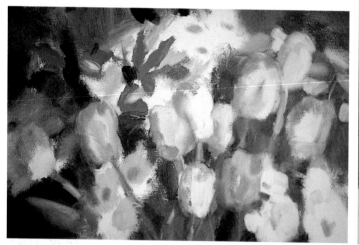

The natural point of interest develops
I added stand oil to the turpentine and placed the darkest darks and did a little more work across the tulips. You can see the centre tulip is already sitting away from the pack as a natural point of interest develops. This tulip is the lightest in tonal value and its edge is the first one you see, so you put it in.

The tulip area compete
Remember this is a close up of a larger painting so this "area" is the point of interest, rather than perhaps one flower on a small painting. Notice the counterchange of tonal values, the light against dark and dark against light. The dark iris lifts away from the light chrysanthemums and the light flowers are lifted by their dark surroundings. This is known as "chiaroscuro" described in the Oxford dictionary as "treatment of light and shade in painting".

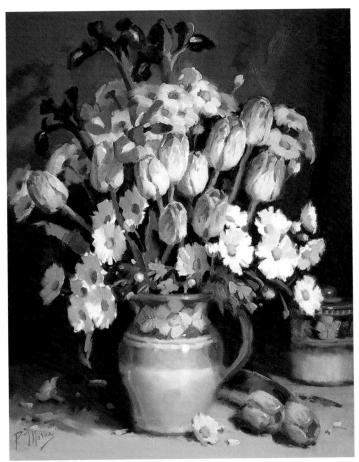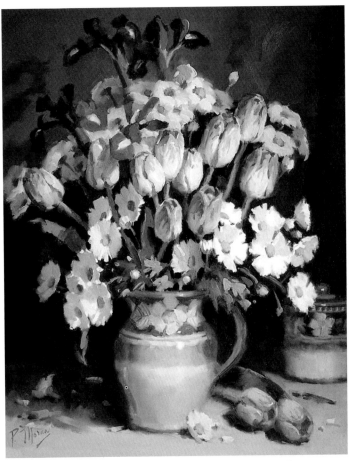

Now relate the tulip area to the whole

Now that the full canvas is shown, notice how focused the tulips
are in relation to the jug and the jar in the background. Their edges
are decidedly "lost", yet they still maintain their characteristics.
YOU JUST NEED A SUGGESTION AND THE BRAIN DOES THE REST.
The painting is "Blush Delight", 61 x 51cm (24 x 20'').

**"Really work at those lost edges, it actually takes a bit
of courage to loosen up and rub out and lose those
details which most students hang on to like grim death."**

You can pack quite a bit of punch into a small canvas and not only will this give you time to complete the subject from life you will learn far more than you ever will by working from a photograph. Have a look at these small paintings and see what you think.

Should you work from photographs?

I do not work from photographs, and if you want to LEARN how to paint I recommend you don't either. Someone who paints from photographs wants to paint pictures, someone who works from life wants to paint.

You are cheating yourself if your aim is to just complete pictures to hang on the wall or to make a fast dollar. To observe from life and gain knowledge from each effort, even if the canvas is not completed, is the way to improve and satisfy the soul. Each canvas is an exercise on how to solve a set of visual problems, and the eye can divide and break down tones and colours literally hundreds of times better than a camera or the machine print ever can.

The subtlety of a child's cheek or a flower has to be seen to be believed, and worked from. You are assessing a subject a thousand times more subtle than a printed photograph could ever be, and I trust the judgment of my eye, heart and taste much better than the one-hour print which will be different on Tuesday from that developed on Thursday.

Also, the eye can only focus on one thing at a time. Working from your standpoint in front of the subject, the

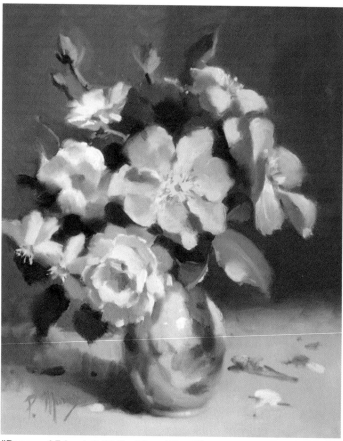

"Rose and Friends", 25.5 x 20cm (10 x 8")

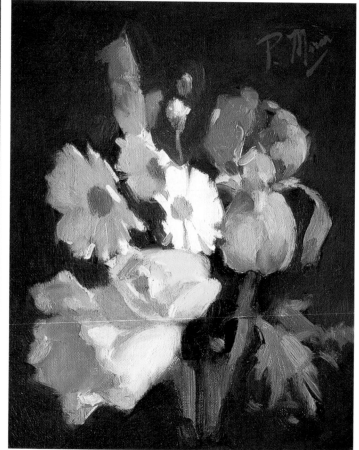

"Tulips and Iris", 25.5 x 20cm (10 x 8")

lost and found edges and areas of focus will appear NATURALLY before you. A photograph does not do this.

I hear over and over, "I have to work from a photograph because the child will not sit still", or the "flowers died and I needed the photograph to complete the picture". The answer is this: the more you paint and practise and observe and measure and rehearse from life, the better prepared you will be for the performance. Your eye will be honed, and even better than that, experience will tell you how to set up simpler compositions.

I have always had the opportunity to churn out paintings of the hottest flower subjects, but the bottom line has always been that I just wanted to improve and paint, paint, paint! As a student I couldn't stand being in the situation where what was in my head DIDN'T come out on the canvas. And I wanted to paint BIG pictures, ones like I'd seen in the galleries which I couldn't afford. I did so many big paintings that I didn't have any for the art shows because I'd gone past their size restriction.

My aim in life is to make my work improve. It's slow, and I'll never be a

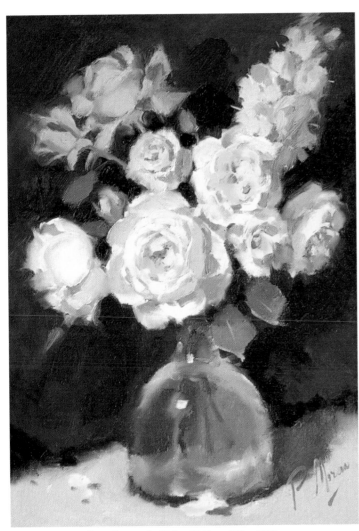

"Troilus and Yellow Button", 40.5 x 30.5cm (16 x 12")

"Poppies", 12.75 x 23cm (5 x 9")

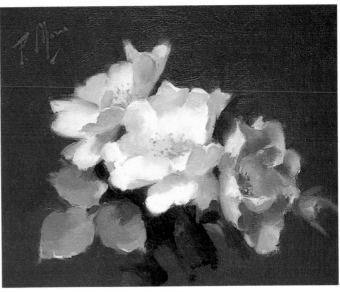

"Single Roses", 20 x 25.5cm (8 x 10")

Rembrandt but I will keep trying to get it right. Years ago as a student, one of my teachers remarked to me that he noticed that when students began working towards an exhibition they stopped learning, there was no improvement in their work at all. I think he meant me because I was working towards a show at the time and I was in the advanced stages of panic, but it pulled me up and I haven't forgotten it.

The ancient method of tonal observation was the method I was taught to paint, and this is what helps me to improve to this day. It suits my own personal integrity and this is how I work:

- I work from life not photographs — I observe.
- I measure, measure, measure.
- I do "more look than put".
- I do not do paintings because "that subject should sell well".
- I do not rush to finish one painting, to get on to the next one.
- I do not take on exhibitions until the core of my work is completed and I know I have time to complete it without pushing.
- I "paint what I love, and love what I paint" (a quote from Australian painter, Tom Roberts).
- I do not do sunny landscapes on dull days or flowers when they are not out, I paint what I observe to be there.
- I strive to paint "visual truthfulness" as the human eye takes in the subject on my canvas.
- I treat each canvas as a set of visual problems to be solved, not just to complete a picture.

Who knows if I can get it right, I might turn abstract!

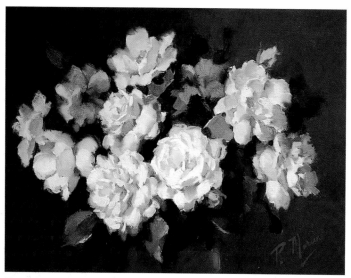

"Window on Beauty", 30.5 x 40.5cm (12 x 16")

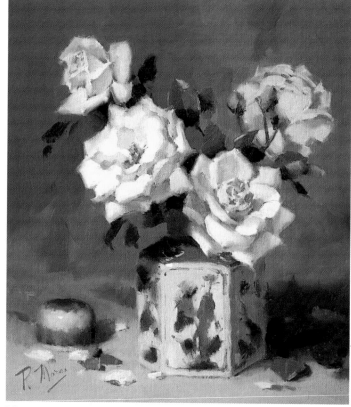

"Ophelia Roses", 35.5 x 30.5cm (14 x 12")

For a ramble in a climbing-rose arbor, an afternoon dress with full gigot sleeves was all the rage in the 1830's. Though the design shown here is sewn in a cotton print from Laura Ashley, it would also look beautiful in organdy—a fine muslin with a crisp, crunchy finish that holds its shape.

Take note that this garden stroller carries a genuine 1840 flounced shawl. Indeed, shawls and all manner of wraps were essential outdoor gear during this era, as was the brimmed bonnet opposite. Like its 19th-century predecessors, this straw reproduction is trimmed with silk flowers.

Bonnet and dress patterns, Amazon Drygoods; bonnet flowers, Dulken and Derrick; ribbons, Karen Augusta; antique jewelry, Lois Nulman; antique collars, shawls, and capes, Cora Ginsberg.

PHOTOGRAPHS TOSHI OTSUKI
STILL-LIFE PHOTOGRAPHS
WENDI SCHNEIDER

CONTRIBUTING EDITOR MARLENE WETHERELL
CONTRIBUTING WRITER MARY FORSELL
HAIR DANNY HAMMOND, MAKEUP PADDY CROFTON
BOTH FOR ROSEANN RENFROW
PHOTOGRAPHED AT THE PLANTING FIELDS ARBORETUM,
OYSTER BAY, NEW YORK

I have had critical comments about the fact that I have my paintings published in print form.

When I am dead someone will probably shove my work on tablemats and lampshades (yes I have seen Renoir on a lampshade) so if many people can get enjoyment from a well-published print of one of my paintings then I am happy enough.

As far as I am concerned the integrity of HOW I execute my work is more important to me than what is done with it. I've seen the Mona Lisa put in some funny places, and I bet Leonardo da Vinci would be hysterical if he could see the tapestry versions I've seen in bric-a-brac shops.

I suppose everyone has to ask themselves what they want out of their work — be honest with yourself, think about it and put it in writing. See what appears on the notepad. Are you striving to become a champion, just see what you've got inside you, meet lovely people on Sundays? I set out to see what I was made of and I gave painting my best shot. I gave myself a fright, I never knew how much I loved flowers and it turned out that my grandmother who died when my father was two years old was an amateur flower painter.

Beauty, genius and greatness are rare gems, and truthfully, most of us are just pedestrian in our work. We can all find examples of great success stories of people who broke the rules, but to be competent and orderly has produced more works of greatness than the "doing my own thing" variety ever will.

I am still working in the orderly fashion and so far it hasn't let me down, I am still improving and aiming for my personal best, and I haven't missed the fast dollar at all.

"James" 30 x 24" (76 x 61)
How do you paint 11 year old boys? FAST! Get as much done as soon as you can as there is always so much more to do! It is the fine tuning that takes the time. This is where everything that has been practised comes into use — there's not much time to measure, your eye should be honed up from all that measuring on the still life paintings — the jars, bread and onions. Go, go, go! Oops he's gone — basketball calling.

"Yellow and White", 35.5 x 30.5cm (14 x 12")

Every good forger knows you don't copy a signature the right way up. You copy it upside down. We follow that lead.

See it better upside down

I have never met a student who measured enough. There are many who *think* they measure enough, but the result on the canvas is what they *thought* they saw, and not what was there at all.

With any subject, but particularly a portrait, you do not aim for a likeness, aim for accuracy and the likeness will take care of itself. Working this way you should be able to begin a portrait all over again and come up with the same result. But a likeness which is the result of a "happy accident" cannot be repeated, and to the educated eye may look just clumsy and crude.

Discipline is admired in opera singers, engineers, dancers, pianists or brain surgeons but, for some peculiar reason, when a painter is undisciplined, it is considered creative, new and innovative, or even genius. Usually, it is just bad painting.

Tools for measuring up
- Steel ruler
- School compass (the old two-legged one with a spike and pencil)
- Curtain rod
- Tape measure

My teacher had a great line which she used to say when re-entering the studio: "Oh, I thought I might have caught someone measuring!" No one ever was. Most students think that once the block-in has been established, no more measuring is required, but in fact, solid measuring needs to continue right through to the end of the painting.

Getting the measure right

What I regard as "measuring properly" for a portrait, is measuring the direction of three or four tiny angles which make up the top eyelid, the same for the eye fold because it may go in a different direction. Measure every direction and relationship from point to point from your standpoint — until your arm nearly falls off. THE MORE YOU MEASURE, THE MORE YOU WON'T HAVE TO MEASURE.

The Oxford dictionary describes measuring as "detailed dimensions", and it is the "detail" where most people fall down. Unfortunately, tedious detailed measuring is a passion killer, and the initial impression and excitement goes right out the window when the drudgery sets in, but do as much as you can on each new painting and very soon you will see a difference.

The purpose of the following demonstration is to show just how much measuring is required to get a likeness, and to show that near enough is never good enough.

See it better upside down

I am told every good forger knows that you do not copy a signature the right way up, because too much of one's own characteristics appear. To get around this, forgers copy the signature UPSIDE DOWN. The same applies to copying a painting — stand it upside down, and copy it that way until just before the end. A Melbourne portrait painter was asked to do a copy of a portrait he'd done 30 years previously of a war-time general. Even though it was his own painting that was being copied, it was still copied upside down.

In many of the European galleries, you frequently see art students with their easels set up in front of a Rembrandt and they paint away while the tourists "mizzle" around. Is there really an advantage to be gained in copying the masters? I have done a few, but they were for teaching demonstrations, however copying the masters didn't turn me into a genius, it just made me recognise how very clever they were. What you do learn is that if you don't measure to the "enth degree", you won't get within a bull's roar of a likeness.

A graphic example of why you should measure
You cannot place a subject like this on the canvas without extensive measuring. The still life set-up for "Tulip Whirl", 100 x 100cm (39 x 39''), although, hopefully, appearing casually placed, cannot be casually placed on the canvas. You can't rely on your eye alone to put all these pieces of the jigsaw puzzle together. Everything on this canvas was planned and measured, including the pattern on the backdrop material.

How pinpoint measuring allowed me to accurately copy an existing painting

My stretched canvas was exactly the same size as the original painting (79 x 107cm, 31 x 42") and I placed them side by side. Each mark I placed was checked from all four sides of the canvas. For example, if a mark was placed three-quarters of the way down towards the right-hand side, I would use the ruler to measure the distance from the edge of the canvas on the original painting, then hold the mark on the ruler and then measure the mark on my copy. The ruler was ideal for a short distance from the edge of the canvas, but the curtain rod was needed for the longer measures.

The rod was better than the tape measure for most of the early work because it didn't flop on the wet paint as the tape measure tended to, but later on, when getting right down to the detail, a compass was used as well as the tape measure, so that the eye area was placed within a hair's breadth of the original. Something like the edge of the eyeball was measured not only in terms of how far it was from all FOUR sides of the canvas, but how far from other areas of the face, as well.

I have to admit this was more time-consuming than I had anticipated, and the copy took several weeks longer than I expected; but I wanted to do as well as I could — anything less would be a waste of time.

After an exercise like this, the next painting should be a pushover!

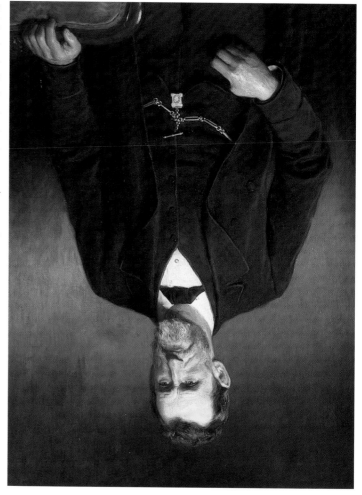

My subject — an original portrait of my great-grandfather
I decided to work on this painting right beside the window to get the best light. The original painting had darkened and yellowed quite a bit, but when I carefully lifted the painting out of the 18 cm (7") wide frame, I could see the original cooler colours at the edge where the painting had been under the frame. These were the colours I wanted to work from, because I wanted my painting to look just as it had when it was first painted.

After standing the original painting upside down on an easel and my blank white canvas on another easel right beside it, I placed a large mirror on another easel about six paces back, so that I could regularly turn away from the canvas and check the reverse view of both canvases. (The reverse view offers a fresh look and shows up errors more clearly.)

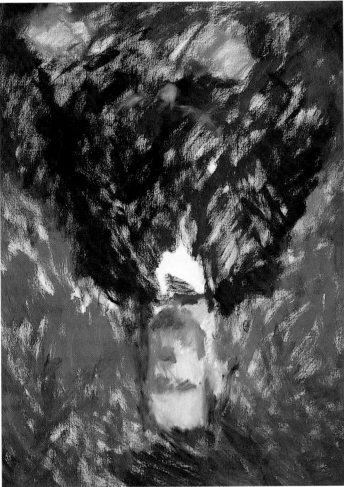

Solid measuring starts here

I used the basic flesh colours I use when I begin any portrait. These include: Yellow Ochre, Cadmium Red, Raw Umber and Indian Red mixed to varying degrees with white.

Using two size 10 hog hair brushes, I mixed two large puddles, one of mid-tone flesh to which I added more Raw Umber for the darker flesh marks. The other was a neutral beige-green which was used at the outer edges of the canvas and I then added some black and French Ultramarine for the middle section.

Keeping it soft and neutral for as long as possible

I used the curtain rod to measure from all four sides how far in from the edge all the tonal value masses were. I decided to establish the shadow mark of the tie (I don't like to give labels like "tie" they are just tonal shapes). This would be the anchor point and I would relate all other points to it. Still using turpentine as a medium, I tightened up the positioning of all the tonal patches. As I used a new tone, I gradually added a new brush — I had six by this stage.

I had not had ONE look at my work from the right side up. I was only interested in accurately establishing the tone/colour patches and their proportions. I can assure you that after establishing an area on the canvas and then going over it to measure if it was correctly placed, I was way out in direction, as well as mass size, in EVERY case.

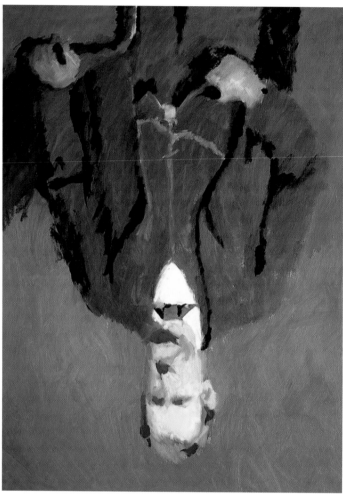

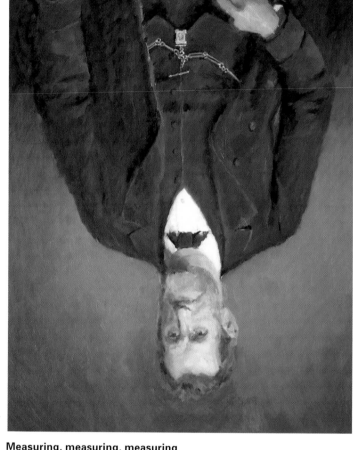

Getting the groundwork just right

I then added stand oil to the turpentine and established the darkest darks. (If I planned to leave this stage for a couple of weeks before continuing, I would soften the edges of these darks to prevent hard edges drying in the wrong place. If I planned to work straight on I would blend the edges in as I went.) I was still doing the tedious job of cross-measuring each mark from all four sides on the canvas. I wanted the groundwork to be as accurate as possible. You cannot build on sloppy groundwork.

Measuring, measuring, measuring

Yes, I was still working with the painting upside down. I genuinely did NOT want to see it the right way up, because it would be too tempting to start aiming for a likeness. Total objectivity was required.

Marking the button shadows was VERY important. After checking I found my marks placed with the natural eye were well out, as were the lapels of the jacket. The exact cut of the clothes is very characteristic of the sitter — and quite a little outfit it is too!

I did just a little more work on this, until I felt there was enough information established for me to go ahead with the refinements the right way up. I put the painting away for a few days to make sure I was well away from visual fatigue and tunnel vision. Then turned both paintings the right way up to pull it into line.

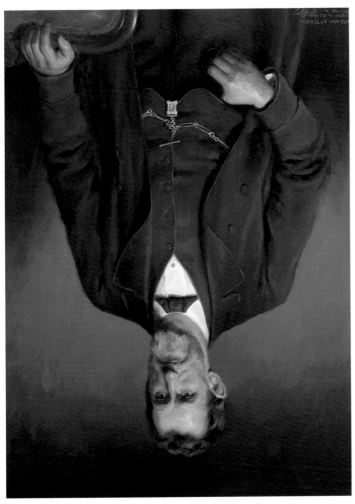

My finished copy of the origianl painting

5 reasons to paint "upside down"

Are there any benefits in copying an upside down painting? Well, yes, there are!

1. Working from an upside down painting makes you view the painting less as a picture and you'll be more inclined to observe the construction. This slows down any attempt to aim for a likeness and encourages a more objective attitude.

2. When you observe the construction more than the picture, it encourages you to keep away from hard edges for as long as possible. It also keeps the hard decisions until close to the end, when the painting is turned the right way up to complete and the last brushstrokes are placed.

3. Working from an upside down picture discourages working on the one spot too long and helps keep the whole canvas moving.

4. The longer you keep working on the upside down painting, the less likely you are to put your own personality and slant into the copy.

5. When you are making a faithful copy of a painting the measuring required is exacting and tedious, but by checking what you have established on the canvas with your natural eye, you will be amazed at just how far out your marks can be. When you realise this you will understand how much more you will have to measure with every new painting you attempt.

"Measure every direction and relationship from point to point from your standpoint — until your arm nearly falls off."

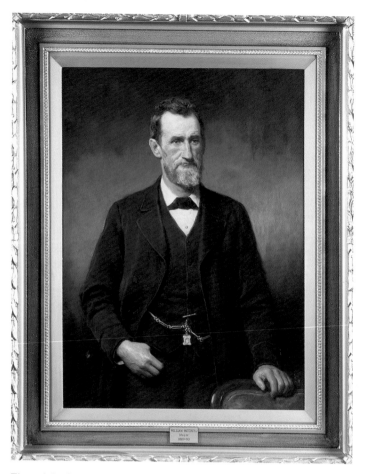

The original portrait painted by James Clarke Waite

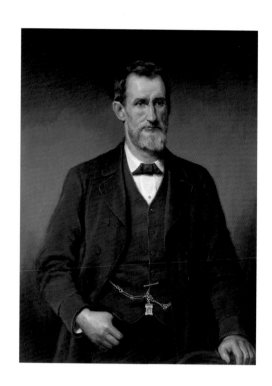

My version — the "new" great-grandfather, "William Mitchell 1834-1915", 107 x 79cm (42 x 31")
My completed copy of the J C Waite portrait. Notice I signed it "Original by J C Waite. This copy by P Moran." When you copy something you must always make it clear that you did.

Genes in action
This is a close-up of the original, rather yellowed painting. Some face! Yoiks! My uncle got the nose, my brother got the eyes, but thank heavens no one got the mouth!

How does it measure up?
My copy of the face, You can see how closely I measured from the original. There was no freehand here and yet I still missed that "something" in the eyes. Ooh! I'd like to fix it right now, but it's time to leave well enough alone.

The original hands
This is the J C Waite original of the hands and fob.

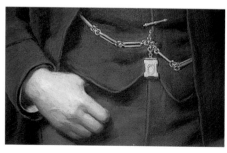

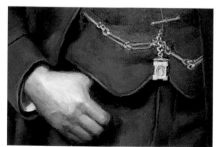

My version
This is my copy of the hands. On close inspection, the fob has a small horseshoe in the middle with tiny diamonds for the nails. I wonder where it is now?

The original portrait painted by James Clarke Waite

This portrait of my great-grandfather, William White Mitchell, from Aberdeen, Scotland, was painted by James Clarke Waite, who not only painted the well-known portrait of Louis Buvelot, but the Alfred Felton portrait, which hangs in the National Gallery of Victoria. Unfortunately few of Waite's paintings survived a fire in the Melbourne Town Hall in about 1901.

The original life-sized portrait was painted 100 years ago and was so realistic that when it arrived in my living room, it gave me goosebumps. James Waite could do that to the viewer. He had accurately and faithfully reproduced my great-grandfather on canvas.

I think it is an unpretentious portrait, and I believe a good likeness. For the demonstration I was determined to paint a copy as indiscernible as I could from the original.

Who was that interesting man?

He was my great-grandfather, who arrived with his parents and siblings at Hobsons Bay, Melbourne, Australia, on the 19th February, 1849. He found a job the day he arrived, then in 1851, he spent six weeks in the goldfields and returned with £120. He went back with his father for another six weeks, and this time came back with £400 — a lot of money in those days. He married Margaret Powell and they had 10 children, two of whom died. One of the survivors was my grandmother, who was an amateur flower painter.

William's family started a bakery which became a biscuit factory. William became a magistrate and sat on the bench for eight hours a day. As well as being Mayor of Footscray on and off for most of his life, he was also a founding member of the Melbourne Harbour Trust, the Melbourne and Metropolitan Board of Works, and was instrumental in bringing plumbing to the Western suburbs. Before then, all water was brought from Melbourne by boat down to the Saltwater River (now the Maribyrnong River). In 1874 he helped establish the Footscray Gas Company and, in his spare time, ran a very successful contracting and building business. He also acquired a considerable amount of real estate, particularly hotels. Phew! My mother's family was just as remarkable, but there are no portraits to copy. I'm sorry to say that the blood has thinned a lot since then; I get exhausted just thinking about these multiple achievements.

A calculated jumble

My painting "Early Camellias", 81 x 71cm (32 x 28''), may look a jumble, but it is a calculated jumble. The direction and relationship from point to point had to be measured very carefully on these camellias, otherwise the character of the flowers and the way they sit, would have been lost.

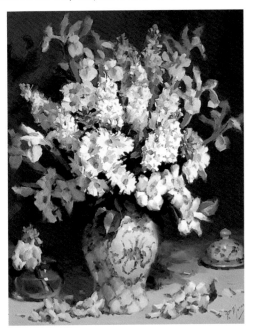

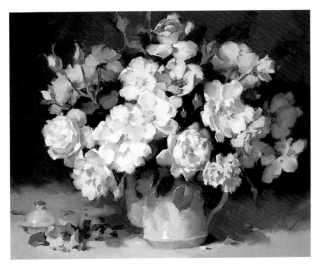

Measure first or your proportions will be wrong

If you go mad and splash around painting flowers with the natural eye and don't watch the dimensions, you tend to make proportions bigger than they are. On smallish canvases like this, "Windrush and Friends", 41 x 51cm (16 x 20''), it is easy to sail over the edge.

Visual truthfulness is not about painting every petal in photographic detail, but in placing the whole subject area in order of appearance. First things first — and everything starts with the block-in

How to tackle the block-in

Some time ago I read a report about a stunning floral creation that regularly appears in a designer store in New York. On this occasion, placed in a huge glass cylinder, were 400 calla lilies all pointing outwards, all cut the same length, their straight green stems groomed together and given one clean twist in the middle. Wow! These mini- malist, architectural designs can make the most ordinary blooms look stylish and breathtaking, however, "a tight bunch of green stems doth not a painting make". Most of us get the biggest thrill out of sniffing and staring at three roses picked from the garden and placed in a little jug in the middle of the table.

I love flowers. I grow them, prune them, sniff them, kiss them, and paint them. When I do paint them I want my painting to look the same as what I see in front of me. So my aim is to place the "visual truthfulness" of the subject before me on to the canvas. Visual truthfulness is not about painting every petal in photographic detail, but

DEMONSTRATION: TACKLING THE BLOCK-IN

Never mind that the spring weather was historically hot, and would probably bump off both the flowers and the artist before the block-in was completed. I set up a vase of flowers of rampant romanticism, completely oppo- site in style to the 400 New York calla lilies I spoke of in my introduction, and stretched a canvas which had grown to 122 x 101cm (48 x 40"). There's no time to sit and gaze at these beauties, so hold onto your hat, we're off!

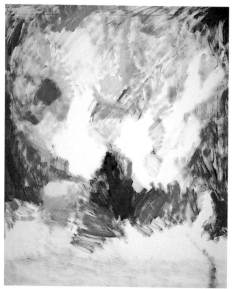

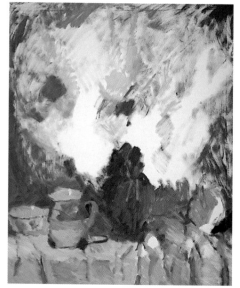

Ask yourself what is the biggest difference between the subject and the canvas?
Of course, the canvas is white and the subject isn't. Using turpentine as a medium, eliminate the white — the easiest way is to place one large rub of mid-tone across the whole canvas, rub out the lightest lights or work around them and leave them out, and place the darkest darks. The darks don't become really dark until stand oil has been added to the medium at a later date; at this stage everything is moveable.

Here, as well as the mid-tone (or value), I used another brush with a wash of Alizarin Crimson as a rub-in for some brighter colours which are in the subject. I established a couple of "anchor points" and covered the canvas as quickly as I could to eliminate the white canvas.

Work from the bottom up
Now you ask yourself again "what is the biggest difference between the subject and the canvas?" The answer is that you have a fuzzy blur which needs to be tidied up a little and a few more things explained to the viewer.

The whole canvas needs to be brought to a further stage of completion. This is a large canvas 122 x 101cm (48 x 40") so where do you begin? If you don't know, or if what you are already doing isn't working, do what I do — BEGIN FROM THE BOTTOM UP. This helps to settle the objects into place rather than having them floating around for too long, when you are working in an area below the halfway mark which is a smaller area to think about. Do not bring anything to a conclusion, and do not work on any one spot too long.

placing the whole subject area in order of appearance, that is, as the human eye observes and the brain processes the pattern of lights, darks and colours before it. The eye tends to follow the lights.

Getting going

Let's say you have set up a still life flower painting, your canvas is placed beside the subject, you are approximately 5 to 10 paces back from both the canvas and the subject, standing on your selected standpoint, you lift up your viewer and observe the subject through squinted eyes to evaluate the tonal value patches, brushes ready . . . yoicks! where do you start?

First of all there is no "rule" about where to start, some people ALWAYS begin top right edge, some people just wash over all the canvas with a mid-tone, then rub out the highlights (this is good for daisies) you can begin in brown and white to give you a good grounding of the tonal values, or if you are sure of your tonal values go into soft colour first and establish the tonal values at the end of the block-in. If you are painting something bright establish the "brights" first so that you can keep them clean. When painting portraits I establish a mid flesh tone/colour first as it is good to get the head in the right position as soon as possible.

Position is everything

Now, getting things in the right position is a bit of a business, and when I was a student I NEVER got the positioning right. No matter how often I rubbed out and re-adjusted, all my paintings drifted to the top, they always looked too high on the canvas, a standard student failing. To get around this I either stretched a canvas with spare inches around the stretcher frame, or, if using a board, I would simply cut off the bottom — WRONG!

It is heartening to know that one of my heroes, the Scottish painter Sir Henry Raeburn (1756-1823), had been known to make this mistake. After an X-ray was made of one of his paintings, it

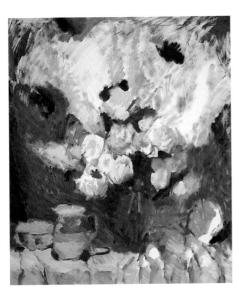

Problem solve as you go
I was still working upwards, but you can see some dark anchor points at the top that show that I was beginning to bring the top down — we will see if it meets in the middle. It won't, there is too much to think about at once, and if it doesn't meet well rub, rub, rub. Every tone/colour, proportion and lost and found edge is RELATIVE to everything else, and the dynamics of painting prove that once you solve one problem, it creates another problem — measure, measure, measure — rub, rub, rub!

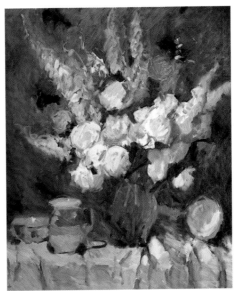

Have contingency plans
NOW the canvas is covered. It was a VERY hot day, and the heat was getting to me and the flowers. Some flowers were opening out and there was a pink peony just above the centre which didn't look very healthy. There was a big decision here — would I continue and take a chance, or would I replace the flower with a leftover which was sitting in a bucket in the dark cupboard? If I pulled the flower it, everything might come out with it. At that stage I didn't think I could bear to begin again — so I continued.

My guideline marks
You can see where I placed dark blobs of paint at the side of the canvas on the halfway and quarter way points. These marks were measured with a tape measure and originally went around the corner onto the canvas, but when those bits disappeared under paint I still had the side of the stretcher frame for reference. I have a viewer with cross wires, and quarter-way wires, so these were the divisions which I used on the canvas. You may choose a different method.

was found that not only did he re-stretch the canvas to re-centre the subject, he swivelled it as well to re-align. I can only imagine the state of advanced panic he must have been in because I have done this myself, but in my case I used a steam iron to press out the crease mark and the painting finished up on the ironing board and not on the canvas. Yes, I saved the painting, but I never EVER want to do it again.

A painting is only as good as its worst point

A crutch or two may be necessary to get the groundwork as right as you can to save precious time and energy fixing up positioning mistakes later; that's not to say that some paintings don't benefit from a good pruning, but of course you can't add on, and there goes another painting in the bin. A painting is only as good as its worst point, and bad positioning is something you can't touch up later. Using a picture finder, or viewer with dividing wires will enable the artist to mark one or two "anchor points" (or more for a larger painting). Place these right at the beginning to mark all other points against. I have cross hairs on my viewer and I tend to mark the centre first on my canvas, with whatever I viewed at the centre of my subject.

If you have a viewer with more divisions that just cross hairs, you can put these cross lines softly on the canvas, the halfway line across and a vertical one on the canvas and the quarter way marks too. On a large canvas I use a tape measure to find the halfway and quarter way marks and paint dark marks at the side of the stretcher frame so that it doesn't disappear under paint as I get going. Now, here is the best tip, after marking the initial anchor points, begin the block-in FROM THE BOTTOM UP. This demonstration shows how to approach the block-in for the best chance of accuracy.

Important ways of thinking

Normally when I show the painting being developed, I deliberately photograph at certain stages to encourage important ways of thinking, for example:

Stage 1: The absolutely first marks on the canvas to encourage the artist to get started.

Stage 2: First light coverage of the canvas to encourage fast canvas coverage because you can't make any judgements until there is something there to judge.

Stage 3: Establishing the darkest darks and lightest lights to encourage the artist to think of the subject as one unit of tonal value patterns and to have laid down the full information of position and tonal values so that as you work up

Work up the main flowers

Stand oil was added to the turpentine as a medium and the darkest darks established. All the information on proportion and tonal values was now on the canvas. At this stage I began to work up the main flowers, keeping in mind how they related to the rest of the canvas, and you can see that the floral background was coming together with the rest of the canvas.

It is said that with each large painting there is at least one big drama — well I had one — the pink peony collapsed and fell off, aaaaaaaah! The good news is that it did it when the painting was still in the moveable stage, but the bad news was that if the replacement didn't sit in there sweetly and the arrangement fell apart, I would have to rearrange all the flowers and rub back and see if I could begin again. (You must only paint what is before you, NEVER make anything up.)

I snipped off the dead peony head, and stripped the leaves off a couple of spare peonies the same colour. I snipped at their stalks to remove every bump so that the stalk would go in smoothly with the minimum of disturbance. The two new ones weren't as fully developed which I felt would be an improvement to the set-up if it worked. It did! They slid into place. Phew!

Then I was on to the really big part of the painting — working across the whole canvas and bringing everything to its conclusion.

Detail

I had in mind a few peonies placed in this Italian jug which had an interesting dark pink top, but when I saw the magnificent buckets of peonies in the florist shop and a friend said "my foxgloves are out, take as many as you want" I knew I was in trouble.

The jug became part of the area of secondary interest and added a great deal to the overall dynamics of the set-up.

My canvas had grown to 122 x 101cm (48 x 40''). The pinky jug is there but it is singing another song in the scheme of things.

certain areas to the next stage of development, all the reference material is all there before you.

In fact, if the artist has skilfully judged the tonal values and proportions at the block-in stage the painting can be left as a quick sketch, because this information on the canvas will be enough to convey to the viewer enough truthful character and atmosphere to be an oil sketch then, if there is time, refinements and adjustments will only be building on what is already there.

However, a certain degree of refinement is required to portray the delicacy of flowers and a rough sketch could mean that the brushwork is more interesting than the subject, and that would never do. *Stage 4:* This shows the FIRST marks in bringing the canvas up to the next level of development. This is usually where

another white flag goes up — "help! where do I go now?" I have put this stage in the demonstration.

How to approach and complete a block-in

Having said all that, the question still remains for some people — but HOW do I do the block-in? So in the following demonstration I decided to photograph the painting at intervals which you normally don't see, instead of showing the completed block-in. I explain HOW the block-in was approached and completed. The subject I chose for this demonstration, like all my paintings, grew from a rather small idea into a rather large canvas.

Key points

- If you are painting something bright establish the "brights" first so that you can keep them clean.

- When painting portraits establish a mid flesh tone/colour first because it is good to get the head in the right position as soon as possible.

- Bad positioning is something you can't touch up later, so use a picture finder, mark some anchor points and establish your subject correctly.

- When you don't know where to start, BEGIN FROM THE BOTTOM UP. This helps to settle the objects into place rather than having them floating around for too long,

- GET AS MUCH DONE AS SOON AS YOU CAN BECAUSE THERE IS ALWAYS SO MUCH MORE TO DO.

- If you can cut down on the tedious block-in stage you can stay fresher longer.

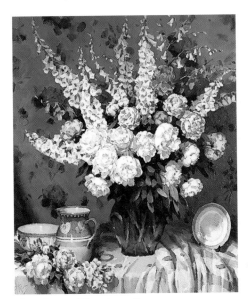

"Peonies and Foxgloves",
122 x 101cm (48 x 40")
Every part of the canvas was brought to a conclusion over the block-in and you can see this is a long way from the first few marks on the canvas. This is why you should strive to GET AS MUCH DONE AS SOON AS YOU CAN BECAUSE THERE IS ALWAYS SO MUCH MORE TO DO. For me it is not only time management but energy management because once tiredness sets in, you stop registering things and mistakes are made. If you can cut down on the tedious block-in stage you can stay fresher longer.

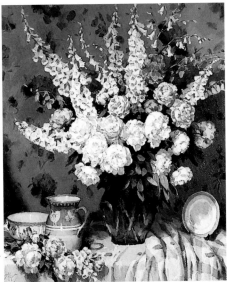

The tonal pattern

Detail
The peony is the epitome of the romantic flower, and as much as I admire Pierre Chardin (1699-1779) and the still life tradition of France, I am not keen on much of their subject matter. I don't want to see dead birds, dead rabbits or dead fish in paintings, either hanging up, flopped over, lying bleeding or with one paw hanging out of a pot. Give me a flower anytime!

Detail
A closer look at the check cloth.

No flowers are the same, but the approach to placing them on the canvas is ALWAYS the same.

The golden rules of flower painting

I can get through 80 percent of Le Louvre, the Uffizi and a lot of other great galleries, at a speed somewhere between a balloon with air let out, and the Road Runner. Why? Because I am not interested in dark brown gloom and doom, no matter how good it is, and if I am considered as shallow as a puddle because of this well, so be it! I find many people who do not know much about art feel quite relieved when I say this, I because I suspect a lot of people think it, and don't say it.

Tonal painters have the reputation of being gloomy-doomy mud-slingers and many galleries won't hang their work because they say that they just don't appeal.

However, an understanding of tonal values should enable the artist to tackle ANY subject and make it appealing. The answer is to get rid of the MUD. If you want to get rid of the mud, how do you do it? Clear rich darks, fresh clean lights, and clear glowing brights will make a painting of any subject far more interesting, but especially when you are painting flowers.

1. Take all the browns off the palette

First of all, unless you are doing a portrait, take all browns off the palette, especially Raw Umber, which seems to dry very quickly and is hard to move.

A good warm grey can be mixed with French Ultramarine and Cadmium Orange, mixed with a little or a lot of white depending on how dark or light you need it.

Cadmium Orange is a very good colour for warming things up without getting too heavy, and doesn't leave stains when moved around as the browns do. "When in doubt, use Cadmium Orange", was the catchcry when I was a student.

2. Begin THIN and finish FAT

Do NOT begin with any oil medium, use turpentine as a medium until you are happy with the block-in. Keep the beginning fluffy and THIN, this way you can change your mind and re-establish as often as you like without building up too much paint. If you get carried away and go in for the kill early with a loaded oily fat brush, there's a pretty good chance that it will have to be moved — and the result is instant MUD!

If the lightest lights or brightest brights begin to get dirty or too heavy with paint, wipe these areas back with a clean turpsy rag, right back to the white primed canvas, and re-establish all over again — don't just put on another coat of opaque paint.

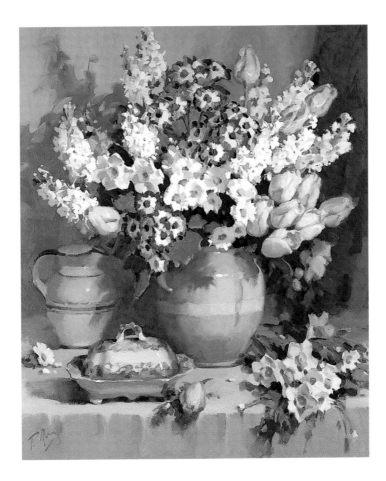

3. Use clear rich darks

When you are happy with the placement of the block-in, add the stand oil or oil painting medium to the dipper and mix the darkest darks. Black is the darkest dark — use it! Other clear darks are Viridian Green, Alizarin Crimson, French Ultramarine. Add any or all of these to black for a beautiful dark.

At this stage do NOT take these darks right up to any borders because you don't want any of them running into anything which needs to stay clean. And leave the hard edges until the end.

If the darks need to be lightened, keep away from white or Yellow Ochre or anything opaque. Try black and Cadmium Yellow for a beautiful dark green, or black and Cadmium Orange for a rich dark brown, or black and Indian Red if you want something warmer.

4. Apply clean fresh lights

Rub back to the white-primed canvas for the lightest lights. Not all canvases are as white as Titanium White, so desirable as it is to leave these areas bare of paint, quite often they have to be painted over. If you have to take something light into a dark area, like a twig or petal or stalk, make a track first. Put a turpsy clean rag over your fingernail and scratch out the twig or petal first, and if you don't get it right the first time, have a few goes until it is where you want it. Then paint the twig or petal in the clean track. Quite often the track looks good as it is just scratched back and no further paint is required at all. This means less opaque build up — thus less mud. Do not drag a light toned brush over a wet dark, because this is guaranteed to make a mess. The alternative of allowing the dark to dry then painting the twig over is impractical and you just make mud a week later (although at the finish you will make the last little flicks over the darks).

5. Ensure clean glowing brights

Use the canvas as a lightener if you are painting bright flowers or a bright dress. Establish the pure colour first — no white paint to lighten, just a wash over the white primed canvas. Then, if it is too bright or too gaudy, bring in the pure colours before using the deadening white. In this chapter you will see how I shaded bright orange gerberas with Alizarin, Cadmium Red and Indian Red before reaching for the deadly knock-back colours such as Viridian and white.

By working thin to fat and constantly rubbing back and re-establishing the darks, lights and brights before using the fat-loaded brushes, a painting can give the easy appearance of being done in one hit. In fact, you may wish to complete it in one hit because you do not have to wait for anything to dry before continuing the work.

The demonstration here shows how to keep in control of the "brights" and set yourself up to be able to choose the level of gaudiness required.

The Golden Rules applied —
"Festive Whirl", 76 x 102cm (30 x 40")

I really enjoyed painting these decorative cabbages. They received an Alizarin only wash block-in, with quite a bit still left showing at the finish, and the darkest darks were pure black and Alizarin. The Italian speckled bowl also has very little paint. The dots were painted over a very thin wash, I did not want this unusual dish to look overworked, the pattern could be unnerving itself without overworked mud turning it into a horror story. If the dots had not worked, I would have simply rubbed back to the canvas and begun again and kept going until I made it work — a painting is only as good as its worst point, and this bowl could have really knocked off a good subject.

- No browns.
- Begin thin — finish fat.
- Clear rich darks.
- Clean fresh lights.
- Glowing brights.

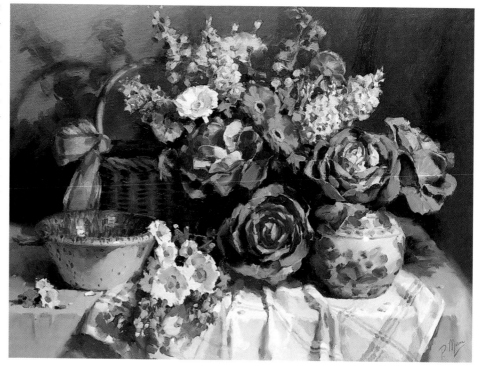

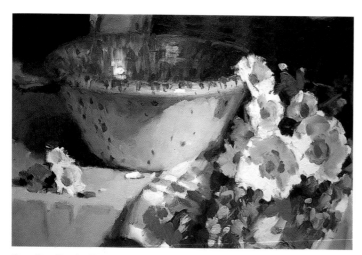

Detail — Begin THIN and finish FAT
Do NOT paint the bowl, wait for it to dry then add the dots a week later — the inside of the bowl was given a turpsy wash of mid-tone, then the drifts of dots were painted FAT, that is stand oil mixed with turpentine as a medium with the oil paint mixed to a buttery consistency.

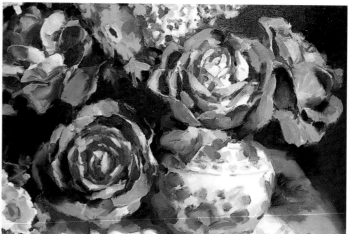

Detail — Look, no brown!
These decorative cabbages were not on sale in pots as they usually are but sold to be used in vases with other flowers. I used pure Ivory Black and Alizarin Crimson for the darkest dark — NO BROWN.

Golden Rule — Clear rich darks
"Tulip Celebration", 76 x 91cm (30 x 36")
These glowing maroon/black tulips had to be approached the same way as the "brights" in the following demonstration. They had a velvety look which needed to be thought out because I didn't want to kill off the rich glow. Pure Alizarin Crimson was established in the block-in thinly with turpentine, and the pure darks, black, Alizarin, French Ultramarine and a touch of Viridian Green brought in very timidly while I figured out the mid-tones. Although these thins eventually were mostly covered by the fats, there is no heavy build-up of paint, just the one coat over the block-in.

Detail
The darkest dark on these tulips was pure Ivory Black and Alizarin Crimson. To set off their distinctive shape I surrounded them with light-toned flowers.

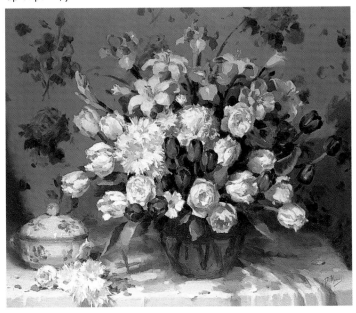

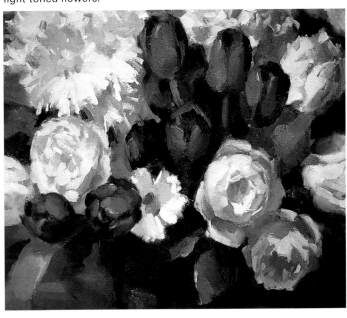

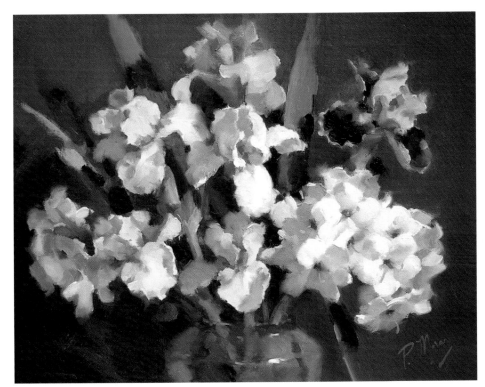

Golden Rules — Make sure your darks are dark enough and apply clean fresh lights
The darkest dark on the iris at top right is pure Ivory Black, French Ultramarine and Alizarin Crimson — a pure rich dark. If you do not get the darks dark enough, the entire key of the painting lightens; the mid-tones become less rich and washed out, and the lightest lights become weaker by being closer to the mid-tones.

How to ensure clean glowing brights

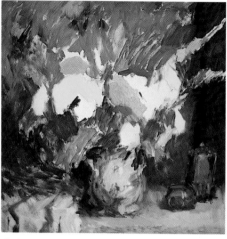

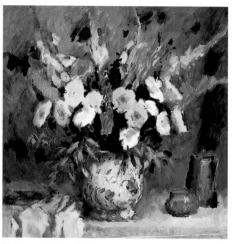

Leave the brown off

When I am painting brightly coloured flowers, the first thing I do is LEAVE THE RAW UMBER OFF the palette altogether. When you are painting anything bright, instead of beginning in brown and white and establishing the tonal range then going into colour with the "brights", you establish pure colour first, then bring in the tonal range around the colour. It is better to establish the colour over-bright so that it can be knocked back, rather than to try and clean up a muddy patch and sap all the life out of your painting in the process.

Here, pure Cadmium Lemon, Cadmium Yellow and Cadmium Orange are established — no white — I use the primed white canvas as the lightener, and I began with just turpentine as the medium. I painted this area LARGER than the eventual area, so that the darks could be brought in rather than take the bright colour out over the darks.

Soft and neutral does it

I covered the whole canvas, which was nearly 101cm (40'') square. When you are doing this KEEP IT AS SOFT AS YOU CAN, AS NEUTRAL AS YOU CAN, FOR AS LONG AS YOU CAN, except for the "brights". If those brights turn out to be in the wrong place, make a clean spot for them by rubbing the new spot right back to the white-primed canvas with turpentine before re-establishing them.

This is the very physically demanding stage, running backwards and forward from the standpoint to the canvas and back again. MEASURE, MEASURE, MEASURE! Rub out, run back, have a look, charge forward and re-establish, rub, rub, rub — run, run, run! Phew! I like to tighten up the positioning as much as I can before I get on to the next stage.

Lightest light, darkest dark and the brights

I added stand oil to the turpentine medium and established the darkest darks. To keep the darks rich — I stuck to Ivory Black, Alizarin Crimson, Viridian Green or Ultramarine Blue — NO BROWN. To lighten slightly I use Cadmium Yellow or Indian Red, NOT WHITE OR YELLOW OCHRE. The full tonal range was established — the lightest light, the darkest dark and the BRIGHTS. I began to work on the gerberas, which are the point-of-interest (but not complete them), and brought some PURE darks into the orange (Cadmium Red and Alizarin Crimson mixed with the cadmiums — Lemon Yellow and Orange).

Detail

Here you can see the start on the gerberas and the beginning of the delphinium.

Detail of finished gerberas

Notice how white and Indian Red and Cadmium Red were mixed in carefully in the shadow areas with smidgens from all over the palette. And notice some of the original wash with turpentine left untouched on the purple delphinium.

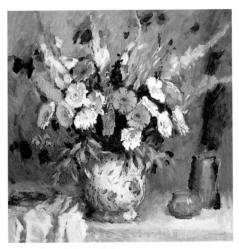

Careful with the brights

My advice is to tread very carefully with brights. You can see some more detail has been placed in the gerberas, still in the pure colours, but they are a little light in tone and rather too gaudy, so I worked across the rest of the canvas and then decided how much of the opaque colours could be used to knock back the gaudiness and still hold the bright rich colour. Between the orange gerberas was a purple delphinium. It was handled the same way. A wash of pure Alizarin Crimson and French Ultramarine mixed together with turpentine was laid down ready for further assessment.

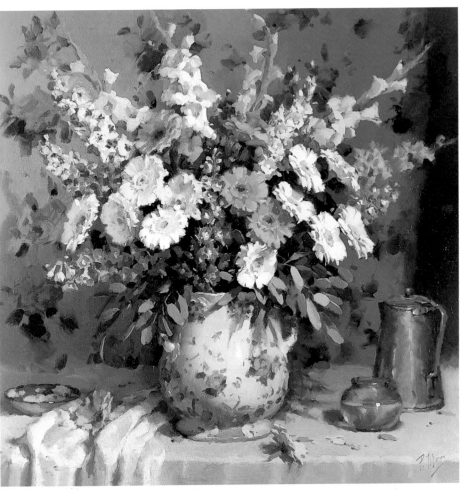

"Holiday Mood", 101 x 101cm (40 x 40")
The subject brought to a conclusion. The colours have a rich glow and walk the line between gaudiness and mud.

Hint

Titanium White should be nearest to the medium dipper because it is the colour most used, and we aim for economy of effort. The other colours are placed tonally from light to dark. Think tone!

Detail of finished delphinium
The original wash of French Ultramarine and Alizarin Crimson was left untouched in several areas. A coat of retouching varnish will seal areas like that so that they don't eventually "powder off" without the medium to hold them together.

49

A Bunch of Flower Demonstrations

I am always being asked, "how do you paint roses?", "how do you paint delphiniums?", "how do you paint . . ." and so on. My answer is always the same, I teach how to paint, how to put on canvas what is before you, not how to paint anything in particular.

I doesn't matter WHAT the subject before you is, whether it be hills, trees, faces, animals or flowers; it is the objective observation of the proportion of tonal value masses and their lost and found edges placed on the canvas that produces the subject on the canvas.

It happens that I love flowers — every colour, every subtlety, twist and turn of them, and flowers are what I paint most — therefore my flower paintings have become the vehicle that I use most to convey how to put what is before me onto the canvas.

Every subject will be different under different lighting — the house on the hill will look different in the morning light, the midday sun and the evening glow — and the same applies to flowers. I CANNOT say THIS is how

Agapanthus and Hydrangeas

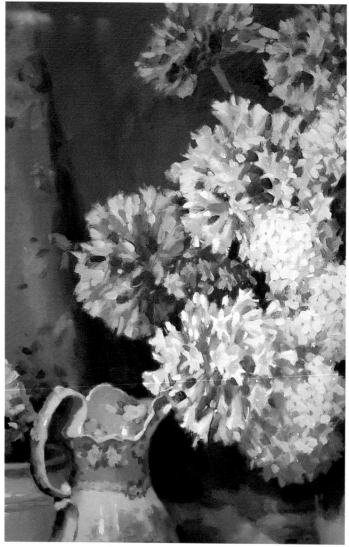

Chrysanthemums

Bearded Iris

50

you paint a rose because no rose will ever be the same, but in the following demonstrations you will see in stages how certain flowers develop and perhaps something in there will assist you over a hurdle. What I hope to show you is that no flower is the same, but the approach to placing it on the canvas is ALWAYS the same.

"I teach how to paint, how to put on canvas what is before you, not how to paint anything in particular."

Delphiniums

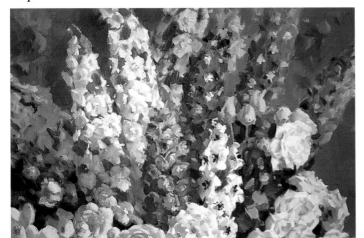

Calendulas

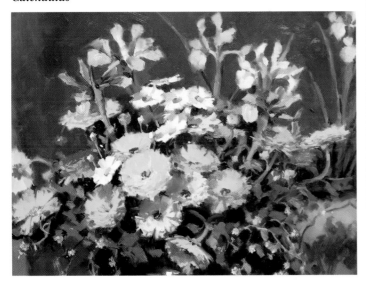

Roses

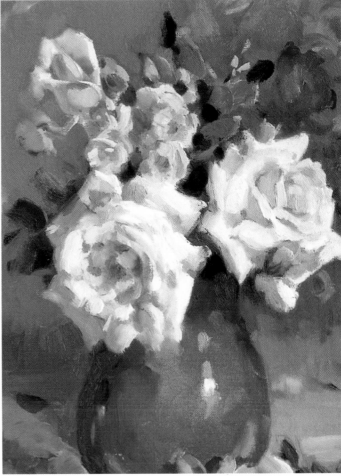

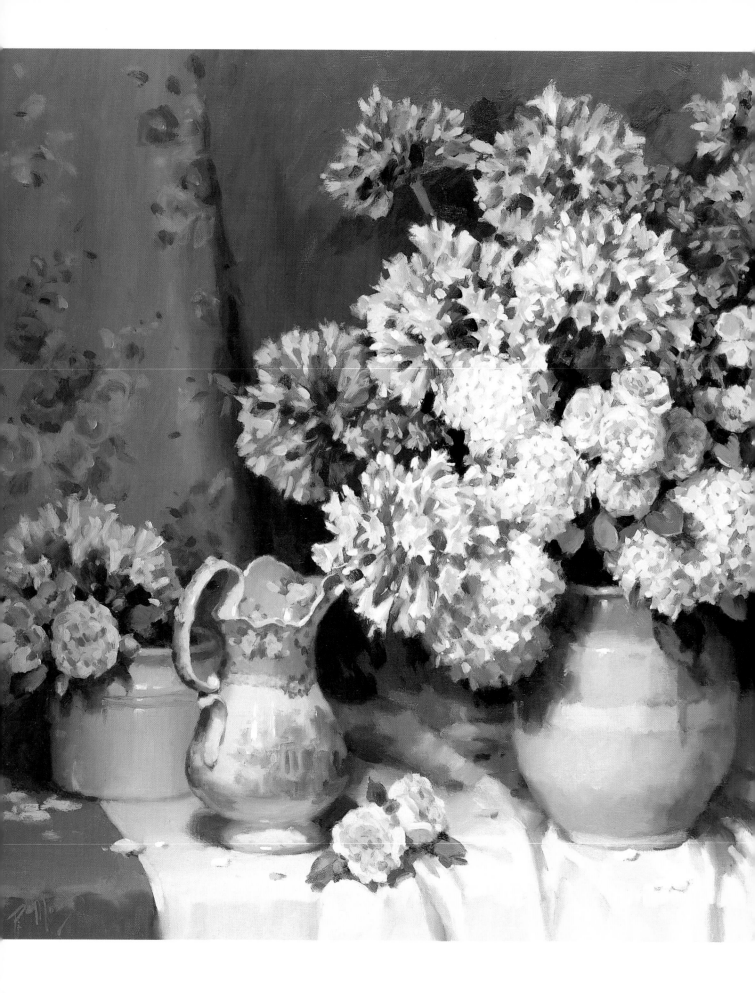

DEMONSTRATION

Soft and neutral does it

Agapanthus and Hydrangeas

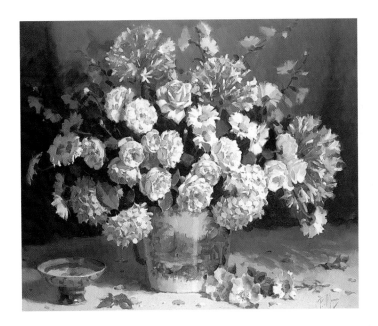

Agapanthus are different at each stage of blooming, and even each fully blown bloom has its own characteristic shape, but the flower's overall appearance is of huge sparkly thistles. In each flower head there are tight buds, trumpets and full-blown starlets. Hydrangeas too, have their own characteristic shape, and they are not quite the round puffballs that you immediately think of at first glance.

"Country Cousins", 91.5 x 112cm (36 x 44")
I called this painting "Country Cousins" because of the international mix of countryware. From the left is Australian Bendigo Pottery; then English country blue and white transferware; the agapanthus are a native of South Africa, and they are sitting in a French provincial olive jar.

Using just turpentine as a medium
When blocking in — keep your work AS SOFT AS YOU CAN, AS NEUTRAL AS YOU CAN, FOR AS LONG AS YOU CAN.

Keeping brushwork broad
Keep those eyes squinted to block out any distracting details, keep the brushwork as broad as you can, bring in some mid-tones — softly, softly catches monkey!

Establishing darkest darks
Rub, rub, rub. The lightest tones can be rubbed back with a turpsy rag over the fingernail — keep away from pure white paint at this stage. Adding stand oil to the turpentine (the consistency to suit yourself, or use oil painting medium) establish the darkest darks. Once the full tonal range has been placed (the lightest light and the darkest dark), it's time to get going on the most difficult area — the middle tones.

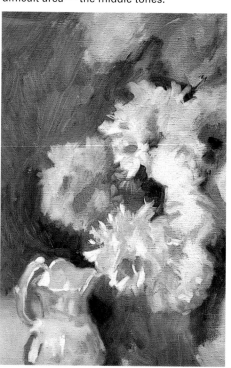

Detail
When a large painting is hanging on the wall in front of you, the eye can wander all over and in and out of all the nooks, but a large painting published into a small area, like this book, does not allow these little areas to attract attention. That is what makes these detail photographs interesting; by isolating areas you get a cameo which sings a song all of its own.

Detail
These roses were used to break up the "wall" of blue.

Developing together
The spotlight is hitting the front flower, making this the lightest tonal value on the canvas. Everything else is receding in tonal value, and these flowers do not have much "local colour" which makes the tonal value evaluations a little easier than if they were bright colours. No one flower should be worked to a finish, the whole canvas should be worked as one unit. DO NOT WORK ON ONE SPOT TOO LONG — although with a subject like this it is very tempting to do so.

Suggesting the flower's characteristics
Study agapanthus flowers to see their individual shapes — the flower heads, buds, trumpets and full-blown starlets.

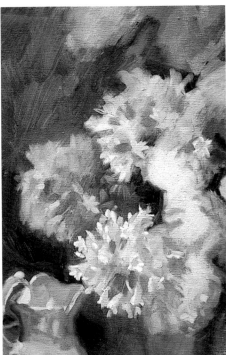

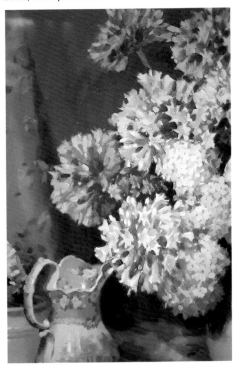

"big brush
big area,
small brush
small area."

Once you know how to tackle hydrangeas you can infiltrate them into other floral arrangements. Not everyone wants bright florals to dominate the senses — these blue flowers can cool things down.

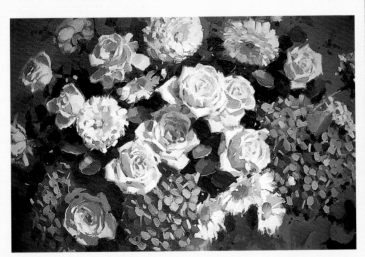

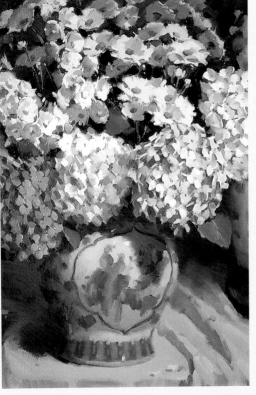

Chrysanthemums

More looking than putting

I call chrysanthemums the painter's friend because these flowers do not move, and will still be alive when the last brushstroke is placed.

As a beginner you need to think through a small painting. As you advance you will need time to think through a large painting, like the demonstration painting overleaf.

"Radiant Echoes",
61 x 51cm (24 x 20")
The pink chrysanthemums on the left and right of the painting came from my garden and are the old-fashioned, rather mad-looking ones — just how I like them. These days flowers are being over-bred and look decidedly tortured, which is very good for stylish arrangements, but not much good for painting.

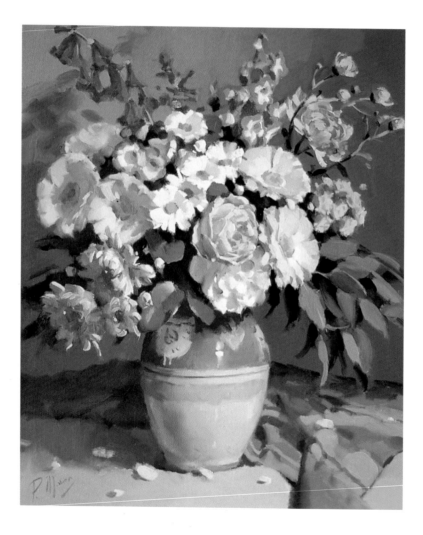

"Rose Momentum",
91.5 x 76cm (36 x 30")
This painting would not have been possible without the three different chrysanthemums, the pom-poms on the left, the daisy-type in the middle and the shaggy ones on the right; they support and set-off everything else in the vase.

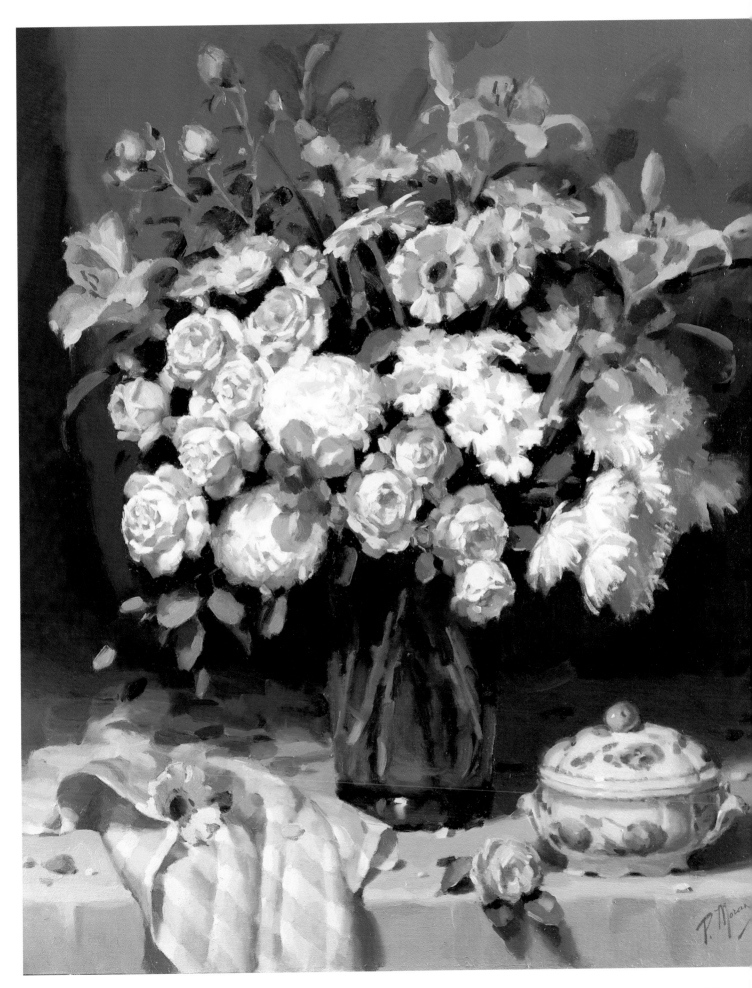

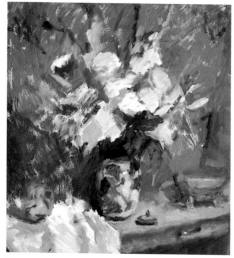

More look than put

The still life was set up with the spotlight ON, because the aim is to arrange a pattern of lights and darks and a balance of shapes and colours. This canvas is quite large, 122 x 112cm (48 x 44"), and something like this takes time, so it must be thought out. The motto is, more look than put! I used turpentine as my medium and this is what the block-in looked like.

Groundwork laid

In this detail we move in to see the chrysanthemums developing. The full tonal range has been established; stand oil has been added to the turpentine and the darkest darks laid down. There is no point continuing without this tonal guide because the next move will be the all important mid-tones which make up the greater area of the canvas, and no judgements can be made until there is something there to judge.

Mid-tones established

Here I go on the mid-tones, placing some here then moving across the rest of the canvas. I can readjust them later when the whole canvas has been brought up to the same level of completion.

Keeping it together

As you can see the two main pinky chrysanthemums are nearly completed and I am bringing the others up to the same stage of completion. Thank goodness the chrysanthemums are holding their shape because gladioli have the frustrating habit of blooming up the stem, the bottom ones die off as the top ones bloom.

The close-up area completed

These ball type chrysanthemums come out in mid autumn and I only get one or maybe two paintings from the season. Some years I don't get any at all.

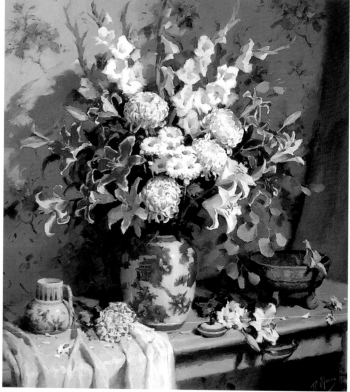

"Lilies and Chrysanthemums", 122 x 112cm (48 x 44")

Hopefully, all this artistry looks artless. Although the ideal flower arrangement is one where you just shove the flowers in the vase and they just look easy and natural, they can be cantankerous and fall into a pattern that is totally unsuitable, usually they all face the wall! It's satisfying to finally arrive at an arrangement that has an easy, natural appearance — even though the set-up has been well worked on. Chrysanthemums will certainly last the distance and give the artist plenty of time to think things out. (The floral chintz in the background was used in the floral portrait of Susan on page 131.)

"Blue, Gold and White",
122 x 137cm (48 x 54")
I used two or three bunches each of these yellow and white chrysanthemums, just to make sure I had plenty to choose from when I was setting them up. I knew I needed a long-lasting flower to see me through this headache of a subject.

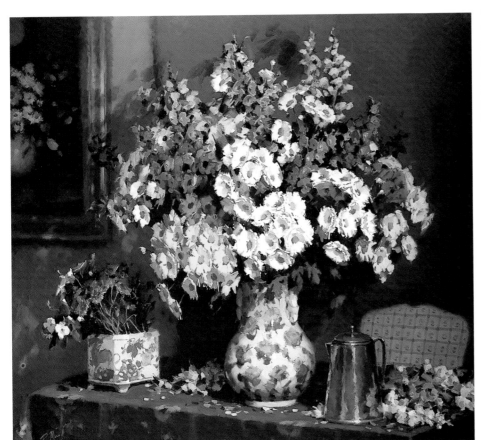

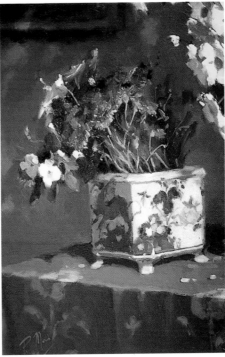

Detail
I needed plenty of time up my sleeve to get this optical illusion to the point where it didn't attract too much attention!

Detail
There was a lot of thinking required here. All these little heads had to be placed properly, but at least only two sets of brushes were needed, one white and one yellow. Flowers of the one colour are always much easier than a bunch of mixed colours which need several brushes and tonal puddles for each flower.

Detail
The difference between chrysanthemum daisies and the garden bush daisies is the way they grow. Here you can see how you get a head of flowers, as opposed to the daisy which has one flower to the stalk.

Bearded Iris

Think Tone before Colour

This subject has several different colours running through it, so the tonal values have to be observed through squinted eyes to avoid being confused by the complexity of the "local colours".

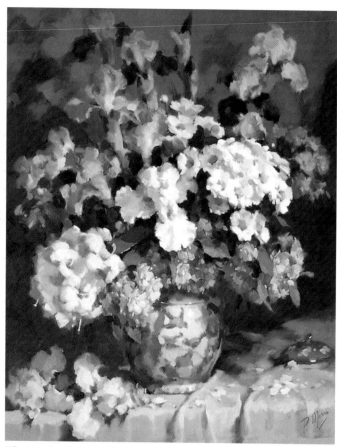

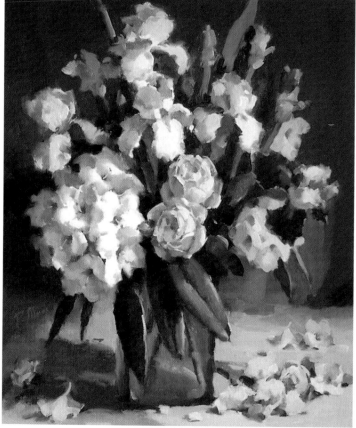

"Spring Opulence", 76 x 61cm (30 x 24")
This variety of iris comes out rather early and arrives with the rhododendrons and spring blossom. You certainly get seasonal feelings with these flowers — early spring in my garden always looks like this.

"Ellen and London Lord", 61 x 51cm (24 x 20")
Iris have bits called things like "falls, beards and standards", and there are about 60,000 varieties in America. I can't say that I have that many, but the way I am going I'm getting there. I'll soon have to start planting them in the spouting!

"Fragrant Fancy", 71 x 61cm (28 x 24")
This variety is really first out in the spring, when there's still a nip in the air.

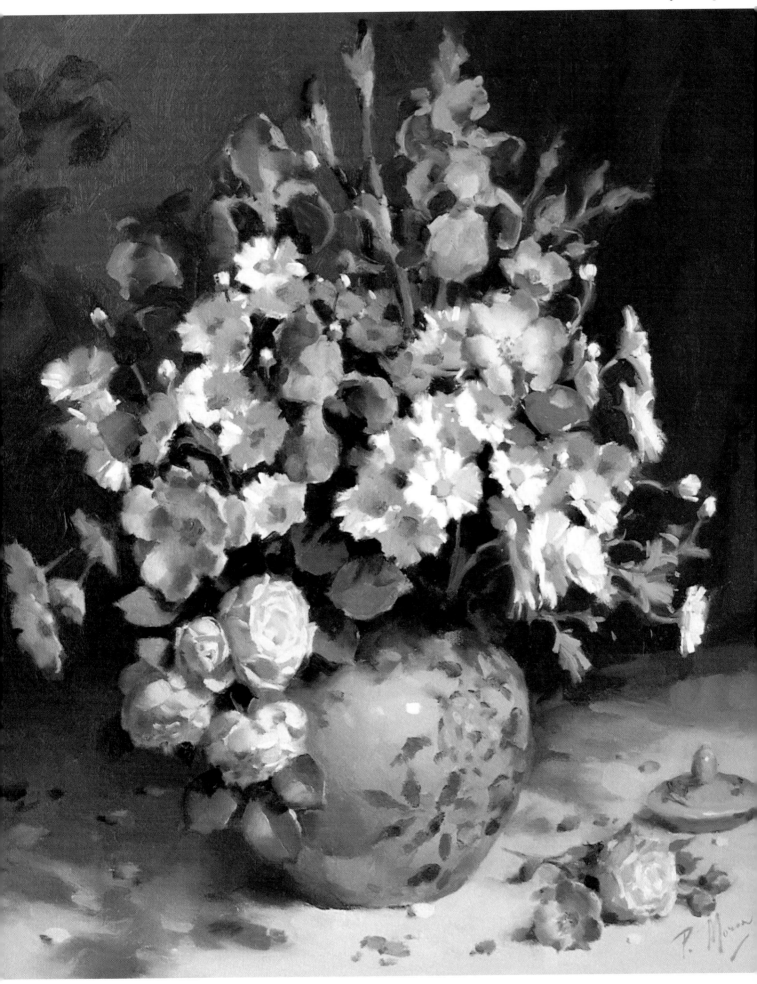

Keep your eye off the "local colours" for this one

When you paint a subject like this, always THINK TONE before colour, and again, keep the groundwork as soft as you can, as neutral as you can, for as long as you can, beginning with just turpentine as a medium.

I have added some mid-tones

As you can see there is no drawing of the known boundaries, the tonal blocks are making their own pattern of light and shade. From this stage, it would be extremely hard to say what the outcome of these patterns will be.

The goal is establishing the full tonal range

Adding stand oil to the turpentine and establishing the darkest darks, something is beginning to take form, but at present we are only concerned with establishing the pattern of the tonal range from light to dark.

The flowers emerge
Hard and soft edges begin to appear. There's plenty of rub, rub, rub, but no heavy build up of paint.

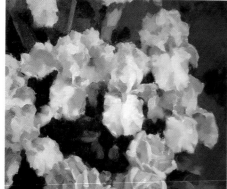

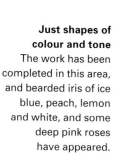

Just shapes of colour and tone
The work has been completed in this area, and bearded iris of ice blue, peach, lemon and white, and some deep pink roses have appeared.

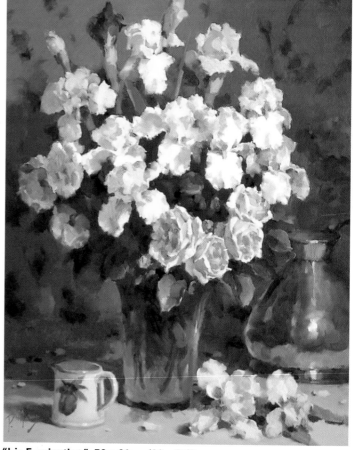

"Iris Fascination", 76 x 61cm (30 x 24")
The complete subject revealed.

"Early Summer", 51 x 61cm (20 x 24")

This variety of iris passes the spring blossom and arrives with the first roses. Early summer and late spring are rather hectic times for the floral painter as there are a lot of flowers which come out for a short time only once a year, like foxgloves, peonies, iris, rhododendrons and some early roses. If you miss these you have to wait another 12 months to get them again but, fortunately, the roses will re-bloom in four to six weeks bringing another set of flowers to accompany them.

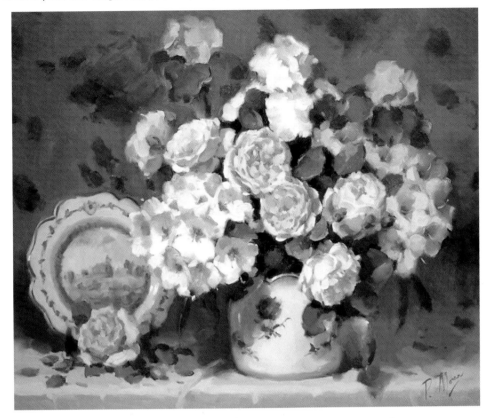

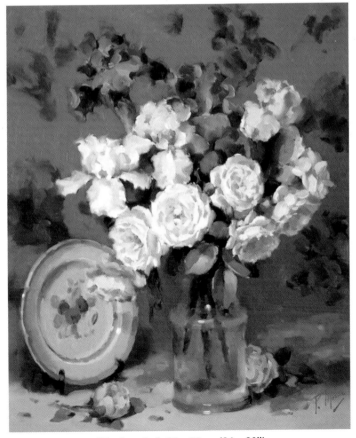

"Spring Jig", 61 x 51cm (24 x 20")
This vase of flowers was sitting on my kitchen bench and I decided to paint it — I love going to the garden and picking flowers for the house.

Delphiniums

How Counterchange adds drama

You could not say this is a demonstration of "how to paint delphiniums" *per se,* because these flowers come in all different shapes from loose and fluttery, to tightly packed spires, in colours from icy blues to dark blues and purples.

A different arrangement of blooms could produce quite a different pattern of colours, tonal values and lost and found edges.

What the following demonstration does show you, however, is how a pattern of *chiaroscuro* (that is, a strong counterchange of darks against lights), can create drama.

Detail from a very large 152 x 152cm (60 x 60") painting "Delphiniums".
See chapter 13 for hints on how to paint large florals

"Timeless Melody", 91.5 x 76cm (36 x 30")
This variety of delphinium is closely packed right to the tips. These specimens may have been produced in a hot-house because they are not usually out at the same time of the year as tulips. Because no delphiniums are the same, they have to be observed as a new set of visual problems each time they are painted. This produces the character and individuality that is desirable in every painting.

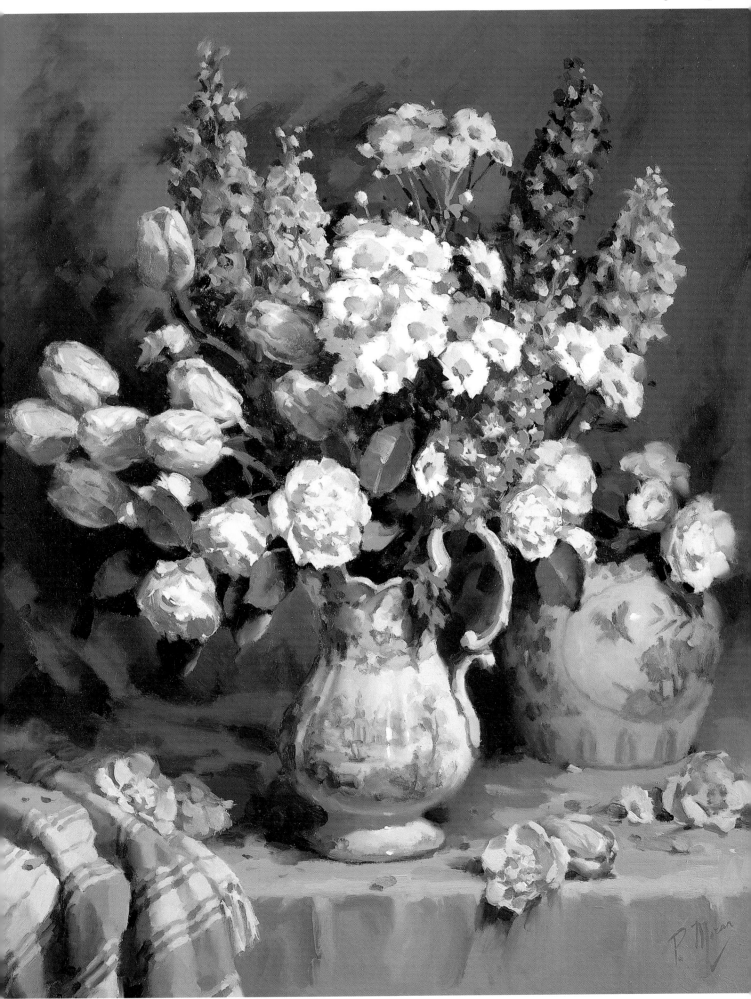

The drama of chiaroscuro begins
A *chiaroscuro* pattern appears even in this first stage.

Strong passages established
I add stand oil to the turpentine and establish the darkest darks. The painting is already looking very strong indeed.

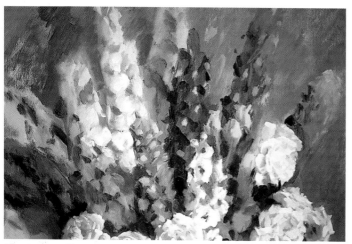

Shapes, not flowers
There is still the strong pattern of *chiaroscuro;* the dark stalks have light centres, and the light stalks have dark centres, but as you see there has been no attempt to "paint delphiniums". As I said before, no flower is the same, but the approach is always the same.

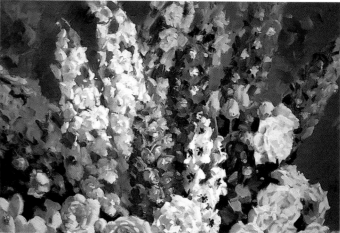

Big brush big area, small brush small area
I break up the solid stalks with a mid-sized brush — the sables are only used judiciously on the flowers in the area of focus. The delphiniums to the back and to the sides have very little detail — the eye can only focus on one thing at a time.

> "There is a strong pattern of chiaroscuro; the dark stalks have light centres, and the light stalks have dark centres."

"Summer Riot", 91.5 x 76cm (36 x 30")
The finished painting. While the delphiniums were "arriving" on the canvas in steps of tonal values and lost and found edges, some roses and a blue and white jug were getting the same treatment.

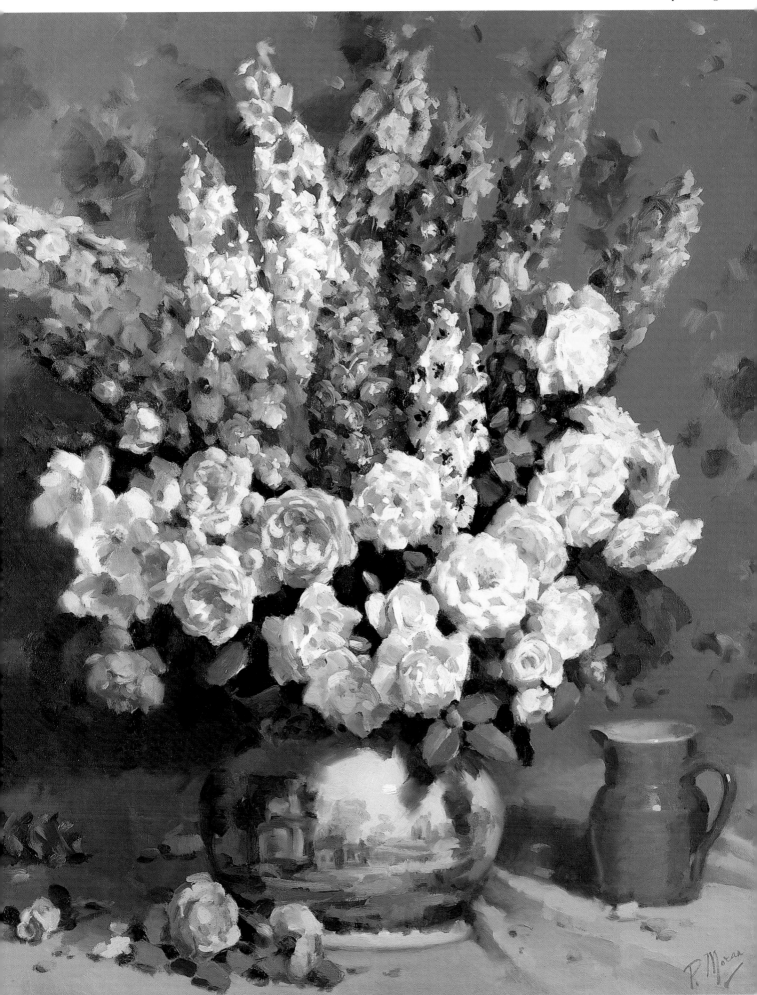

Calendulas

How to handle flowers that won't sit still!

"Calendulas", 76 x 102cm (30 x 40")

Calendulas belong to that group of flowers, usually spring flowers, that move towards the light as you paint them. Daisies, tulips, and ranunculi, have this annoying habit too, but the worst of them all are poppies, which twist and turn and open up before you can finish painting them.

When painting flowers that won't sit still, I try to let them settle and nestle overnight before I begin working with oil medium and making the definite decision. In fact, I try to let most flowers settle in the vase overnight if I can. They all have their peculiar habits and I like to paint them as naturally as possible, and especially keep away from formal "florist-type" arrangements.

"Leave a wide berth around flowers that move."

"Oriental Vase", 91 x 76cm (36 x 30")
Garden daisies are another lot that like to shift towards the light.
This same vase was used behind the calendulas

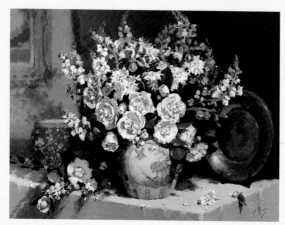

"Camellias", 76 x 101.5cm (30 x 40")
These snapdragons nearly drove me mad as they wandered
all over the place before heading for the light. I had to get
moving on them while they still looked artistic, and before
they all lurched over to one side.

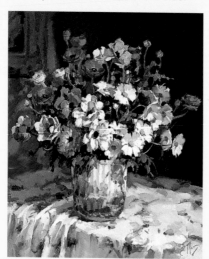

"Ranunculi and Anemones", 71 x 61cm (28 x 24")
These gorgeous things not only move towards
the light but open out then drop off. You really have
to move — paint, paint, paint , rub, rub, rub.

DEMONSTRATION: CALENDULAS

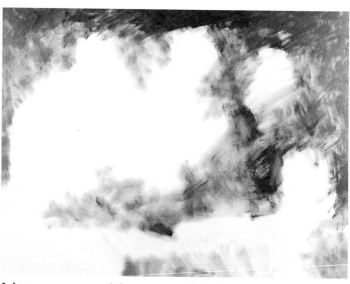

1. Leave space around the movers-and-shakers
This demonstration begins in the usual way, by using turpentine as a
medium and establishing a mid-tone for the dark areas, except for
one thing: I leave a wide berth around flowers that move — it pays to
keep the mud away from these area until the flowers settle.

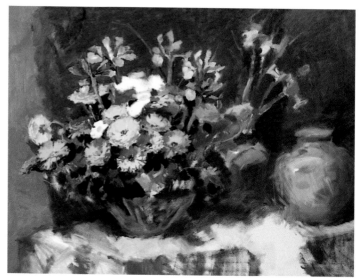

4. Keeping my head
A race against the clock. You can see the calendulas on the right
turning towards the light, it makes the flowers interesting I think.
I did some work on the iris. At the base of the calendulas are some
forget-me-nots, and they are all moving about too, but it is the bright
yellow and orange flowers which are the centre of interest here, so
they must be brought to a conclusion before anything else.

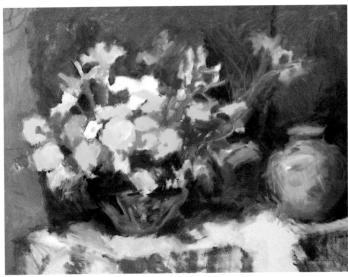

2. Brights in place

These flowers are bright yellow and orange, so the pure colours or the "brights" have been established, and again note the wide margin around this area. You'll see a strategic dark anchor mark here which makes a valuable measuring point.

3. Set the calendulas before they change!

I have let the flowers settle and nestle overnight and now I begin work on them. As you see the whole canvas has been blocked-in and the darkest darks rubbed in, and now I will have to leave everything and just bring the calendulas to completion before they move and open out. The iris also change and move as the warmth of the spotlight opens them wide out and then speeds their demise, but not at the speed at which the calendulas will change.

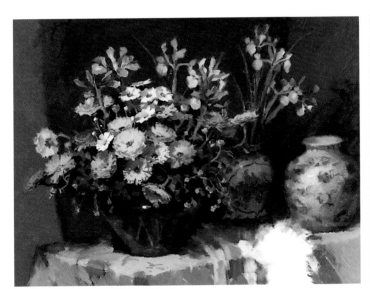

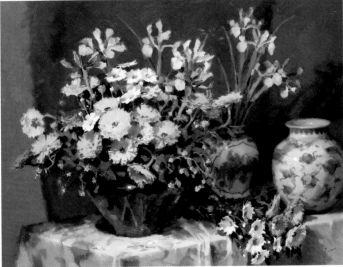

5. Phew! the moving flowers are done.

I move across the canvas and bring up everything else, EXCEPT the next bunch of wandering flowers, the ones on the table. Originally, I had a posy of flowers on the table, but left the area without any paint because I knew I would have to replace the now rather tired looking bunch with the final posy, so I could finish off the painting.

The flowers on the table were blocked-in, keeping them tonally related to the main bunch. The portrait painting dictum, PAINT THE HANDS WHILE LOOKING AT THE FACE, applies here.

6. A vital flower adds interest

Calendulas make a bright and lively painting subject, keep your eyes open for them in early Spring.

Roses

Solve the visual problem rather than paint the subject

It's important we learn to solve the visual problem rather than paint the subject. Bright colours tempt us to focus on the local colour, but we know better than that — we stick to the tone.

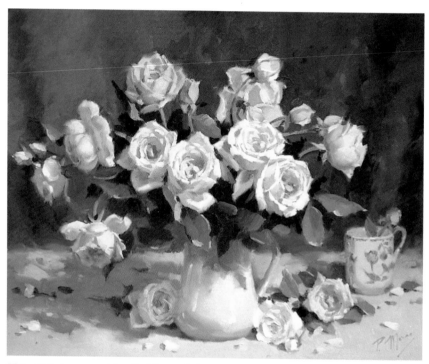

"Royal Highness and Lordly Oberon", 51 x 61cm (20 x 24")

Pink roses in a white jug, a classic combination. Although there is less work when you paint a bunch of flowers all the same colour, it still takes quite a bit of measuring to get the character and attitude of the roses sitting in their own way in the jug. As a student I always had a problem with calculating the height of a flower arrangement, I made them too tall, thus losing their character.

Detail

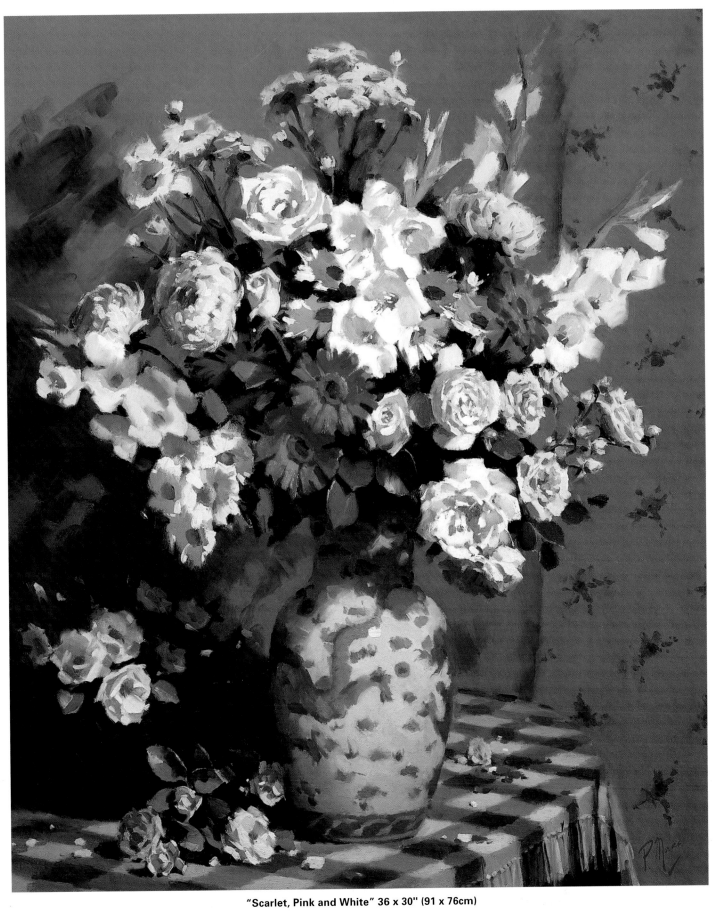

"Scarlet, Pink and White" 36 x 30" (91 x 76cm)
A hint of rosebuds in the backdrop material carry the theme of the little rosebuds on the right.

Think tone, not colour
Because this is a brightly coloured subject it would be easy to lose sight of the tonal values and become excited about the local colour. Pure colours of Alizarin Crimson and Cadmium Red have been laid thinly with turpentine in an endeavour to keep the "brights", bright.

Full tonal extension in place
Adding stand oil to the turpentine medium, the darker tones are being brought in around the "brights" very carefully, and the darkest darks have been placed so that the full tonal extension is in place. Now it is time to move on to the all important middle tones.

Still working thinly
By standing back on the established standpoint, and squinting the eyes, I can identify the mid-tones, some of which I place. This is still just a thin layer of paint, and the highlights have been rubbed out, not painted in.

"Squinting not only helps judge the tonal value, but the tonal value of the local colour, and in turn its place on the scale of light-to-dark of the whole subject."

"Garden Ensemble", 61 x 71cm (24 x 28")
I frequently do this in the silly season, once a backdrop is up for one vase of flowers, it is often there for about three paintings until I take a breath and change it. Of course I would change it if it screamed at the subject, but this is a busy season, and it is the flowers that count.

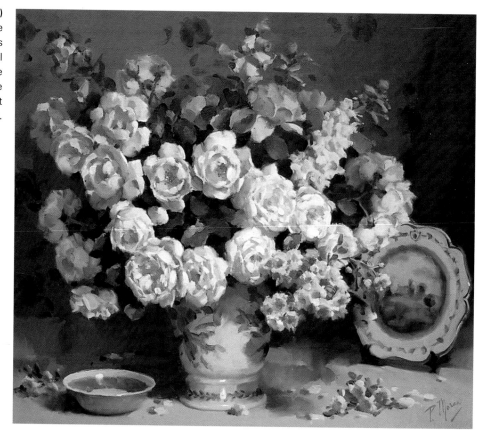

A Shower of Roses

Victoria

Soft *and fragrant as the petals of a rose, these cosmetics and toiletries bathe, soothe, and pamper, leaving skin fresh and sweet.*
Shopping information, please turn to page 126.

Left: Kissed with light rosy fragrance, Pavlova powder in a china cache by Chamart Exclusives and body cream by Shalimar.
 Opposite: Primrose body splash by Descamps in an antique bottle from Cherchez blushes with color and fragrance. Wallpaper by Laura Ashley.

PHOTOGRAPHS BY NANA WATANABE

Heart to heart,
sharing the secrets
of loving...
in a whisper
of blush ruffled silk
and a sigh of white lace.

Laura Aldridge

JESSICA McCLINTOCK

Costa Mesa
South Coast Plaza
Crystal Court
714.557.0888

San Francisco
353 Sutter
415.397.0987

Santa Clara
Valley Fair Mall
408.243.5531

Inquire about the new Jessica McClintock fragrance

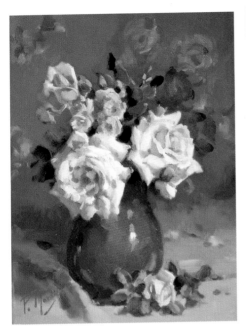

"Rose Power", 41.75 x 30.5cm (16 x 12")

Ah ha! So it is roses I am painting. There has been no attempt to "paint roses", just an attempt to solve the visual problems in front of me — a jug with some roses in it.

This hybrid tea rose is what many people consider a rose should look like. I chose this for the demonstration because some artists find these roses a bit complicated, but as you see, the whole subject is a "light effect", and by establishing the blocks of light on the roses the subject is simplified.

Detail
"Mermaid and Ballerina", 51 x 61cm (20 x 24")

The lovely single yellow rose here is Mermaid. It was very popular in the 1920s, but watch where you plant it because it grows to 9 metres (30 feet) and has killer thorns! On the right is Ballerina which is a show stopper on my standard bush, and everyone asks, "what's that?"

"If you choose one rose as the 'anchor' and measure the direction of all the other roses against it, you will be able to catch the way that they settle in the vase."

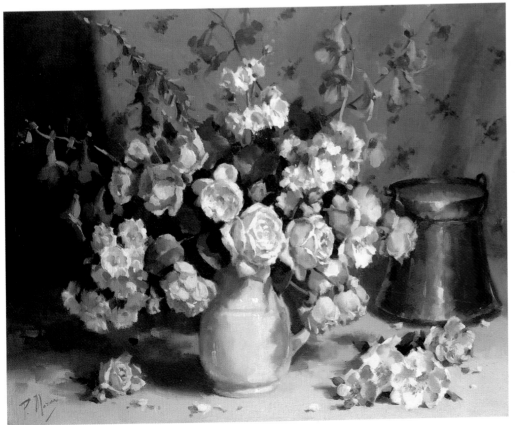

Detail of main roses

"Garden Gaiety", 61 x 76cm (24 x 30")

A slightly patterned backdrop is a good way to soften all those spiky stalks and tie them together, otherwise they could draw too much attention away from the point of interest — the roses. Well, that is if the roses are to be the centre of interest, and the smaller flowers are the accompaniment.

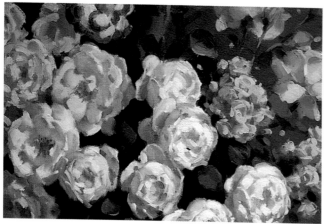

Detail

"Lyrical Vibrations", 71 x 76cm (28 x 30")
These old-fashioned roses are all from my garden and I find them simpler to paint than the hybrid tea, and I like their very subtle colours. Even though they frequently have masses of little petals, the globe shape is a very easy structure to paint.

"Classic Gold", 76 x 61cm (30 x 24")
This painting features Peace and Seafoam roses. Checked cloth has to be measured carefully or the pieces won't fit together. I would suggest placing marks where the lines cross, and then matching them up. Notice the crossed areas become closer as the pattern recedes from the eye. Count how many lines go into the vase, and notice that the tonal values on the bench top where the light is hitting are lighter than the cloth dropping down from the bench. Everything on the dark side is darker. Notice the reflection of the checked cloth on the side of the vase. Reflected light is not as bright as direct light, it is like moonlight compared to sunlight. Make sure the reflections become part of the object, and don't just sit on it.

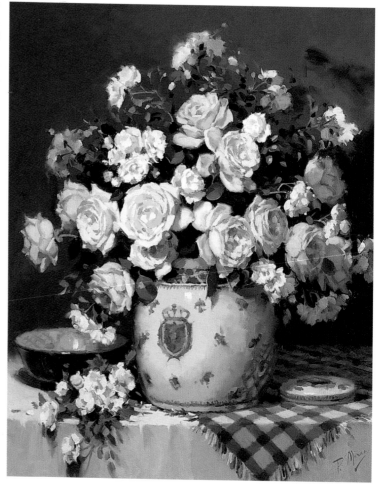

Hint

It is always much easier painting a bunch of flowers all the same colour. You can use the same set of brushes across the whole area, and it is easier to judge the tonal values — rather like painting in black and white

"Reflected light is not as bright as direct light, it is like moonlight compared to sunlight."

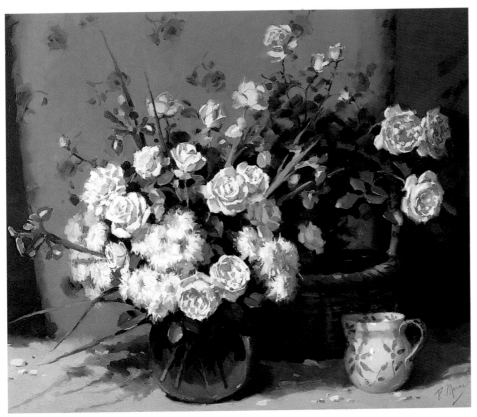

"Roses in Bloom", 76 x 91.5cm (36 x 30")
I frequently use patterned backdrops, for those times when there is an area that "needs something". It is not necessary to fill up every blank spot on the canvas. THE SPACES CAN BE AS INTERESTING AS THE OBJECT, but gentle "tie-ins" can hold a painting together and carry the eye around the canvas. The sparsely patterned backdrop here at the top right-hand corner is a sympathetic echo of the roses in the vase.

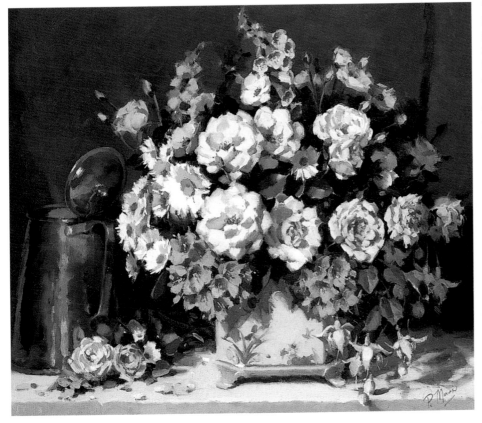

"Burst of Beauty", 61 x 71cm (24 x 28")
How would you like to be a flower in my garden? — as soon as they put their heads up I chop them off! You do have to plant these type of flowers yourself, they simply are not available to buy.

Always tilt the flower away from the viewer, don't have it fully staring back at you. If it refuses to tilt away, then slightly turn the vase away from you. This lot behaved quite well.

If you have a passion for floral painting then you will already know that your greatest challenges are gerberas, iris, tulips and lilies — the full range of plastic looking "unpaintables".

You can paint those unpaintable flowers

W hy is it that just when you really want to get stuck into some painting, there's nothing to paint? There's not a flower in the garden after the roses finish, and the choice at the florist shops ranges from the undesirable to the unpaintable. The undesirable ones, for me at least, are hot pink carnations, brown chrysanthemums, or stiff-stemmed hot-house rosebuds (that all face the ceiling and never open up). That leaves the beautiful, but unpaintable, iris, gerberas and tulips.

These flowers go straight up and do look very stylish when they are all cut the same length, all the one variety, and even all the one colour; but they are a little passionless in a painting on their own.

Flowers that lurch, swirl, nod, have unruly petals, throw shadows and look a bit mad (like peonies) are an artist's dream. Fluffy flowers like wattle or chrysanthemums can be fun at the finish when a mad splash around with a loaded brush can be very exhilarating and cover a multitude of mistakes. Some camellias don't take too much thinking, they are like saucers with a blob in the middle; but the great classic beauties like rhododendrons and roses are an artist's nightmare.

But, after the roses, we don't have much choice — we are left with the unpaintables! In a vase they all go straight up, their form is definite and the line is hard. They are the perfect models for the plastic look!

There are two strategies to keep in mind when faced with a bunch of unpaintables: they are BRUSHWORK and ARRANGEMENT.

Strategy 1 — Brushwork
Paint against the form, keeping away from hard edges as long as you possibly can.

Strategy 2 — Arrangement
Arrange the surrounding objects and the background to soften the stiff flowers in the vase.

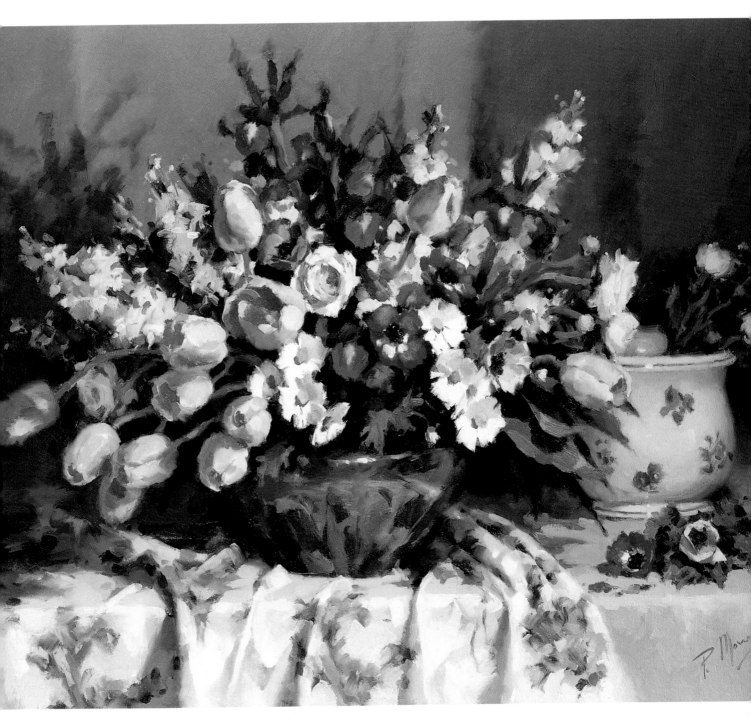

Balancing lost and found edges avoids the plastic look

In "Tulips and Ranunculi", 76 x 91.5cm (30 x 36''), even though there are plenty of supporting flowers and the little red and black flowers take the starring role, the tulips still do not lose their character. The cluster on the left demonstrates the way they fall, and they are sitting together as they would if they were on their own. The one on the right is supported by the tulip leaves. The iris still show their character at the top against the lighter backdrop, but both the tulips and iris and their stems have a balance of "lost and found" edges to avoid the plastic look.

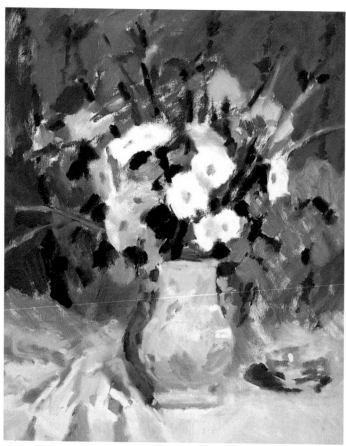

The initial marks
I make the first marks on the canvas, using just turpentine as a medium.

Keeping it thin, neutral and moveable
I cover the whole canvas as quickly as possible using big brushes. I keep the paint thin, the colours neutral and everything moveable.
I add stand oil to the turpentine and establish the darkest darks and lightest lights. From now on, I will mix the paint to a buttery consistency.

Paint against the form, keeping away from hard edges as long as you possibly can.

Strategy 1: Brushwork
Keep away from painting edges for as long as you can. There is one phrase that stands between a mess and a master-piece, "It's not what you paint but HOW you paint it that counts".

In this demonstration we have iris and gerberas, the least difficult are the gerberas. If you like their stylish rigid appearance, by all means paint them as they are, but work at all times with your brushstrokes going in all directions, until you decide where and how many hard edges you want.

Gerberas are deceivingly difficult to paint. They are similar to daisies and are best approached the same way, that is, don't paint them petal for petal, screw up your eyes, observe them from your standpoint to eliminate the details, and paint them against the form.

If you paint their swan-necked leafless stems in one clever sweep with the form you might finish up with a painting in which the stems attract more attention than the flowers.

If the stem is attracting too much atten-tion, either go sideways up the stem or at least break the line or rub the hard edge sideways with your finger here and there.

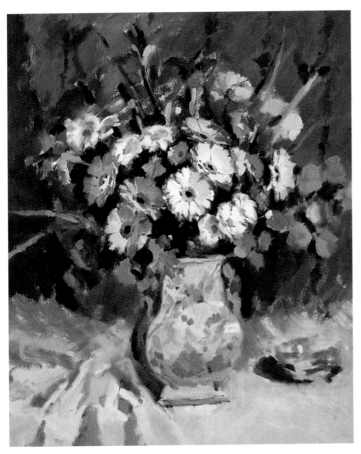

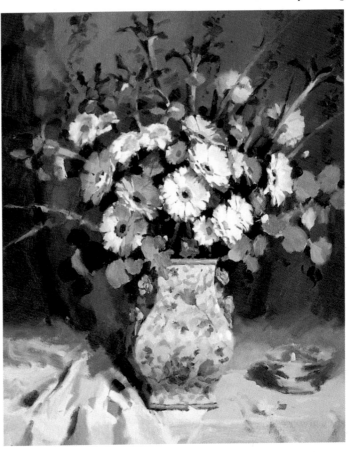

Developing the overall painting

I begin at the point of interest, the main flowers, but don't complete them before working right across the canvas. I avoid working on the one spot too long and keep the whole canvas at the same stage of development before going back to the main flowers to develop them further.

Creating lost and found edges

Time to tackle the tricky bit — the iris. These formal, rigid, spiky points of secondary interest have to do the job of being interesting without being too interesting. I work the background and the iris at the same time and blend them together, leaving some edges out, putting some in, rubbing some out with my finger and painting what I observe to be the tonal pattern from my standpoint with my eyes half closed, but not working petal to petal. Phew! What a balancing act!

Strategy 2: Arrangement

As you will see in the demonstration, it is possible to arrange the flower surroundings to do the job of softening the stiff flowers in the vase for you. Here's what I did:

- I added some floppy blue gum leaves.
- I used a softly patterned vase with similar colours and a wavy shape.
- I folded the material so that the shadow lines vaguely resembled the iris stem pattern. If I had wanted to take the eye in a different direction or soften the line further, I would have "tweaked" the material in a different direction or used a different colour.
- To ease the shapes down, I added the bowl at bottom right so that all the action wasn't happening in the top quarter.

- Bear in mind that a patterned background will soften shape.
- I placed a spotlight so that the tonal value of the background shadow made the iris look interesting without dominating. (My bench is on castors so that I can move it about. If I pull it towards me and bring the spotlight forward as well, the background is further recessed and goes darker in relation to the light-toned gerberas, but if I move the bench right back towards the backdrop and move the spotlight back with it, the background is well lit and it lightens in tonal value. This way I can choose exactly the tonal value of the background so that it can either set off or neutralise the strong lines of the iris.)

Arrange the surrounding objects and the background to soften the stiff flowers in the vase.

How careful arrangement plays its part

Spotlight creates interesting background shadows

Patterned background softens shape

Notice the broken edges on the iris leaves at the bottom left. These leaves did not make themselves obvious when I OBSERVED the subject as a whole, so that's the way they had to be on the CANVAS, not making themselves obvious when observing the canvas as a whole. Hard edges would surely bring them to the fore.

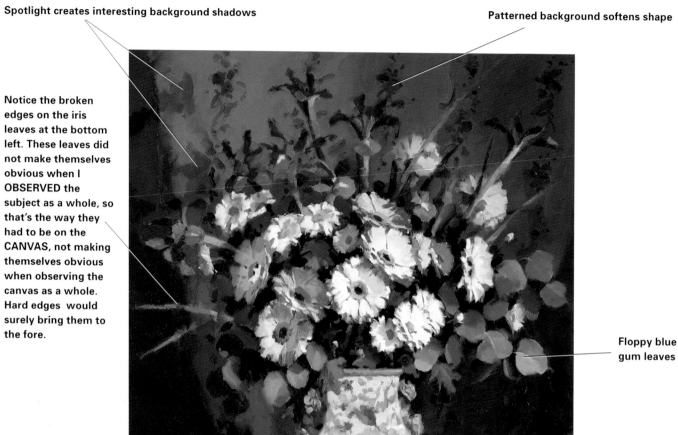

Floppy blue gum leaves

Folds on material resemble iris stem pattern

Softly patterned vase

Bowl adds an interesting tie-in with a pattern that has a resemblance to the iris petals

"Peach and Blue", 91.5 x 76cm (36 x 30")
I think losing the edges on a painting is far harder than you think it is — it really takes courage to just rub out an edge, especially if a lot of time was spent putting the edge in, in the first place. Don't just do a uniform rubbing back. Try to work out which part of the edge you want to keep and which parts you can afford to lose so that the subject still explains itself even though the edge is lost.

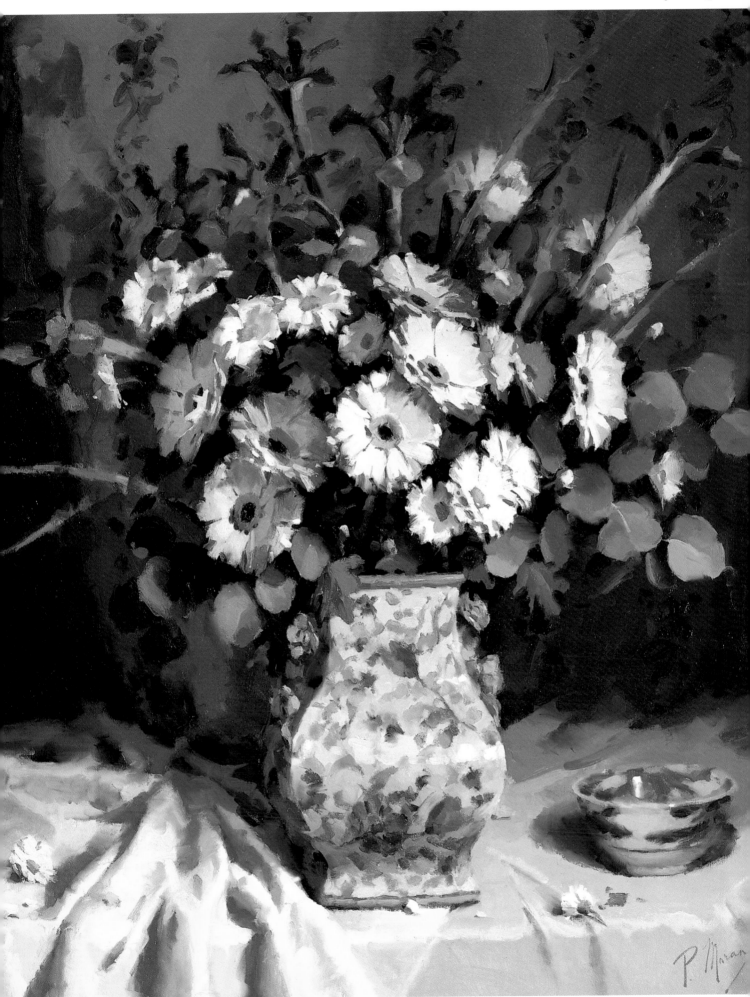

P. Moran

You may reach a certain point in your painting and then come to a dead halt. What to do next? The answer is to make a painting within a painting.

The "where do I go from here?" syndrome

Ask yourself these questions

You can simplify the process if you get into the habit of asking questions. When you have a big white canvas ask yourself these questions —

1. **What is the biggest difference between the subject and the canvas?**
The canvas is white. So begin to eradicate the white canvas, using turpentine as a medium, and cover the canvas as quickly as you can. In this case you can begin by establishing a couple of mid-tones, in this case a couple of "anchor points" and some yellow because we are painting sunflowers.

2. **What is the initial impression?**
Some huge yellow sunflowers hitting you in the eye. Try to keep the initial impression in your mind.

3. **Which area is the point of interest?**
Keep this in mind too, because it is a good spot to go back to each time you have to begin again to bring the canvas up to the next stage of development.

As a teacher, I think my most asked question is — "Where do I go from here?" — and the first time it is asked is usually after the block-in is completed.

You must keep the whole canvas worked on at the same time, but each time you begin the next level of development you DO have to begin somewhere, and although it must be stuck in your head that you DO NOT WORK ON THE ONE SPOT TOO LONG, there are times when you do have to work on the one spot for quite a while. The thing is that when you are working on one small area, you have to keep one eye on the big picture, because what may look very important when you are honing in on a small area, may not be that important when the whole subject is evaluated as one unit of tonal values and lost and found edges.

When you are working up one area, you have to do a PAINTING WITHIN A PAINTING, that is, the developed area should not be isolated but an assimilated part of the whole canvas.

CASE STUDY

Let me show you how to deal with the "where do I go from here?" syndrome as it occurred in this painting. When you are doing a PAINTING WITHIN A PAINTING, you must keep your eye on how each small area relates to the rest of the canvas, tonally, and observe the "lost and found" edges.

There is one main sunflower which is a large bright area, surrounded mostly by the darkest darks.

The top of the sunflower is against the lightest light. This large area of light tonal counterchange of tonal values sets this area apart as the point of interest.

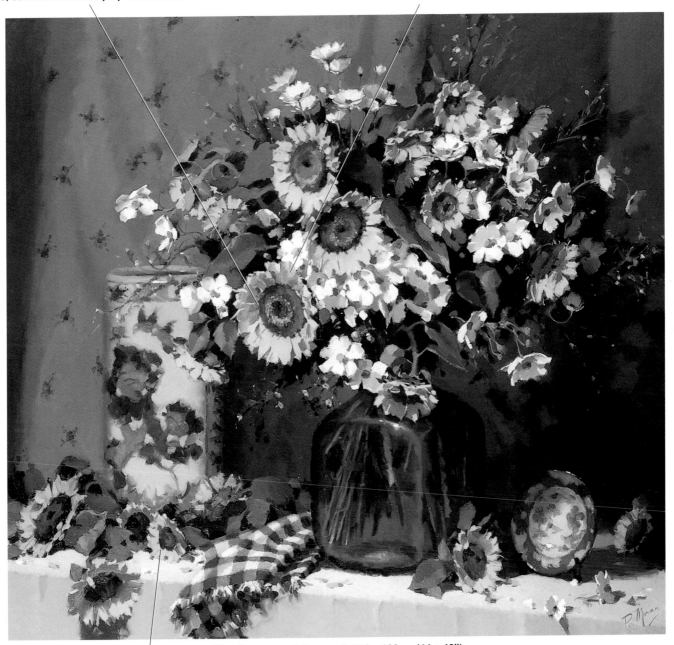

"Sunflowers and Cosmos", 112 x 122cm (44 x 48")

The sunflowers on the table are out of the spotlight, they therefore have a reduced tonal range, less "local" colour, and the edges have been "lost", yet at some stage during the painting these areas did need to be worked on one by one.

What is the biggest difference?
The canvas is white, so you must cover it as quickly as you can.
Begin with a few mid-tones.

Make simple statements
Place one mass of mid-tone for ALL the darks. Do not bring it in too
closely to the "brights" — the pure Cadmium Lemon and Cadmium
Yellow. Make a SIMPLE STATEMENT from what you see.

"Make all decisions from your standpoint, eyes squinted and relate every mark to the WHOLE canvas."

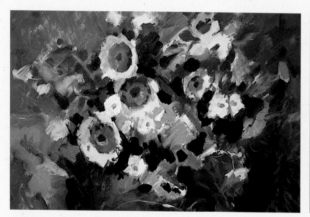

Keep an eye on the whole
When the "Where do I go now?" question arises, a good
plan (though not the only one) is to return to the point of
interest. Here work has begun on the sunflowers, and the
rest of the canvas has been brought up to the same stage.
The tactic is to go forward and complete the sunflowers,
one at a time. Although the adage, DON'T WORK ON THE
SPOT TOO LONG, must be acknowledged, there ARE times
when you do work on one area for a considerable time.
Just make sure that when working up a certain area, one
eye is kept on how this area relates to the WHOLE canvas.

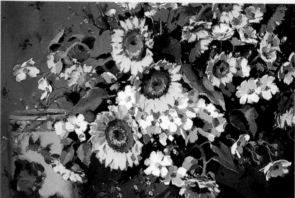

Big brush big area, small brush small area
The main areas of the sunflowers are painted with a broad
brush, and just a few No 2 sables used to place some
stamens in the centre, and a couple of petal edges. While
you are completing the PAINTING WITHIN A PAINTING
make sure you stand back and don't see too many little
details. You would have to be very close to the subject to
see a great deal of detail, and that may mean that you are
peeping at the subject from your canvas, and not making
your judgments from your standpoint.

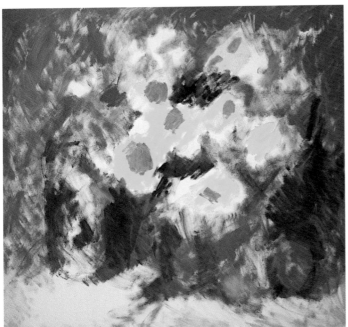

Time for mid-tones

Into the yellow we place some mid-tones, and into the mass of mid-dark we place some darker darks. Aim for a big soft block-in, keeping EVERYTHING AS SOFT AS YOU CAN AS NEUTRAL AS YOU CAN FOR AS LONG AS YOU CAN .

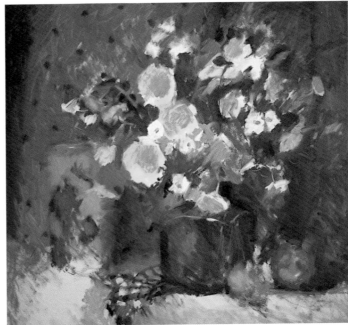

Tidy up a little

Nothing has been completed, just a lot of rub, rub, rub, but the groundwork has been completed and here it is, the first major WHERE DO WE GO FROM HERE? The answer is — back to the point of interest, back to the initial impression — the sunflowers.

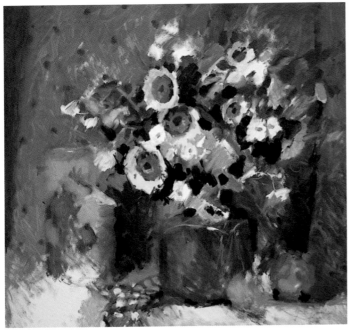

A painting within a painting

This is where we begin to do a PAINTING WITHIN A PAINTING. These particular sunflowers have very dark centres, so while you are placing those darks, ask yourself "are they the darkest darks on the whole canvas?" — remember to view your entire subject from your standpoint. While you are painting the lightest lights of the sunflowers, ask yourself "are these the lightest lights on the whole canvas?" Continue with your PAINTING WITHIN A PAINTING, but keep one eye on the whole subject. So where do you go after the sunflowers?

Because the flowers are the point of interest and they do not last as long as you would like, keep going with the bunch. Get onto the white cosmos, and ask yourself the same questions as above.

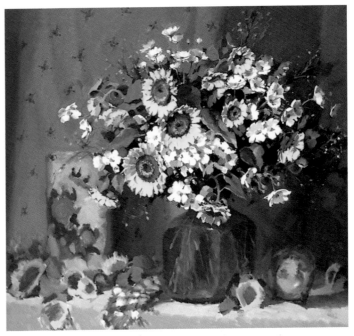

Here comes the next question

Hopefully the flower area has been completed before the flowers shrivel up under the spotlight. Here comes the next WHERE DO WE GO FROM HERE? You can see that a few more marks have been made on the vase on the left, but it has not been brought to completion — no time for that. We have laid some sunflowers on the table which we have blocked in. We now begin another PAINTING WITHIN A PAINTING. As you hone in on these flowers which are out of the full glare of the spotlight, and are not the centre of interest, another phrase comes to mind. PAINT THE HANDS WHILE LOOKING AT THE FACE.

So as you ask yourself, how light? how dark? compared to the rest of the canvas, there is another question — "HOW LOST AND HOW FOUND are the edges?" As you know the eye can only focus on one thing at a time, be conscious of the fact that you cannot overwork an area that we are not really looking at — the problem is that we ARE LOOKING AT IT WHILE WE ARE PAINTING IT.

Make all decisions from your standpoint, eyes squinted and relate every mark to the WHOLE canvas.

There is nothing like the challenge of doing a LARGE painting. Everything you have experienced on a small painting escalates in an exponential curve when you tackle the big job.

Painting big flowers on a large canvas

I once questioned the leap in price from a small terracotta pot to the larger one, and was told that you can get more smaller pots in the oven. So the price you are paying for the big pots is not for more terracotta, but for unseen inconvenience and production costs. It's rather the same with a large painting. You can't judge it by mere yardage but by the design that requires such yardage and the rarity of successfully executing such yardage without a flaw — a painting is only as good as its worst point.

Plotting — and planting — ahead

Now look at the foxgloves pictured here. I plotted for twelve months to paint foxgloves and rhododendrons. I planted my own foxgloves, I stripped and re-limed my workbench, bought a large vase especially and sat like a frog waiting for the rhododendrons to bloom before my foxgloves keeled over. I only had one week when they matched and prayed I wouldn't have any overseas visitors or family dramas.

I knew the foxgloves were going to be a problem because I had fed them so well I thought they would never stop growing. I was looking at them eyeball to eyeball in the garden, and I knew if the rhododendrons had a bad season the foxgloves would be totally unpaintable. I was lucky, everything fell into place.

I find that with difficult flowers you do have to stretch yourself a bit but even if you don't pull them off, it makes the next painting so much easier. It's always more interesting to tackle something different and there's always the chance you'll be able to say, "Whoopee, I did it!"

Unseen inconvenience

It took me two days and blisters to stretch the 1.5 x 1.5m (60 x 60") canvas. It took me two days to set up the still life, not to mention lifting a heavy Chinese screen that refused to go where it was supposed to, and huge vases full of water which were too heavy to lift, so they had to be emptied by siphon every time I changed my mind. The still life had to be arranged to the centimetre to fit both it and the canvas in the room. The canvas was very heavy and unwieldy to move around, and unfortunately I had to put it in a different place to photograph it, as the spotlights wouldn't fit in! The tone/colour puddles, especially for the background were HUGE.

I had to stand on a stool to paint most of it, which meant getting down to stand back for every judgement, not to mention working on my knees for the bottom half and getting up off those to get back to the standpoint. I had very sore muscles.

Flowers don't last, so I just had to keep at it day after day, and I cried when I knew it was going to work.

Was it worth it? YOU BET IT WAS!

What constitutes a large canvas?

I tend to paint everything life-size, that is, the true representation of what is in front of you. Foxgloves and larkspurs are very tall beautiful flowers, and rhododendrons have very large flower-heads and are even more beautiful, and in particular I found these long stemmed Sapphos with their plum throats just fascinating. As fate would have it, I bought a set of 1.5 x 1.5m (60 x 60") stretchers which were on sale so everything was coming together for the big project. I suppose I could have pruned everything down, but I liked the feeling of space and atmosphere that seemed to emanate from the loose arrangement. I liked the light-toned bench — there was no need to cut anything out, it was simply a large subject. I didn't force myself to think up something for a big canvas, it just arrived.

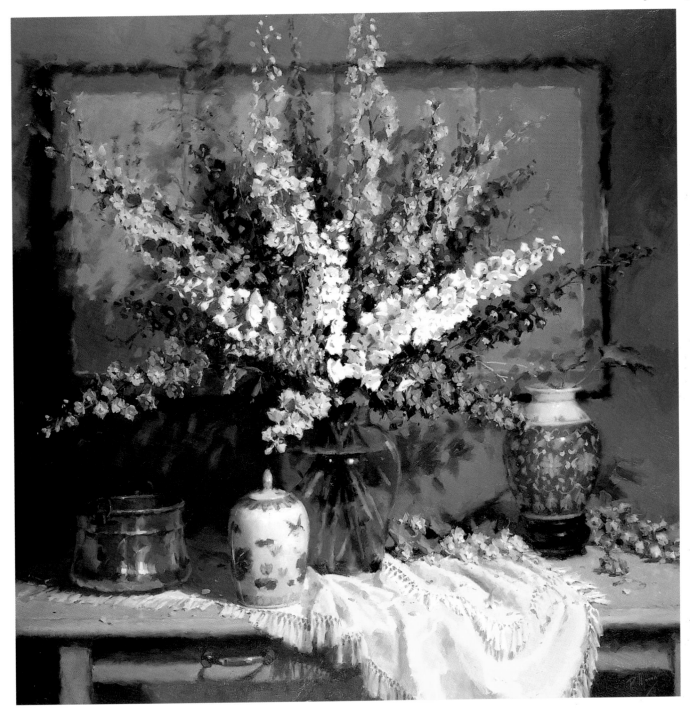

The Delphinium challenge — four feet of glory!

The colour "delphinium blue" just takes your breath away but delphiniums go straight up, or in the case of the painting shown here, four feet of delphiniums going straight up! When the florist said, "Look what I got in for you." I said, "Isn't there anything smaller?" and there wasn't, so I was stuck with them. They looked superb. I couldn't chop off the poetically graded tops, and breaking the stems off didn't shorten the flower part. They swayed and bent with their own weight and the tips flipped. Wow!

I put them in a glass vase with a shape that sprayed the flowers out a little, but they still looked so formal and static. But so beautiful.

I added a pale yellow fringed table-cloth which would normally dominate a smaller subject, but not here. I stood back and thought, here's another five foot canvas! I'd just finished a canvas that size and swore I'd never do another one again, but what else can you do with four foot unpaintable delphiniums?

Foxgloves and Rhododendrons — a very large floral still life 60 x 60''

1. The first marks

My canvas is square so I make sure my viewer is square. First marks on the canvas — these were well judged through my viewer which had cross wires on it to help me along.

This canvas is almost as tall as I am and certainly much wider. A lot of canvas to cover with a little brush and a lot of judgements to be made.

2. Have lots of paint puddles on hand

A few more guiding patches. Make BIG tone/colour puddles to match the area to be covered. As the first step is to cover the canvas as quickly as you can, there's a lot of distance to be covered. While you have a brush in your hand see where else you can use it. Now I can't seem to find any size 14 brushes. BIG AREA — BIG BRUSH, I guess I'll have to scrub harder.

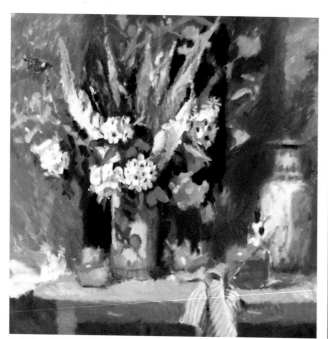

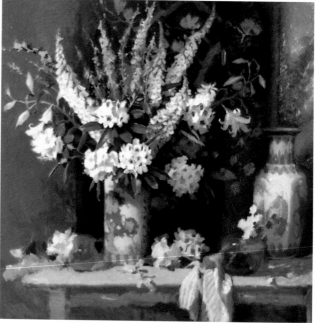

5. Bringing up the focal point

I am lucky that the flowers are fresh and lasting well, they got a bit of a knock around with the arranging. I now get moving on the point of interest, those two breathtaking rhododendrons in the middle, the pale pink one and the magical Sappho. The foxgloves are interesting the way they change colour on the way up the stem. I'm sure they'll keep me busy when I get to them.

6. Control those edges

All the major flowers and the background are now done — phew. I have been doing a lot of work looking and observing in the mirror. You have to be careful with a large painting that you don't get the edges too hard, they will cut like a knife if you do. Fortunately I have a large mirror that takes in the whole subject and the canvas too — I can look at them both at the same time. There's hours of work in each object in this painting, and still there's the table area and the cloth to go. The mixed puddles for the background were huge, after all they have to cover a couple of metres of canvas.

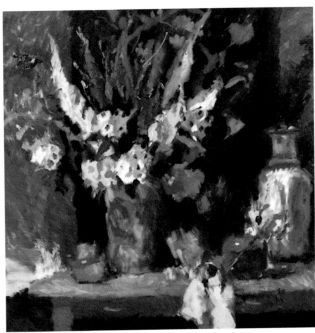

3. Getting physical

Covering the canvas as quickly as I can. I think there will be a lot of changes on this job. I'm up on a stool with a tape measure — I've lost my anchor marks! This is something I hadn't thought of, I've hardly started and my wrist is tired. This is a very physical part of the job covering the canvas and getting down off the stool to go back to my standpoint to check the marks. Well — the canvas is covered.

4. Measure, measure, measure

Adding oil to the turpentine, I establish the darkest darks and the lightest lights. I'm actually taking my measurements from the bottom of the canvas, establishing the table area first and then working up, then doing a bit at the top and working down. Hopefully it will all meet in the middle. I frequently use a tube of black for a large painting, but I've nearly wiped one out now — I'm really getting through the paint. I'm approaching this painting as I would any other, working across the whole canvas.

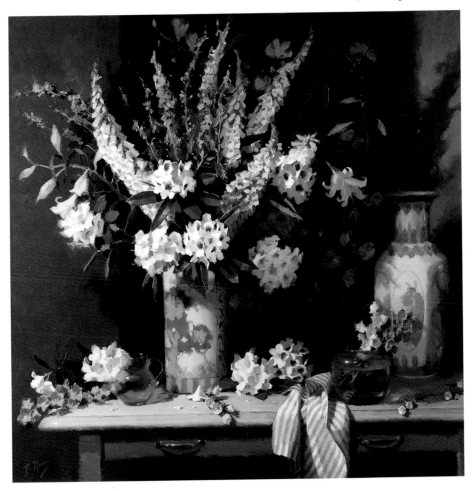

7. Whoopee — "Rhododendrons and Foxgloves", 60 x 60", finished!

It all went rather smoothly. There were no major frustrations — just an ENORMOUS amount of work. I actually rather enjoyed quite a few areas of it — I came out to have a pick at the striped cloth one night when the television was boring and managed to complete it quite happily as it all slipped into place. I can't tell if it's worked yet, I'll put it away — after a few more picks and straightenings. I'll then have another look at it. I wonder where I can put it away, it doesn't seem to fit anywhere! I'll have to hang it frameless until it is dry — it goes on and on.

91

A portrait is just a still life using different colours

You don't believe me? To prove it, I'll do a simultaneous demonstration of both!

I am not going to say a portrait is a breeze because it isn't. However, it certainly is not as terrifying as most people think. Over the six years I was a tutor in portraiture at the Victorian Artists Society in Melbourne, Australia, we had so much fun that no one wanted to leave. There was a two-year waiting list, and all for portraits.

I must tell you that there were plenty of crossed-eyes and alarming hair-styles on the canvases, but a nudge in the right direction and we were on our way again, since portrait painting is addictive.

Most tonal painting classes include all three subjects, portrait, still life and landscape, because it is the APPROACH that is taught, not the subject. When I was learning, we never knew until we arrived at class which subject we would be tackling, whether we would have to dial up the heating to keep our nude model warm, and take our own knitwear off; or put our knitwear on to go across to the park for a landscape lesson.

For this demonstration I will work simultaneously on a portrait, and on what I call a "slow demise" still life (one that lasts longer than flowers but not as long as vases!), to show that if you can tackle a still life you can tackle a portrait.

I will explain the flesh colours fully in a subsequent section.

Master the tonal painting approach and you will be able to paint any subject

"Sorrento", Victoria, Australia, 30.5 x 40.5cm (16 x 12")

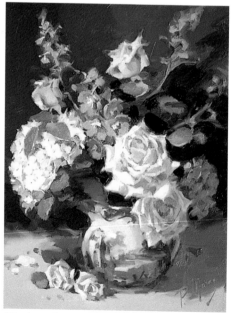

"Summer Posy", 30.5 x 40.5cm (16 x 12")

"Geoffrey", 30.5 x 40.5cm (16 x 12")

Most tonal painting classes include these three subjects — landscape, still life and portrait — because it is the APPROACH that is taught and not the subject.

These three paintings were done on a very useful size, 30.5 x 40.5cm (16 x 12") — not too big to paint on site; a good size to be able to analyse and finish the flowers before they die, and just perfect for a head study. The human adult head measures 9" and fits onto this size canvas with great ease.

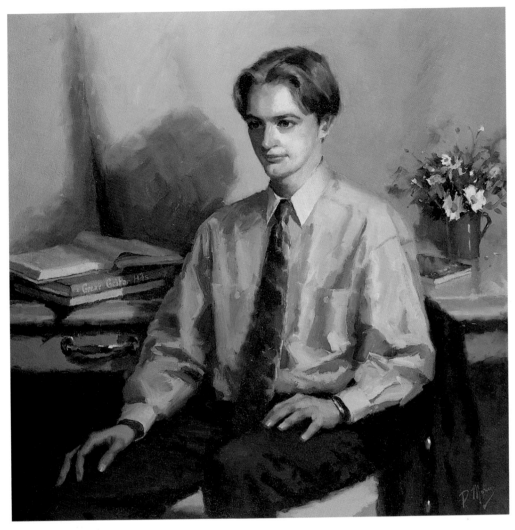

"Scott", 91 x 91cm (36 x 36")

"If you can tackle a still life you can tackle a portrait."

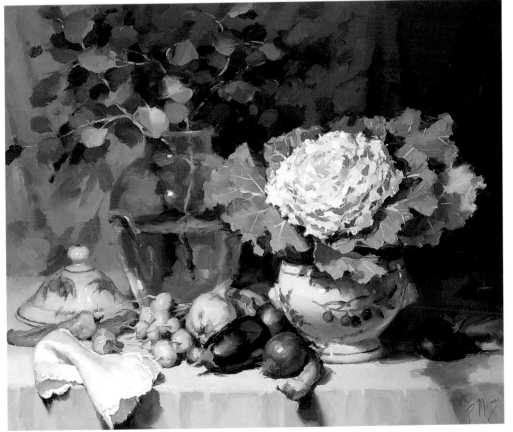

"Ornamental Cabbage and Friends", 86 x 92cm (30 x 36")

Simultaneous Portrait and Still Life

The first marks show the difference
Using turpentine as a medium, I make the first marks on the canvas, some mid-tone flesh colour for the portrait, and a bit of colour and some anchor marks for the still life. See, already the still life is more complicated!

Quickly covering the canvas
You'll remember these words from the flower chapters — use thin paint, and keep your work as soft as you can as neutral as you can for as long as you can. I cover the canvas as quickly as possible because you can't make any proper judgments until there is something there to judge — everything on the canvas is relative to everything else.

Establishing darkest darks and lightest lights
Adding stand oil to the turpentine (how much you use is up to you, or you could use oil painting medium), I establish the darkest darks and the lightest lights. Notice that in the still life the jar highlight has been established as one of the lightest lights at this early stage. However, the lightest light in the portrait appears to be some white flowers in the background, and they will certainly have to be knocked back!

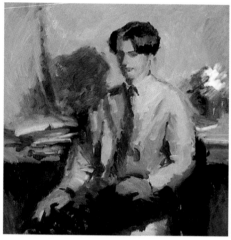

"It is the APPROACH that matters, not the subject."

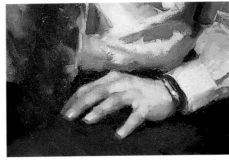

Working on the focal points

I work a little bit on the point of interest, the ornamental cabbage in the still life and on the head in the portrait. Oh dear, I don't mean Scott's head looks like a cabbage, but you know what I mean.

After a bit of work on the area which is attracting the most attention, I move across the whole canvas bringing the rest up to the same stage of development. It's important to keep the whole canvas moving.

Bright colours and scary bits

Some work has been done on the bright colours in the still life and a bit more across the whole canvas, and in the portrait a bit more work has been done on the scary bit THE HEAD, and across the whole canvas, including some books and some daisies which are appearing.

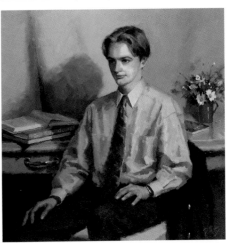

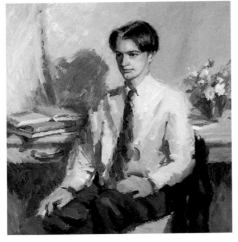

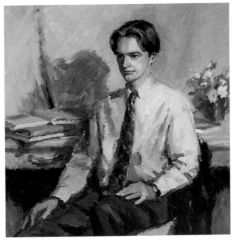

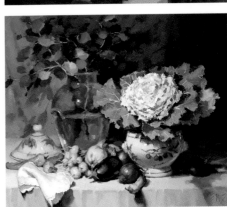

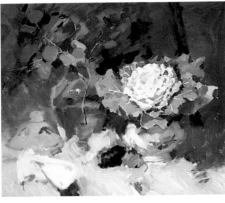

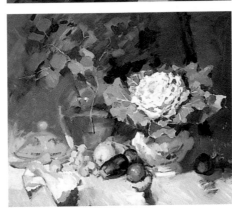

Both finished!

The smallest areas of a canvas are the darkest darks and the lightest lights, the bulk of the canvas is covered with middle tones — and these are the hardest to evaluate.

Notice that the white daisies on the right side of the portrait are in shadow, and they have been painted many tones darker than they would have been if they were in full light. Tonal values have to be evaluated in relation to the WHOLE subject and not taken in isolation. It is the light effect on the whole subject which has to be established.

Detail

Here's rule of thumb: Big brush — big area. Small brush — small area. A still life gives you time to brush up on your brushwork.

Creating Areas of Interest

It is the highlight on the copper urn that is important, and the base of the copper teapot that carries the eye.

It is the shadow underneath the pink cabbage that sets off the coffee pot.

It is the pattern on the cloth, and not the cloth itself that is important.

The shadow of the criss-cross bowl is more important than the bowl. So, it is not the object we are setting up, but the pattern the object creates. Therefore, it doesn't have to be an object that is the point-of-interest in a painting.

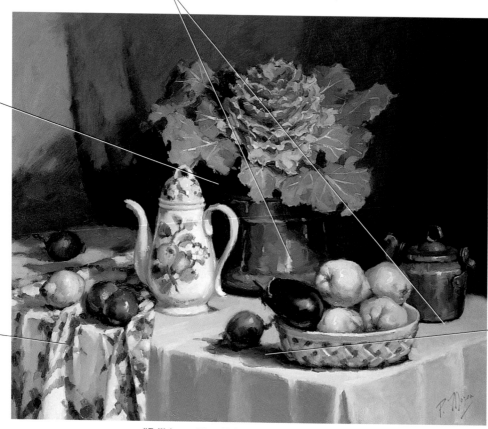

"Edible and Inedible" 76 x 92 cm (30 x 36")

Examine the arrangement of the pink ornamental cabbage featured here. This pink cabbage has been placed and lit *not* as the point of interest but to create *areas of interest*. The point of interest in a painting does not have to be an *object* — tonal painting requires an overall pattern of lights and darks, but in still life the objects and the way they are placed and lit create the balance of lights and darks. Are you with me? Well, just hold on and I'll explain further.

"It is not the object we are setting up, but the pattern the object creates."

In this particular still life the centre of interest is the middle
circle of the canvas encompassing: the bottom part of the
pink cabbage, to . . . the right-hand side and handle of the
coffee pot, to . . . the/eggplant/quince, back to . . .
the pink cabbage! The full circle.

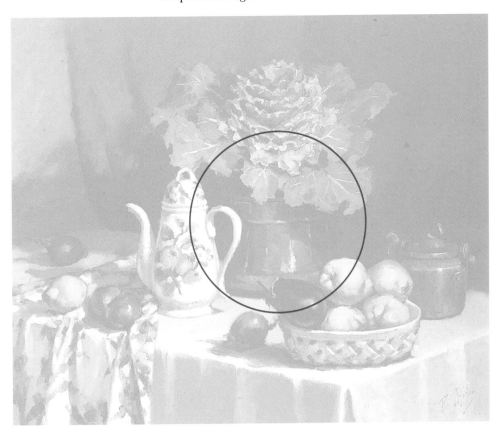

Now after all that quiet prac-
tice and analysis you will
be able to see how it all works on
that "panic job". Go one step
further and mix some slow
demise objects with some flowers
like lemons and gerberas. The
slow demise objects will give you
time to have a think about the
quick demise objects. You see
there is so much you can practise
on in the boring old still life —
make it interesting and they
won't be able to hold you back!

Hair-splitting degrees of value
All these whites, creams and highlights to divide tonally.
Just screw up your eyes and observe the whole canvas
and work back from your lightest light. It is easy to get the
lightest light and darkest dark — it's the MIDDLE tones
that need all that practice.

This is where we come to grips with the two fundamentals of portrait painting: applying flesh colour and measuring the face.

The golden rules of portrait painting

1. Colour

2. Human measurements

1. Colour

The original flesh colours were dug out of the ground; they were natural iron oxides in rusty-reds, black, browns and ochres. In the early days, they were mixed and ground together in the studio by the apprentices and prepared each day for use by the master painters. The colours were absolutely permanent, which is why the ancient paintings are still around today.

The Cadmium Red we use is a chemical replacement of Vermilion which was first used in Europe about the eighth century and replaced the natural ore, cinnabar. The colours of these natural oxides were all very suitable for flesh colours, and the modern versions still are.

At the beginning of the 19th century, colours and dyes began being chemically manufactured. These colours were designed for exterior use on buildings and carriages and artists paints were a by-product. Because these early chemical colours were unreliable, and they faded and cracked, artists continued with the earth colours for portraits because they were reliable and produced the best flesh tones. Even though today's, synthetic colours are more permanent and reliable, and the colours are absolutely accurate, many artists consider it is still the earth colours which produce the best flesh tones.

Interestingly, two advances were made simultaneously at the beginning of the 19th century. Not only was a new range of chemically made colours introduced to the artist but, in 1840, paints previously contained in skin bladders were put into a brass or glass syringe by William Winsor who had established his colour business a few years earlier. Twelve months later, in March 1841, an invention was patented by John G. Rand (1801-1873), an American painter born in England, which was to change the course of painting forever — it was the collapsible, portable metallic tube for oil colours, and his brainwave is still used today.

Previously, except for a few notable artists such as Camille Corot (1796-1875) and John Constable (1776-1837), most landscape artists sketched outdoors and painted indoors, but suddenly, with the advent of the portable metallic tube, and the new colours, there was a surge of "plein air" painting. The Impressionists were followed by an army of artists who began and finished their paintings outdoors.

Colours to use — flesh colours from the earth colours

These three colours are the basis of all flesh colours. Mix them with Titanium White.

In addition:

Raw Umber

Cadmium Red or Vermilion

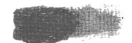

Yellow Ochre

Indian Red — Use this colour judiciously, because a small amount goes a long way, and keep away from it until you have to use it. Indian Red is useful for "knocking back" the orangy-reds but if you use too much the whole face will become dirty and lifeless.

Colours to avoid

DO NOT USE Viridian, Alizarin Crimson or French Ultramarine in the flesh colour.

It is the SUBJECT we want to portray on the canvas, we don't want the artistry to show. That is why it is best to keep away from blue, green and alizarin in the flesh colours. These colours tend to sit ON the skin and not become part of the flesh. Yes, blues and greenish hues can be seen in the flesh, but you can get the blues out of Indian Red which is a

Viridian

Alizarin Crimson

French Ultramarine

blue/red, and if Raw Umber and white are added it goes rather lilac. If you mix just Raw Umber, Yellow Ochre and white it becomes a soft olive green.

These mixtures will give you the blue and green hues and will become PART of the flesh colour without sitting on top of the skin. However, the blues and greens seem to be more obvious when painting by daylight — if you are working by a spotlight there seems to be hardly any at all.

Today, with so many varying influences and so many colours to choose from, is it any wonder that "Flesh Colours 1, 2 and 3" came on the market? Do NOT use them!

I have tried many recommended flesh combinations which include Cobalt Violet, Raw Sienna, Ivory Black, Naples Yellow, and so on. I know many artists use them successfully, but they're hard to handle and they are traps for "young players". Who needs extra problems? All you want to do is to get on with the job.

I still use the colours that I was taught to use, I have never diversified. This combination is wonderful, it obviously takes practice to work out the subtleties, but it doesn't take long to get a really lovely flesh colour.

This is NOT a formula, but a ground plan to give confidence and really get you on your way.

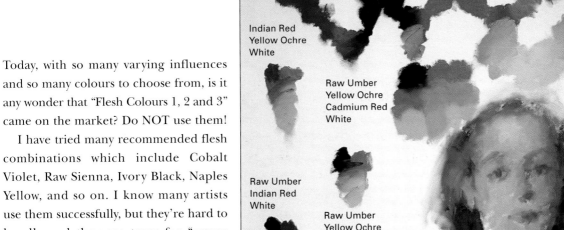

Colour problem solving

1. Never use blue. What, never?

The model had blue eyes and blue eye shadow, but one of the students had painted her with brown eyes and no eye shadow. When I enquired why this was so, the student replied, "But you said NEVER to use blue".

Blues are to be kept away FROM THE FLESH ONLY. If the sitter has blue eyes and blue eye shadow, then blue must be used, but use it judiciously for the eye shadow. I would suggest keeping away from it until after the block-in, in case it lands in a spot that needs to be readjusted and it works its way into the wrong place.

2. Paint them alive, not dead

One of the students' portraits had the most horrible lilac tinge to the face, making the subject look extremely unwell. It turned out that the Cadmium Red had run out and the student thought they could make do with Alizarin Crimson. Never use Alizarin Crimson — remember you are painting someone with blood running through their veins, not a corpse.

3. Ruby red lipstick

The model had a very dark Alizarin Crimson lipstick. I suggested to the students that they stick to the basic flesh colours until the block-in was well established and they had a fairly good idea where the mouth would be before placing any of this violent colour on the lips. They were wonderful — I have never seen a roomful of people go so silently and gingerly about their work.

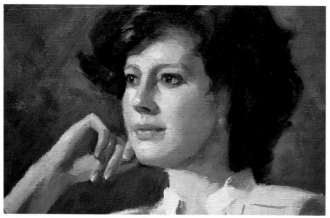

Don't make different tones, different colours
The dark side of the flesh must look like the light side in shadow. When you are mixing a different tone, make sure it is not a completely different colour. (This is a detail of a larger painting "Lizzie".)

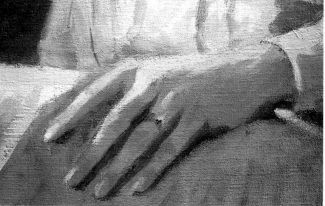

Detail of Lizzie's hand
Notice the lost areas in the shadow side of the hand; the ring is only suggested — the eye and brain do the rest.

A word about the Ivory Black and flesh colour

I have had new students say to me when I have told them to lay Ivory Black on the palette, that, "my last teacher said never to put black on the palette". The truth is that red, yellow and blue can make any colour. It is also true that it doesn't matter what you use as long as you arrive at the exact tone/colour that you desire. Black is a marvellous colour for making rich greens and rich browns, but keep away from black in the flesh colours, at least until you are confident about what you are doing. I have never used black in the flesh colour.

Use Indian Red judiciously
James' skin is very fair, and Indian Red was used in the shadow side of the pink cheek. Indian Red is also useful when painting natural lip colour.

Be careful with lips
If the sitter is wearing lipstick which only Alizarin Crimson will match be very, very careful. Keep with the basic flesh colours until the block-in has been completed and you are sure you won't have to move this colour which stains and seems to go a million miles for every dot.

2. Human Measurements

All you need to be armed with are the basics, the rest is observation. There is too much to be taken in at once without hair-splitting lessons in draughtsmanship, so it is better to get something down on the canvas, then look up your problem on the face chart, or the measurement diagrams, and see if you can sort out it all out without too much of a struggle.

Watch out for babies children or teenagers

If you are painting babies, children or teenagers the measurements are a bit different:

Babies have big heads and little bodies, and short legs and big eyes. Instead of the eyes being the the centre of the face, as they are in an adult, in babies the **eyebrows** are the centre.

There is more than an eye-width between the eyes and not much eye white showing.

Noses are button-like, the nose bridge is hardly formed and flows into the face.

The top lip of babies goes ʰʳ ˡ
middle.

A **ch**
adult siz

The
about th
length, a
relaxed p
teenagers t

These ar
to OBSERVE
or different ᵗ

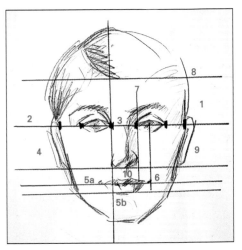

The human face
1. Eyes halfway down the head
2. Head 5 eyes wide
3. One eye-width between the eyes
4. Nose length halfway between the eyes and chin
5. Mouth
 (a) mouth opening one-third down between the nose and chin
 (b) base of lower lip halfway between the nose and chin
6. Corner of the mouth falls under the centre of the eye iris
7. The corner of the eye falls in line with the wing of the nostril
8. The hair line falls between the eyes and the toᵖ ᵒᶠ ᵗ d

e eye and finish at the

f the nose is eye width

ructure is harder and
the lines on the face
ically soft. When
tay on the one spot
nst making the

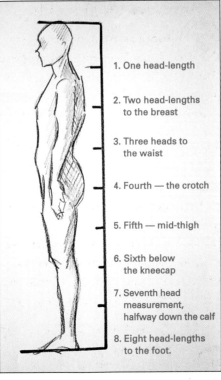

1. One head-length
2. Two head-lengths to the breast
3. Three heads to the waist
4. Fourth — the crotch
5. Fifth — mid-thigh
6. Sixth below the kneecap
7. Seventh head measurement, halfway down the calf
8. Eight head-lengths to the foot.

Figure measurements

The standing body proportions relate to the head, that is, "how many head-lengths go into the body?" If the body is sitting, or is half lying down or just scrunched, the head-length may not land in the same place, as when standing, but you still measure from the head-length. Ask yourself, "where does the second (or third, and so on) head-length land in this pose?"

Shoulders are approximately 2 HEADS WIDE. If the subject is sitting the second and third head measurements could land anywhere.

Arms — The elbows are at the waist and the wrist is at the crotch.

"Katrina", 40.5
As the child gr
is between the ᵉ

"Prue Little", 35.5 x 30.5cm (14 x 12")
On a very young child the EYEBROWS become the centre of the head; in an adult the EYES are the halfway mark of the head. The eyes of a child are larger in proportion to the head; as the face becomes an adult (then elderly) the eyes become smaller in relation to the rest of the head.

The nose is not much more than a button, and the bridge is not formed and flows into the face. The young child's head is about two-thirds of the adult. From about seven years to ten or eleven, the centre of the face is between the eyebrow and the eye.

Measure your own hand

In my portrait class I handed around the ruler and everyone measured their hand span. It caused great comment because everyone's hand was so different.

Stretch your hand out from the thumb to the little finger along the ruler and measure your own hand span. Mine is 21.5cm (8½"). So if the average head measurement is 23cm (9") I know that the head size I am painting should be a bit over my hand span.

Note in this diagram the simple hand measurements. The knuckles are halfway down the hand but on the palm the fingers are shorter because of the webbing. The next set of knuckles are halfway again, and the third set of knuckles are another halfway. As the middle fingers are longer, the knuckles curve in a half-moon across the hand.

Face shapes

Often the shape of a person's face creates an optical illusion. You may think that the sitter has an exceptionally high shiny forehead and make it bigger than it should be (a failing of mine), but if you KNOW that the eyes are halfway down the face and you measure, you may find that there is too much top and not enough bottom.

Someone may have a very prominent nose but guard against making the nose too long and if you know that the nose should land in the middle of the lower half of the face you may find you have sailed well past and the face is getting the "Neddy the Horse" look.

DO NOT AIM FOR A LIKENESS, AIM FOR ACCURACY AND THE LIKENESS WILL TAKE CARE OF ITSELF.

It is easy to paint a likeness when the sitter has obvious characteristics, which is one of the reasons why it is easy to recognise a portrait of a famous person even if the portrait is not all that good, or a rather abstract job, because famous people often have very recognisable features.

Measuring

You may have a sitter whose measurements actually break the rules, so unless you KNOW what the divisions of the human body are and you measure you will not be able to portray that characteristic accurately.

The adult head measures approximately 23cm (9"). You can vary the portrait a little, say from 24cm (9½") down to 21.5cm (8½") and still have it looking life-sized on the canvas. I have noticed that if the painting is to be hung in a large hall, it is better to go to the slightly larger end of the scale as large open areas tend to shrink paintings. If the portrait is to be hung with other portraits, you don't want yours looking slightly on the monkey size — I'm not suggesting the other portraits look like gorillas.

Don't make the portrait too difficult for yourself, just get going and you will find that a little bit of success creates a lot of enthusiasm.

"Lauren" — detail of a larger painting
The centre of the face on a teenager is about the eyelid, and the nose is not yet full length.

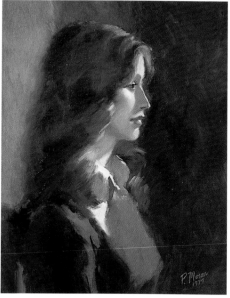

"Virginia", 51 x 50.5cm (20 x 16")
I painted this as a student, but it is a good example of the profile of an 18 year old. The measurements are that of an adult, but there is a youthfulness in the smooth contours and full lips.

"Sir Louis Matheson", Vice Chancellor of Monash University, Melbourne, Australia, 1959-1976, oil on canvas, 112 x 92cm (48 x 36")
A portrait subject like this which is to hang in a large space cannot be less than life-size. This portrait hangs up high on a wall in the Blackwood Hall at Melbourne's Monash University which makes it appear considerably smaller than it is.

When I was first asked to do the painting, it was suggested the paintings already hanging were about 76 x 61cm (30 x 24"), but when I got up the ladder with the tape measure the nearest painting was 122 x 92cm (48 x 36"). Proof of the curious optical illusion that paintings shrink in large areas.

"Judge Frank Walsh", 76 x 61 (30 x 34")
This is the way judge Walsh sat as we chatted, so that's the way I painted him. I like to paint the sitter's own body language, I do not like pretentious poses that conceal the character.

Detail
He has a wonderfully prominent nose, but as it turned out that we talked through the whole portrait, the portrait became a full-on one with the sitter looking at the viewer. Making the nose too long would have been an easy trap to fall into — GUARD AGAINST MAKING THE NOSE TOO LONG.

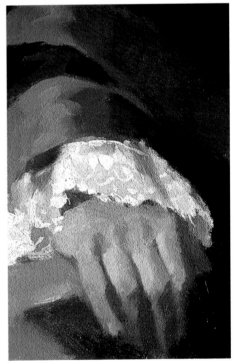

Detail

103

1. What do you see?
After the establishment of undetailed masses, with your eyes well screwed up — this should be all you will see. MAKE A SIMPLE STATEMENT OUT OF WHAT YOU SEE. This is what I call a "dolly" painting, a child-like blob of red for the mouth area, blobs for the eyes and a dob for the nose.

2. The eyes
With your eyes STILL SCREWED UP, let in the minimal amount of light. With a SINGLE flesh-coloured mid-tone, establish THE WHOLE SHADOWED EYE SOCKET AREA to the shape of the subject in front of you. Everyone's eye socket shape is different. Everything on the dark side is darker than the light side, in this case a dark eye socket and a lighter eye socket.

3. Eyeball shapes
Still with the eyes SCREWED up, establish two darkish eyeballish things — get the right colour later — this is just the groundwork. I love this stage of the portrait, this is where the sitter begins to panic a bit, especially if it is a commission.

Painting the face: a demonstration

When we get down to it, it is the face that counts in a portrait, and the point-of interest in the face is . . . the eyes. The eyes are the centre of the portrait, so what do the budding artists paint after the block-in? The CLOTHES! The face is so scary to tackle it gets left until last, then it doesn't match the body, and there goes the portrait, in the bin.

This is exactly what happened to two attempted portraits of my mother. It was 10 years before I managed to paint the face first after the block-in, and eventually finish a portrait. For the first portrait I encouraged her to wear a stunning gipsy outfit with a different pattern on every area of the dress. She smiled for eight long sittings while I painted the outfit, looked unhappy for the next two and then we fought before I could finish the portrait; I didn't have the heart to cut my mother up and burn her as I usually did with failures.

So take courage, as soon as the block-in is completed get to work on the face, and especially the eyes. Of course, if you are working across your canvas eliminating your problems in order of appearance, (tone, colour, edges lost/found, proportion), the eyes and face will appear without aiming for a likeness, however, because this is the area where most students sink rather than swim this demonstration is a guide to help you across.

Now working and making all decisions from your standpoint, carrying your palette and brushes with you, let us begin.

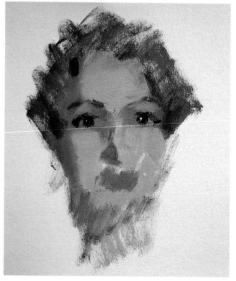

7. Still working in the EYE AREA
The flesh tones around the eye are more in the pinks and rusty reds, DON'T USE BLACK at this stage, even if the mascara can be seen from forty paces.

Make all judgements from your standpoint and ask yourself:
(a) Are there highlights in the eyes — two or one?
(b) Are BOTH highlights equal in tonal value?

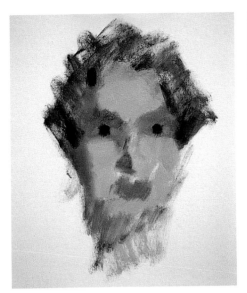

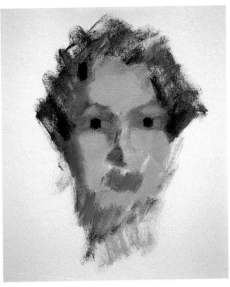

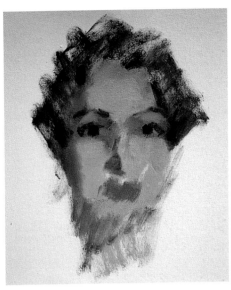

4. Eye white
Some "eye white" — some Raw Umber and white will do. Don't get into anything that isn't made from the basic flesh colours.

5. Flesh tone
Some under-eyebrow flesh-tone — don't use your lightest flesh tone at this stage.

6. KEEP YOUR EYES SQUINTED
Use smaller brushes. REMEMBER — SMALL BRUSH: SMALL AREA, BIG BRUSH: BIG AREA.

n twenty-two stages

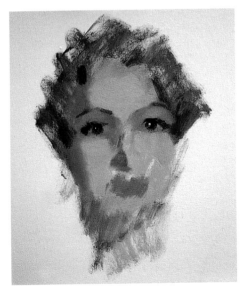

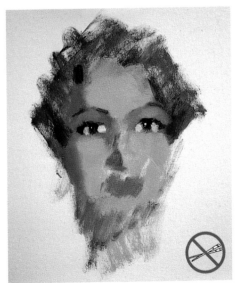

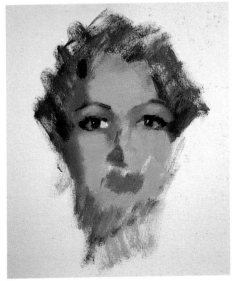

8. Painting out and painting in
In other words — establish larger, softer areas and bring the outside area in. Here I use the forehead flesh tone to neaten the eyebrows rather than paint the eyebrows out, and the under eyebrow flesh tone to clarify the darker eye areas. Painting out and painting in can be used to harden/sharpen an edge without actually painting the edge with a small sable. Of course, this is all rather rough — but it gives the idea.

9. DON'T DO THIS!
When I say "eye whites" I only describe an area. They may not be white when related to the rest of the canvas, they may be well down the tonal scale. OBSERVE — don't assume the four sides of the iris are the same.

10. Avoid the stare-like look
In fact, the four "eye whites" could be all different. OBSERVE. It is a good point to note because any lack of observation here could alter the direction of the gaze or give a stare-like look.

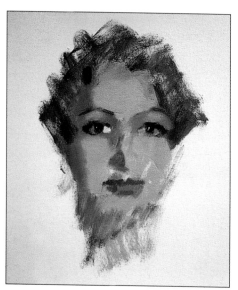 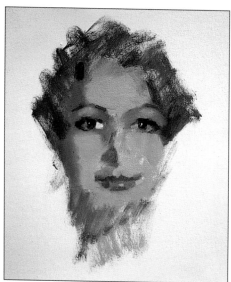 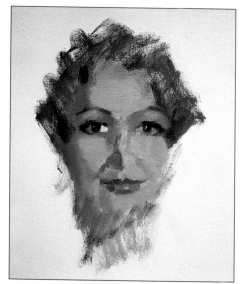

11. The mouth
Into the blob, the pinkish area painted AGAINST THE FORM between the nose and the chin, we add some more blobs in different tones. Of course, every mouth is different and everything depends on the lighting. With the light at a different angle, this situation could be completely different, but this is the approach.

12. Watch those expressions
The outside flesh tones brought in — then if it needs it the mouth tones brought out, PAINTING IN AND PAINTING OUT. Keep going until you are happy with it. Paint AGAINST THE FORM as much as you can — keep the marks with the form to a minimum. If the model hasn't had a break, watch for the downturned "model's droop" mouth, if it is there DON'T paint it. Either both have a break, and a giggle, and look for what is there or not there when the model is animated. Don't deliberately paint a pleasantness that isn't there, but on the other hand don't paint the model's droop because it is there.

13. Lines around the mouth and cheek
LINES? When you hone in and look at them on their own, they become all out of proportion and especially when the artist is trying to be objective and paint "warts and all" they can actually be overdone. Observe the whole face and ask yourself just how much attention do they attract when you are looking at the point-of-interest (probably the eyes). They are not hard bone, they are soft flesh and have soft turns. Now if you have placed your flesh tones accurately, the "lines" may appear as one tonal area touches the other. However, if you have looked at the model and decided these marks need to be strengthened, paint them AGAINST THE FORM. Tend towards a warmer flesh tone, don't head straight for the Raw Umber first off, and ask yourself are the lines attracting enough attention or not enough attention, compared to the whole face.

Have a think, did you look at them when the sitter first came to be painted, or were you talking and animated so that you were only noticing the colouring or the eyes and not saying to yourself "what huge black drooping lines this person has around their mouth"?

"If the model hasn't had a break, watch for the downturned 'model's droop' mouth, if it is there DON'T paint it."

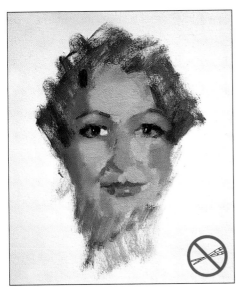 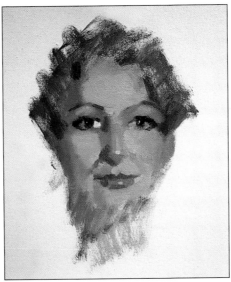 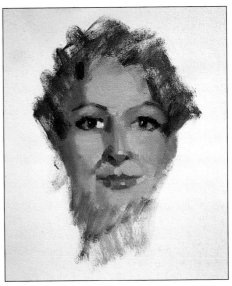

14. Dealing with pink
(a) THE NOSE
Have a look at the general overall tone compared to the rest of the face — sometimes the nose is a light tone, often it is darker in colour than the rest of the face. The nether regions tend to be pinker, like the chin, cheek and nose (and fingers and toes, and so on).

(b) DON'T DO THIS
Now be careful when you pink the cheeks — especially on the light side, don't darken the TONE like this. Check the tonal values — everything on the light side is lighter — you may be putting a shadow rather than just pinking the cheeks.

15. Note where the highlights fall
Be careful with the nose highlight (if there is one). The nose is formed like a verandah, it protrudes and if, (I said "If") the light is coming approximately from the side above, the highlight has to hit on the top, and the verandah throws a shadow underneath. In other words, OBSERVE where the highlight hits — if there is one, and where the shadow falls — if there is one. Ears also tend to be pinker.

16. Now — check what I call the "nostril tadpole"
Observe and measure. Students invariably get the tadpole shape with the tail at the wrong end! Nostrils may not need the same brush — if one is on the light side and one is on the dark side they will be different tone/colours. They tend to be of a warmish tone. Again keep to the reds before you hit the Raw Umber — and take into account how they relate to the WHOLE face (or canvas if you are doing a bigger subject). Ask yourself "are they attracting too much attention or not enough attention?", and don't have them so dark and obvious that all the viewers try to brush the blow-fly off the canvas. Paint them out and paint them in. Maybe the darkest flesh tone, straight Cadmium Red and Raw Umber, may be needed for the dark side.

"Students invariably place the nostril tadpole shape with the tail at the wrong end!"

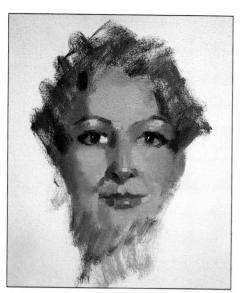

17. Eyeshadow make-up
Be careful — go darker in the darks, lighter in the lights. Mix the colour with flesh tone first to see how glaring it looks. Take the whole face into account.

18. DON'T DO THIS!
So the hair is dark and has a fringe. Don't just glue on a black fringe, and don't use the same brush for the light side as the dark side.

19. Screw up your eyes and OBSERVE
I hope you are still making all decisions from your standpoint — that dark fringe might even be a different tone, a different colour altogether. Near the hair line try a dark flesh colour first, then bring it in darker if it is needed — and paint against the form for as long as you can before painting with the form. Keep those brushstrokes going in ALL directions. On a blond, the fringe may be lighter than the flesh-coloured shadow underneath.

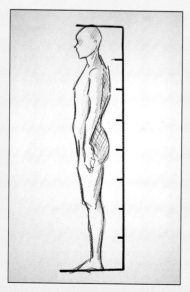

The most common mistake

Now I will tell you of the most common mistake of any student or professional artist I have ever seen. If the painting includes the body, the artist seems to lose all sense of measurement after the face has been worked on. Oh, the freedom of painting material or a suit or hands or anything other than the face that doesn't have to be exactly right, and the first thing that happens with this freedom is that the body GROWS. Hands get bigger, feet get bigger and most assuredly you will have a big body with a pin-head.

Guard against doing sloppy work away from the face.

20. Don't let the jaw dominate

Observe the tonal value and size. Most students accept the tone as lighter and bigger than it generally is, thus giving the poor sitter a jaw that dominates the face. The chin is a little ball in the middle and is in a "nether region". Observe where the tonal value lies in relation to the whole face.

This left side of the chin doesn't look the way flesh goes, it has just been cut off. The right side has been given a "turned" look, (pretty rough, but you get the idea). Squint your eyes and really look at the flesh edge, then open your eyes a bit more and see how many tones there are. Sometimes on close observation, and in some situations there is an edge, exactly the same as you see on some vases.

21. Flesh edges — lost or found

Now I've added a little more finish to that jaw on the left side by placing another tone between the dark and the light, and knocked back the eye whites.

I was taught to observe the Italian portrait painters such as Bronzino — who used to "turn" the flesh edge rather than either lose the edge or, horror of horrors, paint a hard cutting edge. Observe your own sitter's situation and see for instance how the edges "tone-off". (You can open your eyes a little more now, we're getting near the end!) I'm sorry, I had to get rid of the blue eyeshadow, I couldn't stand it any longer!

22. Line the mouth up with the eyes

A common mistake which changes the face completely is not taking the corners of the mouth to exactly underneath the centre of the eye. Of course, if the head is at a different angle you might find that the mouth does not line up with the centre of the eye, or the ears may well fall above or beneath the nose. Just as long as you KNOW where they SHOULD line up then you can adjust accordingly. Check the adult head measurements diagram, and remember that children line up differently.

"You can open your eyes a little more now, we're getting near the end!"

Use the following hints as a checklist and you'll avoid big trouble when it comes to painting your first sitter.

How to go about painting a portrait

Now you are well armed with everything you need to know to begin a portrait:

Orchestrating the sitting

If you have someone to sit for you, this is how you would go about setting it up and what you would require. Portrait painting does not need a studio, it can be done anywhere that you can clear a large enough spot. In fact, none of the paintings in this book were done in a studio, they were all done in a large room.

As long as you have enough room to make a standpoint of about five to ten paces back from the canvas (all decisions are made from one standpoint), a portrait can be set up anywhere. I painted the demonstration of June Cortez in a small room where I can only get back about eight paces. This is not really adequate for a large painting, but it was adequate for the 76 x 61cm (30 x 24") and I make up for the lack of space by working with a mirror behind me.

Working with a mirror

If you turn your back to the canvas and sitter, and look at them both backwards in a hand mirror, it not only doubles the viewing distance, which enables clearer identification of mistakes (crookedness, colour and tonal difference), but it helps maintain your initial impression which can be lost under a battering of analytical judgements.

I found I was working so continually

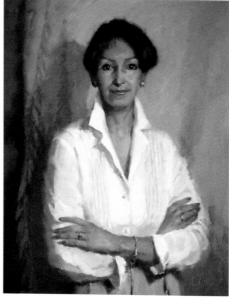

"June", 76 x 61cm (30 x 24")

from the mirror, that rather than down tools all the time, I placed a shaving mirror on a pedestal and set it up behind me. This did the job well, other than the occasional backing into it, or crashing it over. Tut! I now have a sideboard at the end of the room with a 2.14m (7 foot) wide mirror which works beautifully and it keeps the sitter entertained because they can actually see both their own reflection and the canvas being worked on.

Time limits counter waning concentration

The standard time that most people can maintain peak concentration is 20 minutes. A friend of mine, who is a gallery guide, said that after 20 minutes

people stop absorbing and get a bit bored — so it's time to finish. I recommend you endeavour to keep the sitting to 20 minutes. Although there will be many times when you are roaring along like a train and both you and the sitter are happy about it, for the general run of the portrait stick to the 20 minutes.

Have a five minute break and shake yourself around, and TRY not to look at the canvas — you can even cover it up. Your brain needs to be fresh otherwise you will stop seeing things and "tunnel vision" will set in. If you haven't looked at the canvas, when you view it again with a fresh eye the differences between the canvas and the subject will be more apparent and you'll see exactly what needs attention.

It can sometimes be rather hard to move a sitter who is very comfortable and can't be bothered moving, but just do your best. They may not know it, but "model droop" will be taking its toll and a relaxation of the pose can throw different shadows, alter foreshortening and the body will be slumping so slowly that you may not pick it until it's too late. Model droop is also subtly changing the face too, somehow the face loses its freshness.

June Cortez was surprised just how tired a sitter can get — she put it down to "consciously protecting your personality for a long period of time" — and was ready for a cup of coffee very early in the proceedings. (Nothing stronger for the artist I'm afraid — that will REALLY

throw your judgement off.) June also had to keep her arms and hands posed and they became numb by the end of the sitting — especially as I did the old artist's trick of saying "just a couple more minutes" and I kept painting for another half hour.

It is far the best thing to get the sitter in a comfortable position, and preferably not cross their legs or hold their hands up as the discomfort sets in very early. The pose that is hard to keep makes the whole procedure difficult for everyone, however we couldn't get around it in this case, this pose was JUST June!

Dropsheet
You will need this even where you think you won't It's just amazing where paint and turps appear.

Spotlight
A 150 watt globe in a photographers' lamp stand, or a spotlight hooked up somewhere, will do the trick. If you are lucky enough have to have stable northern daylight (or southern light if you live in the southern hemisphere) then use that, but a bit of practice with a spotlight won't hurt in case at any time you have to go on location and you can't work by daylight, The moveable spotlight also enables you to tuck yourself into a corner if you don't have much room.

Once the spotlight is set up on the first sitting, DO NOT CHANGE IT FOR THE DURATION OF THE PORTRAIT.

If it has to be moved, set it up exactly as it was for the first sitting — do not go changing the light effect.

It is recommended to those who are just starting out doing portraits, that you only have one light source. A secondary light source is confusing, especially if you haven't broken down the barrier on assessing tonal values. In fact, I don't remember Velasquez, Vermeer or Rembrandt using anything other than one light source, and if was good enough for them it is good enough for me.

When you are setting up a spotlight for a "portrait" as opposed to a light effect on the children reading, try to place it where you can see the colour of the sitter's eyes. June told me that her eyes were not brown or green, but grey with yellow flicks.

I explained that from eight paces I couldn't see the yellow flicks, but together we were happy with the result. (Wait until you paint the men — they are always the first out of the seat to see the result.)

Chalk and masking tape
Use masking tape or chalk and mark everything you can think of once the set-up has been decided upon. Mark the floor where the spotlight sits, note the height. Mark the floor or platform where the subject sits or stands and where their elbow/hands/rear end or costume sits. Even if you have no intention of moving anything someone else will do it for you, or you'll knock over the lamp yourself.

Portrait checklist

1. Basic human measurements.
2. The flesh colours.
3. The face chart.

Other than your usual painting equipment, here is what you will need to do to begin a portrait.

Place the canvas beside the sitter, mark the floor or your dropsheet where your standpoint will be, and begin working as you would on a still life.

(a) Use a hand mirror to view the subject backwards occasionally which gives a fresh view, and shows up deficiencies.

(b) Use an egg-timer and set it for 20 minutes. Try to have a five minute break when the bell rings, as this will prevent the model from getting "model droop" and the artist developing "tunnel vision".

(c) Mark with chalk and masking tape:
- where the spotlight is placed
- where the chair is placed
- perhaps where the sitter's arm or feet rest, and so on.

Everything will have to go back in exactly the same place each time the sitter gets up, and for each new sitting before you begin painting. Don't think you will remember where everything goes — you won't.

Begin with a 41 x 30cm (16 x 12'') head study, and take three or more sittings, if you pull that off, start to go bigger and bigger. You're off! Portrait painting is addictive.

Handling the sitting

You'll be nervous, of course, but follow a few simple guidelines and all will be well.

Y ou never know what sort of sitter a person will turn out to be. Some are just glad to sit down and shut-up while you do the work. Some are wrigglers, and although they say that they are still looking at their spot you can see by their body and the tilt of their head, the ONLY thing that hasn't moved are their eyes on the spot.

My biggest problem is that I'm a chatterbox

I find the subjects so interesting (I have painted some wonderful people) that they usually finish up being chatter-boxes too. I do find that a bit of chatter and a giggle keeps the subject animated and keeps the "model droop" at bay. If I have set the sitter up for a profile or three-quarter face, usually just as I am about to observe and paint they automatically look at me as we speak.

If you can't train a sitter (or bludgeon or bribe them if it's family) to keep their eye on their "spot" when they speak, it's better to maintain a nice calm ambience with some music and just get on with the job. Just don't let them slide into an over-relaxed posture if you are painting a normally sharp active person, like a champion of business/sport or education. You don't want a sloppy pose and a bombed-out look on the face.

Sitters are people too!

If it looks like the sitter is not going to be glued to maintaining the far-off gaze to their "spot" or as it mostly happens in my case that we are going to be chatting, I just leave them looking at me and get going with the job. It's hard for the artist to realise that the sitter can get a bit uncomfortable under the unrelenting analytical gaze that we give them. They don't realise that we are not looking at THEM, we are objectively assessing their visual appearance.

What I suggest to the sitter, if I am doing a full-on face portrait, is that when the time comes to REALLY look at how their face and eyes are put together, that they look at my forehead or a silly bow in my hair, rather than feel obligated to stare back at me which may make them feel uncomfortable. A bit like the way that television newsreaders look at the sheets BEHIND the camera, it still comes out looking like they are looking down the lens.

It's okay to be nervous

Don't worry if you are a bit nervous when you are doing a portrait — you've probably lost your edge if you are not. I usually don't sleep well before portrait sittings, and I finish up

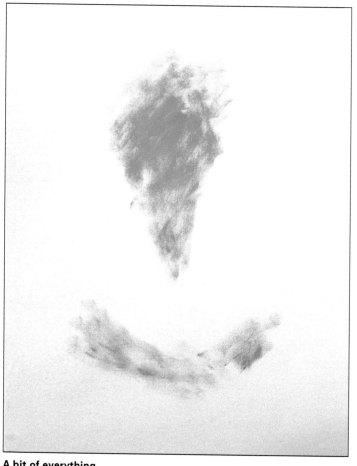

A bit of everything
First marks on the canvas, some mid flesh tone, a bit of everything — Cadmium Red, Yellow Ochre, a dash of Raw Umber and white. I use turpentine as a medium at this stage. As a good deal of time has been spent getting the set-up right, there is often not a lot to show for the first sitting — on a larger canvas and subject there might not be anything at all for the first sitting.

after them with a far-away feeling from exhaustion, not only from the concentration, but the sheer physical effort of covering the canvas, talking and running to and from the canvas and standpoint. But it doesn't take long to get over that and look at the result — the nearest thing you can get to actually having the person in room at that moment in time, forever.

Background material

The only colour I liked behind June happened to be a tablecloth placed over a darker colour, just to break the line and give a bit of interest, and take the plain look off. I threw it over a curtain rail,

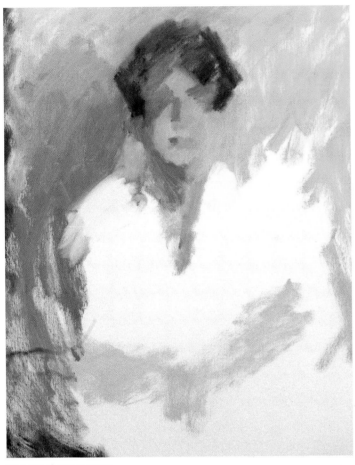

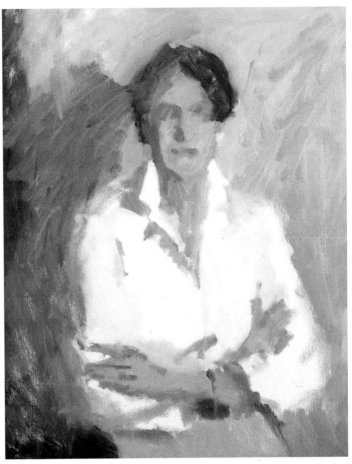

The big three mottos

When you are working keep those eyes squinted so that you can observe only the simplest masses and shapes. Work as soft as you can, as neutral as you can for as long as you can. Use a big brush for a big area — covering the canvas as fast as you can. Three little classic sayings straight off.

Nothing definite yet

Keep making your judgements from your standpoint, only going to the canvas to make a mark, then going back to check it — MORE LOOK THAN PUT. Use a separate brush for each tone/colour, AND work on every part of the canvas a the same time INCLUDING THE FACE.

This was the end of the first sitting and as the model was returning the next day I did not soften the shirt edge (don't leave anything definite that can't be rubbed out at this stage). What a shame because we beat the "third sitting cancellation syndrome" by both getting colds after the first shot!

but it could have just as well been a door or a screen. A successful method is to place lightweight composite board against a wall and drape materials over that, or pin them tightly for a smoother look. Anything that has been set up in a still life will do for a portrait — floral material, a print pinned up, a screen or of course you can be as grand as you like. If you have the space you can have an interior behind, or other people, however I would keep it simple to begin with. It's the human being that counts, and it's the flesh colours and shapes we are trying to conquer first. Just remember, it's not WHAT you paint, but HOW you paint it that counts.

> **"Keep making judgments from your standpoint, only going to the canvas to make a mark, then going back to check it."**

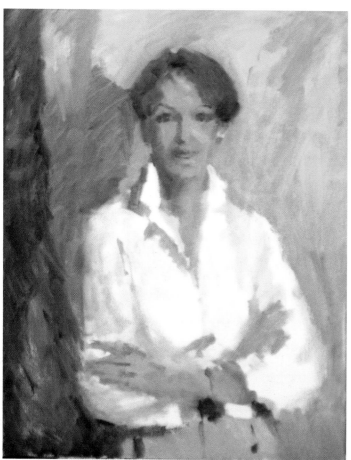

Refer to the face chart

Now I did some work on the face. At this stage of a painting USE YOUR FACE CHART as a guide. This is where you MUST make the effort and work on the point of interest — THE FACE. You have to capture the freshness of the face before the sittings become a chore for both of you and before you develop tunnel vision and keep making the same mistakes.

The darkest darks and the lightest lights

I add stand oil to the turpentine medium and establish the darkest darks and the lightest lights. This always throws everything out; it looks so sudden but it MUST be done so that the mid-tones can be judged.

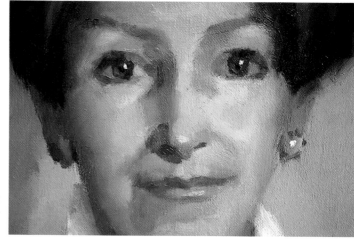

Detail

I did not overwork the face area, but you can see with the establishment of simple patches of tone/colour that this woman has looked after her skin and it is a face of a well-groomed mature person.

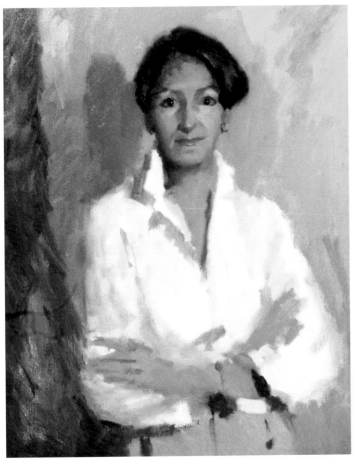

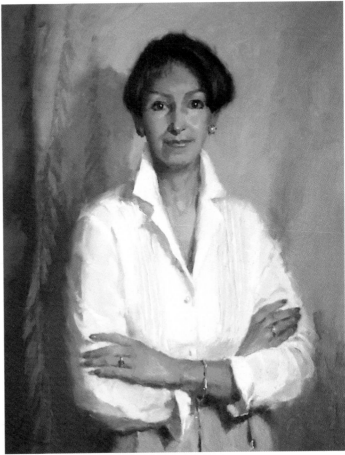

Don't panic

This is the stage where everything goes horribly wrong. Don't panic, it happens in nearly every portrait — about the second or third sitting it all goes backwards. Just get on with the rest of the canvas, then you can work on the completion of the face to your heart's content, or until the sitter falls over. June fell over but I didn't send her home, I just gave her a medicinal brandy and shoved her back on the spot again.

"June", 76 x 61cm (30 x 24")

The final stage is quite different from the groundwork. That is why you shouldn't be disheartened in the early stages, just use the face chart and the human structure diagrams and keep going. I guarantee the second portrait will be leaps ahead of the first one.

I do not try to "bring out the character" of the sitter as I believe they do that all by themselves with clothes, hairdos and body language. All I try to do is suggest backdrops and select clothing from those which they would be happy to be painted in. June's favourite colours are gold and yellow, so I used a gold-yellow backdrop, and she is very fond of crisp white shirts, and that did the job of showing off her very expressive hands.

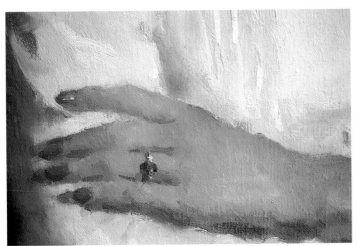

Detail

An old studio adage is "paint the hands while looking at the face". This doesn't mean crudely blobbing in hands of the "this'll do" variety — you can still have all the expression of the hands with lost and found edges if it suits the particular set-up of the painting.

Provided you base a large complicated painting on a simple framework, you can get away with almost anything!

Designing a portrait in order of appearance

If you are planning to put more than just the sitter in a portrait and you are brimming with unbridled enthusiasm for a kaleidoscope of colour, complicated interiors, flowers, still life and the dog and cat thrown in for good measure, go ahead. Yes you CAN make it work. Rembrandt did when he painted "The Night Watch" which measures 359 x 438cm (141 x 172"). A BIG picture.

The painting shows 18 officers, at least 13 other figures, and a dog, and

How Rembrandt did it

Rather than have a static row of heads which can be seen in so many multiple portrait paintings, Rembrandt arranged the subjects into a design of tonal values, creating:

1. One point of interest (the central man with his face lit).

2. A point of secondary interest (a man one step back, his face in profile).

3. Tie-in areas (faces and bodies turned this way and that into the light, with poles and flags half lit at angles to carry the eye from one area to the next).

4. Neutral areas (areas of little interest which keep the points of interest away from the edge and carry the eye).

Apparently each man was paid according to how much of himself was in the picture. Some were a bit miffed that there wasn't much of them in it at all, but on the other hand the commissioners of the portrait were probably pleased that they didn't have to pay so much.

I am explaining all this because I think it illustrates that a large complicated painting is based on a very simple framework.

after it was stabbed by a vandal some years ago it was cleaned and found to be full of colour as well.

In order of appearance

All paintings whether large or small, busy or simple, need to have one point of interest; areas of secondary interest, and a neutral area — all placed IN ORDER OF APPEARANCE.

The theory is that the brightest lights appear first and then the eye follows the light.

The best way to get all these visual truths in order of appearance is to work from life.

Large complicated paintings worked from photographs usually have hard edges from one end of the canvas to the other, heralding their origin to the educated eye, and their visual truthfulness is lost in paths that lead nowhere. The eye can only focus on ONE thing at a time and working from life from one standpoint will put all the large complicated areas into one unit as the human eye takes it in — creating "visual truthfulness" on the canvas.

Ask yourself these questions

Go ahead, right now, do this test. While you are reading these words are your eyes able to read the paragraph above or below? Of course not, the eyes can only focus on one thing at a time. Everything around the focused area is a series of lost

edges and reduced colour and tonal range. Now have a look at anything else in the room around you.

How well can you see the object even a couple of feet away from the focused area? Unless you are a fly, not very well, Hence the studio adage "paint the hands while looking at the face".

If the head is the point of interest in a portrait, or, to go even further, if the eyes are the centre of interest, how close in competition should the areas of secondary interest be? For instance a bright frock, the hands, a vase of flowers, a busy background and so on.

Get the eye in

Generally speaking, in a commissioned portrait, the subject should be placed so that the angle of the light shows the colour of the eye. In other words, three generations later the family will be able to say "great-grandfather Mitchell has exactly the same colour eyes as my brother", which is just what happened when I borrowed my great-grandfather's portrait to copy (see chapter 7) and we all stood around and discovered who had his nose, eyes, forehead and stance. Nobody had his mouth, which was just as well because it was a mouth that nobody would have really wanted. However, the life-sized portrait brought him into the room like no photograph had ever done and it brought me out in goosebumps, which, to me, is what portrait painting is all about.

In order of appearance

All paintings whether large or small, busy or simple, need to have one point of interest; areas of secondary interest, and a neutral area — all placed IN ORDER OF APPEARANCE.

The theory is that the brightest lights appear first and then the eye follows the light. By darkening this painting you can see how the light areas are still visible.

**"The Night Watch" by Rembrandt, 359 x 428cm (141 x 172");
Rijksmuseum, Amsterdam**

If Rembrandt can do it . . . This BIG picture contains 18 officers, 13 lesser figures, a dog, and it is also full of colour as well!

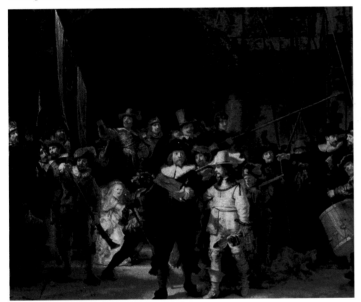

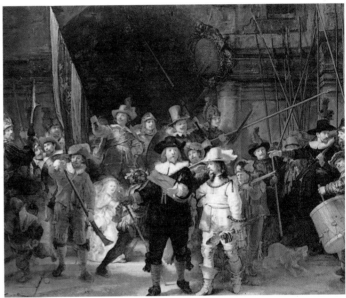

Turning a picture into a portrait

In the demonstration painting of "Alan" overleaf the design of the portrait was meant to be one in which the sitter was NOT leaping out of the canvas, but one where he was almost part of the background. We wanted it to look as though the sitter had just shoved back the things on the table, so he could sit down and read his book. I could have made it a "no portrait" or in other words, just a general picture where the sitter had his head down in shadow and was reading a book, but by having the subject look up and drop the book slightly, as one would if someone came into the room and spoke, it became a portrait.

When he looked up the light hit the side of the eye and showed the colour, and the counterchange of the light and dark side of the head was lifting it away from the background. Also, the white collar was the lightest light on the canvas and it ensured that this area of the canvas was jumping to the fore tonally, with the result that the half lit, busy still life on the table was recessed tonally.

The other thing that happened was that if the book was being read it would have been lifted up and there would have been a very small light-toned area, but when the book dropped slightly, the light came over the shoulder and hit the pages, making a larger light-toned area which attracted more attention. This carried the eye still further away from the still life making a nice balance between the very interesting still life and the sitter. The sitter wins the competition for attention by a head!

So you can see what is meant by DESIGNING a portrait, the poetry is achieved by the way the subject is placed and lit. By manipulating counterchange of tonal values you can put the attention anywhere on the canvas that you wish.

Turning a picture into a portrait

Establish the first marks

I work my canvas sizes around life-size, measuring from the head size. Head size in an adult is approximately 23cm (9'') so after setting up the subject and the sitter I did a very broad sketch on a canvas-covered board measuring 51 x 61 cm (20 x 24''). Then I worked out what size canvas I would need before I purchased the stretcher frames. I don't keep irregular sizes in stock and in case my judgement was out I purchased a couple of sizes, the leftovers to be returned or used somewhere else. The size I settled on was 86 x 107cm (34 x 42'') and you can see here I had just established the first marks on the canvas, using only turpentine as a medium.

MEASURE, MEASURE, MEASURE!

Cover that canvas — measure, measure, measure; rub out, re-establish and measure from point to point. How many times does the head go into the body, the vases, the table, the stripes?

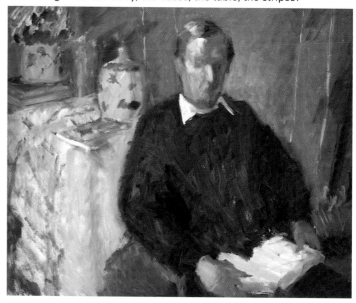

The colour of the cyclamen flowers are repeated in the planter and the striped material.

The navy and white are reflected in a reduced tonal range on the ginger jar.

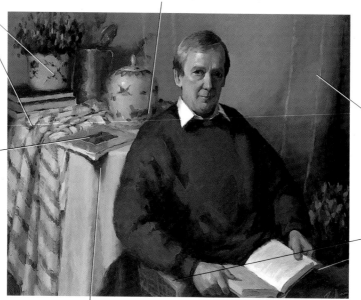

The copper jug colours are repeated in the face and hands and on the central area of the book cover.

These are "tie-in and carry-the-eye" stripes going up the backdrop material.

The hair colour is reflected in the arm of the cane chair.

The grey area of the book cover is reflected in the backdrop material.

Although this is a quiet portrait, there is a lot happening to keep the viewer busy. There are many colour tie-ins in this painting.

Hopefully all the design looks artless — just as the actor must not look like he is acting, the painting should not look obviously contrived.

Place the darkest darks and the lightest lights

Adding stand oil to the turpentine and mixing them together with the end of my brush (mix to the consistency which suits yourself), I established the darkest darks and lightest lights. The tonal range and basic pattern of mid-tones was established and I began to work across the rest of the canvas in the oil medium.

Don't let the still life take over

I worked across the whole canvas bringing everything up to the same degree of completion. I had to be careful not to overwork the still life or it would attract more attention than the sitter. This area had to be kept loose even though there was a lot happening and all the props were my favourite pieces.

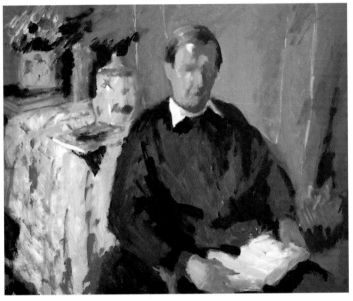

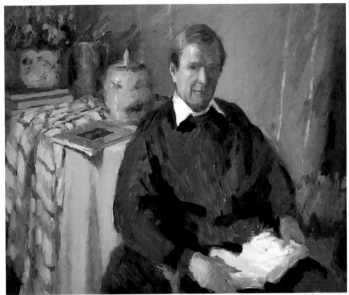

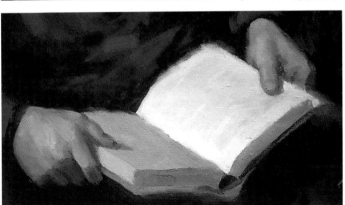

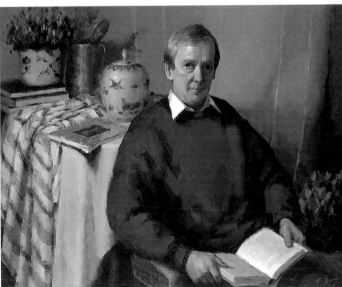

"Alan", 86 x 107cm (34 x 42")

Detail
The hands and the book are quite simple blocks of tonal values.

Detail
It is the pattern on the vases and highlights on the copper jug which are areas of interest here. There are no hard edges to break the still life as one unit of pattern. The eye is given a lead as to what the objects are and the brain does the rest.

Men need a helping hand when they are trapped in their business suits.
Here's a suggestion for livening the whole thing up.

Give a portrait drama — liven up the background

It's a sad fact that after painting many portraits of men in business suits that the imagination gets a bit stretched as to how to make the next one a bit different. It seems to be the situation that when the time comes to have a portrait painted of a man who has made his mark — although he can be wonderfully interesting — he is not visually colourful. Women of the same age can wear subtle or bright colours, put on great make-up and do amazing things to their hair, but the poor men are stuck with the grey or navy suit, and the same hairdo they've worn for donkey's years.

Costumes worn by judges, professors and the clergy are an artist's dream, a chance to wallow in fabric folds, satin or velvet and COLOUR, but the chance to paint them doesn't come every day, month or year. Men in casual clothes can be more colourful, however, it is more usual for a commissioned portrait to require a suit or jacket.

Is there a typical sitting schedule?

I cannot give anyone a schedule of the amount of work that should be completed in each sitting — everyone and every situation is different. It may take one sitting or three to set up the arrangement depending on the size and how complicated the subject is. Just do exactly what you are comfortable with and use your general intelligence. It could be three sittings or 30 to complete the picture — John Singer Sargent took six sittings to complete the gorgeous "Lady Agnew", but 40 to paint Mrs Shepard.

A case study

The man to be painted here was very interesting. He had good strong colouring and although it was to be a head study originally, I could not possibly leave out those wonderful hands. Since he was tall, at 193cm (6 feet 4 inches) the canvas size was getting bigger and bigger. The final size was 101 x 76cm (40 x 30"), quite a way from a head study.

When the subject is something you have painted many times you can get that sinking feeling and you know you just don't want to do it again. The way to bring back the excitement is to change the surroundings. I do it frequently with still life/floral paintings, especially with things like white camellias which I have been painting for years.

I get a new vase or cloth or backdrop, and it makes it all new and fresh and exciting.

I knew for some time that I might have the opportunity to do this portrait, and I had time to plot and think about it. What I envisaged was some sort of tapestry behind the sitter in rich colours, but when I scrummaged in my pile of backdrop materials I only had one with roses on it, which I immediately discarded. Then, as I began my "putty-putt" around the shops to find something suitable, I realised what I had in mind didn't exist — and I began to consider the roses with more tolerance.

Fortunately, while driving I caught a glimpse of a cotton throw rug in navy blue with gold swirls in a shop window. I made a fast U-turn, and a fast purchase, and home I went.

I liked the rug so much I immediately did a still life/floral, just to give me the feel. The only trouble was when we set up the portrait the navy blue was too dark, so, luckily, the reverse side did the trick — it was a dull gold with rusty/maroon swirls. A good omen, I thought, and also a good omen that the sitter happened to have the time available at the time I was available, so in ten days we held six, two-hour sittings, then one last sitting a few weeks later to polish it off, and one last fresh look.

Get as much done as you can

I always quote ten sittings when I am including hands or a costume, just to be on the safe side, because there are always those sittings when you go backwards; about the third or fourth sitting it begins to go horribly wrong. I find with nearly all my portraits that about the third sitting, either the artist or the sitter gets a cold — this time it was me.

Portraits begin as fun for the sitter, but, to be honest, they really do lose interest if the sittings go on and on. Not in every case of course. Some artists and sitters love them going on and on, but I have noticed that after about the third sitting an appointment gets cancelled,

"Portrait of an Englishman", 101 x 76cm (40 x 30")
The problems were ironed out to the best of my ability.
Portraits are certainly the great tests in life.

someone gets a cold or the sitter wears the wrong shirt/tie/jacket/nail polish, and they start to look at their watch a lot. That's why it is so important TO GET AS MUCH DONE AS YOU CAN AS THERE IS ALWAYS SO MUCH MORE TO DO. In other words, everything takes twice as long as you think it will — so move it!

Everyone has their own speed. I like to get the block-in out of the way as quickly and as painlessly as possible. For the first sitting, I do the set-up and paint a canvas 41 x 51cm (16 x 20") approximately of the whole subject, with as much information as possible on placement and colour. Then I take a few days to decide on the size and dimensions of the canvas, and I do a block-in from my small painting so that I can get going on the important things, like the face, at the second sitting. This eliminates one or two of the sittings, saving the freshness of the artist and sitter for the all-important face, rather than wasting it on the block-in stage where shapeless blobs are exhaustingly being shoved around the canvas. It also means I can quietly and thoughtfully get the basics placed in my own time because if they are not right to begin with, the painting is doomed. So, plan to cheer up a portrait by introducing some colour or pattern into an otherwise mediocre colour scheme. But just remember, it's the face that counts, if you miss that, you miss the portrait.

Portrait of an Englishman

Creating something to judge

I put down some mid-tone flesh colour to establish where the head and hands would go. I worked with turpentine only at this stage. I aimed to get the canvas covered as quickly as possible, as everything on a canvas is relative and no judgements can be made until there is something to judge.

Making my guide

Still only using three big brushes I applied a sort of neutral fleshy beige, a dusty navy nothing, and a pale blue colour. I was not establishing a tonal range at this stage, I was just trying to get SOMETHING down as a guide.

Establishing the tonal range

Then it was time to establish the tonal range and break up those simple broad masses. Notice even at this early stage how the background pattern was being established at the same rate as everything else. Do not finish the figure then glue the background pattern in. Keep the whole canvas moving — everything is relative: too dark, too light, too much to the left, too bright, not fresh enough, needs to be knocked back, and so on.

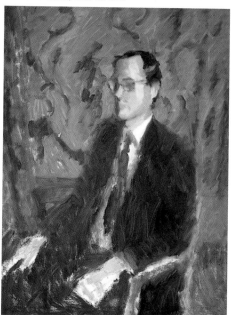

"Just remember, it's the face that counts, if you miss that, you miss the portrait."

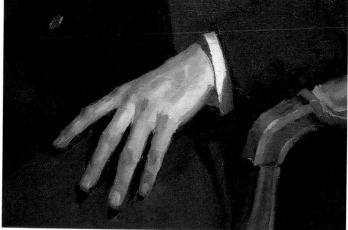

Detail

Although it is not correct to wear dark trousers with a jacket that has gold buttons, the hands were lost on the lighter trousers, but the darker background created the stronger tonal counterchange and lifted the hands very well.

Achieving the full tonal range

After adding stand oil to the turpentine, I established the darkest darks and the lightest lights. This gave the full tonal range and a reasonable positioning of masses as a preliminary to working on the point of interest — THE FACE.

When you reach this stage do some work on the face but DON'T complete it. Never work on the one spot too long because there is a tendency for that area to grow or shrink, and then as you work on the other areas you will find that they don't fit together; you will have to move everything and then there goes your balanced subject. You could find that something awfully important won't fit on the canvas, or the portrait is too high or too low, or too much to one side so that the finished portrait looks like you pruned one side to fit the frame Don't let anything drift off its mark.

Working across the whole canvas

The hands, the suit and lower background were worked on to bring the whole canvas up to the same level of completion as the face. Remember the adage: PAINT THE HANDS WHILE LOOKING AT THE FACE is a good adage to work by. At this stage I had done no further work on the face.

Making adjustment

Still no further work on the face and I was very keen to get back to it because it was not right, neither was the background. Adjustment, readjustment, and on and on it went to the end, or until I decided it was the end.

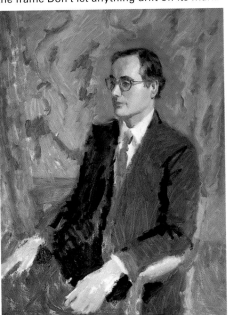

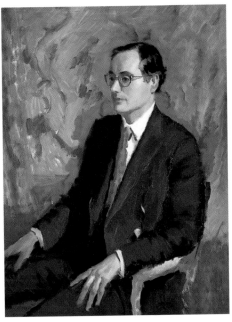

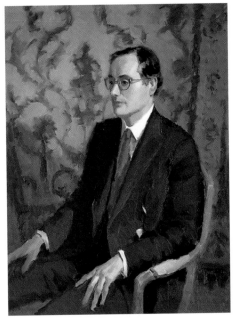

Detail

Detail

The face is in focus the tapestry is out of focus — the eye can only focus on one thing at a time.

"If the basics are not right, the painting is doomed."

Practice is the key to proficiency in portraiture and the most accessible subject you're likely to find is your own peculiar face!

The easiest way to paint a self portrait

"Las Meninas" by Velasquez

I had done a couple of self portraits before I first saw this painting by Velasquez and I immediately recognised that here was an artist who worked the way I was taught — on his feet observing and evaluating with his palette with the brushes in his hand. He had painted a composition based on a balance of lights and darks. He even had the back of the canvas showing just as I had done in one of my early self portraits.

The whole picture looks like a clockwork scene where the batteries have run out, or a freeze frame from a movie. Everyone is in the process of moving, they haven't arrived at any pose, even the dog seems to be reacting to the foot. I was told that if you stood in front of the picture and stared at it with your eyes half closed, it moved! Well, I went to the Prado, battled tourists and managed to get a quiet moment to observe it, and there was certainly an encompassing feeling of movement about it.

This painting is gloomy and a bit ugly, not at all the thing to cheer up the living room, but the artist's capacity to portray the "visual truthfulness" has enabled him to capture the atmosphere and character of the moment with such honesty, it becomes a magnet which can draw you in.

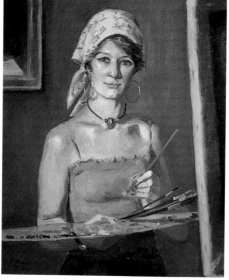

"Self Portrait", 1977 61 x 51cm (24 x 20")

As in the Velasquez self portrait, I am on my feet with my palette and brushes in my hand and the back of the canvas is showing on the right-hand side. This was one of my earliest experiences of practising measuring and I did it until my arm nearly fell off. Of course if you are looking at yourself in a mirror you will find as you raise your arm and brush to measure, your view is obliterated, but you just have to use your general good sense and work your way around it.

The canvas measures 61 x 51cm (24 x 20") and the figure is much less than life-sized; it is "sight-sized". That is, I placed the canvas next to the mirror, both exactly the same size and painted on the canvas exactly what was in the mirror, no bigger no smaller, but "sight-sized".

Portraits need lots of practice but fortunately, you only need look in the mirror and there's a model — the only model who charges no fees, will sit until you drop, appears on time and is ready for a cup of tea when you are! You can also make a complete idiot of yourself and no-one will ever know but you. On top of all this, your self portrait can all be done in a corner of the room with just a mirror and a spotlight, oh, and don't forget the dropsheet.

The many versions of you

The self portrait isn't an ego trip, it's a convenient way to practise all this information on yourself. The big surprise is that after looking at yourself in the mirror all your life, the minute you consider yourself as a bunch of tonal masses, you don't look anything like you thought you did. Then there's the big decision of how to portray yourself, because what is the REAL you?

This is a lot of pressure. My suggestion is to just peer at the mirror, squint your eyes and go for it. Get some practice in before you get dressed up and do the all-smiling teeth and hairdo version.

Sight size and life size

Sight size is making your painting the same size that your subject appears — no bigger, no smaller. If you put your canvas right next to your subject, you will paint it roughly the same size. Therefore sight size equals life size.

If you moved your canvas away from the subject and also moved your standpoint back, you can still paint sight size. In this case, the subject will appear smaller and much more of the background will be included in the painting.

The farther you move your canvas from the subject, the smaller the sight size will be. In order to paint life size in this situation, you use measurement.

The portraitist as seeker of truth

Don't let anyone tell you a self portrait is an ego trip, it isn't. In fact it's the opposite. I have found that most artists have been brutal on themselves when they paint a self portrait.

The first thing the truth-seeking self portrait painter does is to paint exactly what they see in the mirror. Which is right. What they see is a squinting, peering face, usually dressed in clothes they would normally be too ashamed to give to the poor — their painting clothes.

Just as in every development process there is a pendulum swing, as the artist usually initially goes for the "warts and all" approach. Then the pendulum swings right back the other way and the next self portrait is the "cheerful" one. Then the determination to "get it right" sets in and, over a period of time, there is the "thoughtful" one and the "dressed up" one, the "light effect with no features" one and the "in the studio" self portrait where the tools are the point-of-interest and the artist appears as a gnome popping up through bottles and brushes.

If you follow this sequence, it is perfectly natural. It is all good experience in the end and you can nod wisely to yourself when your see other newcomers to the self portrait going down the same road.

How to get started with a self portrait

Start small

Buy a 20 x 26cm (10 x 8") mirror and cover one half by taping a cut piece of canvas to one side. You will be surprised what you can get in a piece of canvas this size. It will not be life-sized, but small to miniature, and very good for practising. You can get an effect quickly, and even try different light effects. Paint a lot of little studies if you want to — move the spotlight around and try back lighting, above lighting, three-quarter lighting, or anything else that takes your fancy.

Just place the mirror with the canvas taped on one side (the same size as the other half of the mirror) on the easel and paint your face right next to it — with the canvas next to the subject. You couldn't get a better position for judging the difference between the subject and the canvas. You work exactly as you would if you had a sitter positioned.

Measuring is a bit difficult because when you hold up the brush to get the direction of an eyelid for instance you can't see it in the mirror, but just use your general intelligence. When I was starting out I had to practise everything on self portraits because my natural eye was so far out — my judgement was almost the complete opposite of reality. When I began measuring the direction and relationship of one point to another, I was shocked to see how incorrect I was.

Then try a bigger one

To work on a larger scale, use the 26 x 20cm (10 x 8") mirror without the canvas taking up one side, and place a canvas board the same size next to it. You may need two easels, one for the mirror and one for the canvas, but make sure they are still placed exactly beside each other.

41 x 31.5cm (16 x 12") is a wonderful size for a head study — the adult head is 23cm (9") and sits well in this shape, up to 61 x 51cm (24 x 20") and beyond. You will gain something every time you try a self portrait.

Don't take any notice of what anyone says, do a smiling one of yourself if you want to — and have a look at what teeth look like!

Materials you need

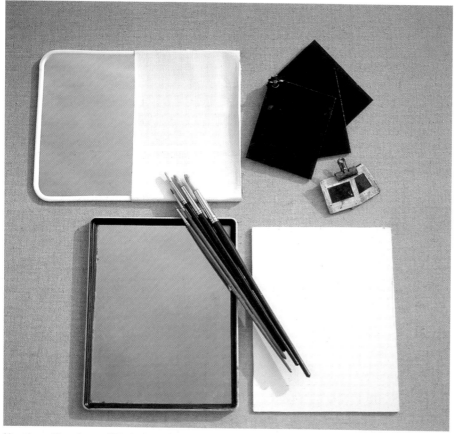

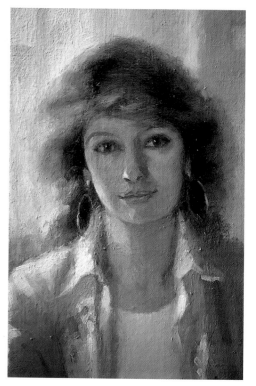

Here's a nifty piece of kit for starting the self portrait, clockwise from top left:

- **For smaller than life-sized self portraits**
 An inexpensive mirror from the supermarket. A good size is 21.5 x 29cm (8½ x 11½''). Tape a piece of canvas over one side so that the mirror and canvas occupy half of the space each. All you have to do is place this set-up on the easel, look at yourself in the mirror side, and paint yourself on the canvas. What could be easier than that? The canvas is beside the subject and you have a little head study to get you going.

- **For identifying tones**
 These are two pieces of equipment that I found invaluable when I first began painting, and used for many years thereafter — three pieces of smoky perspex held together with a bolt and screw.

 Looking through all three gives you the lightest light of the subject, looking through two gives you the next set of lights, and looking through one allows more lights to be observed. For my landscaping box I have three under-exposed transparencies held together with a small clip.

- **For almost life-size head studies**
 Use an 8 x 10'' mirror and a 20 x 26cm (8 x 10'') canvas board. You may need two easels to hold these for a bigger self portrait just as long as the easel with the canvas is placed beside the easel with the mirror.

Animation

The hardest thing to get into a portrait is animation. When you place a sitter in the unnatural situation of sitting frozen, what happens is the state called "model droop" and tense lines will appear on the face. You must not paint this lack of animation on the canvas. Have a break, have a chat or joke or fall over the spotlight cord and keep your eye out for what they look like when they are relaxed and natural.

Flesh in Shadow

This self portrait was done in 1978 purely as an exercise and I learned a lot from it. I wanted to paint flesh colours in daylight away from the spotlight, and work the flesh tonal values back from a light background, which I did using the basic flesh colours shown previously.

I wanted to develop my visual memory, by sitting down and observing seven things then going up to the canvas and remembering them. This was a bit of a mistake because I had to get up, pick up the palette and the brushes and this became such an effort that my knees went on me and I became so tired that I would often get up to the canvas and couldn't remember what I'd got up for.

This painting has many layers of paint because I changed my mind a few times, and I changed my clothes too — I began in winter and finished in summer.

Flesh in the shade

One of the main reasons for doing this painting was to practise flesh colours, particularly flesh in the shade. THE FLESH ON THE DARK SIDE SHOULD LOOK LIKE THE LIGHT SIDE IN SHADOW, it shouldn't be a different colour.

The only light area is the strip on the left side of the face and the tip of the nose. The rest of the face is many tones darker. The one thing I did learn was how to paint the lemon-coloured top in the shadow. To this day I still remember how I did it and the properties of the colours I used.

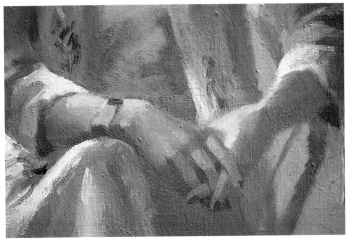

However, this is much harder to do with a self portrait. These photographs of me (taken in February 1993) show a great deal of difference in the face on the left to the face on the right. Regardless of which one looks like me, the self portrait is bound to finish up the serious one, and you'll see this illustrated when you look at my three self portraits.

127

DEMONSTRATION: HOW I PAINTED MY OWN SELF PORTRAIT

I had been considering doing a self portrait for quite a while, and every now and again I would look in the mirror and think — "not now". I was looking in the mirror at the end of the room one day thinking about a still life when I suddenly thought "do that!" — just me standing there wondering what to do.

I didn't change a thing, not the clothes nor hair or where I was standing, nor did I add the still life things in the background, they were there ready to be used. I did tweak them round a bit though and it took quite a long time to get them right.

I normally work with a 150 watt globe in a photographers' lamp on a stand so that I can move it about, however as the light had to be placed behind the mirror and canvas the 150 watt wasn't making the distance, so I put in a 300 watt globe.

I decided to use a 112 x 91cm (44 x 36'') and placed that beside the mirror. The only problem was that the simple method of painting exactly the same scale as the mirror (sight size) had been replaced by the more difficult task of viewing one scale and painting another.

To overcome this, I taped the mirror so it was the same proportion as the canvas. Then I used a felt pen and divided the mirror up first by making a cross in the middle, then into quarters, then I marked the canvas the same way with a paintbrush.

The following demonstration will show exactly how to proceed with your self-portrait, whether you are painting "sight-size" (see picture 1) or "life-size" (see picture 2). I decided to paint life-size and scaled up from the mirror image size. For those who wish to know how this is done, or feel confident enough to try it, set up your canvas this way, and follow the demonstration.

1. This is how I recommend a student to set up their self-portrait

The canvas (30 x 24'') is set beside the mirror, and the mirror is taped with masking tape to the exact size of the canvas. there is only one light source on the subject (yourself) and you will have to place it so that it doesn't flash in the mirror.

Mark the half-way and quarter-way squares on the canvas with some dark paint, and use a tape measure to get it exact. Then with a felt-tipped pen square off the mirror exactly the same. This way you will be painting exactly the same size and everything will be on the same level.

It may or may not be life-size, but paint exactly what is in the mirror which is "sight-size" — (see page 20), this keeps it simple.

2. Scaling up for a life sized work

1. Instead of a long narrow canvas the same size and shape as the mirror, I am now using a larger and squarer canvas (44 x 36'').
2. First of all, I have made the mirror a squarer shape by placing masking tape over the top of the mirror so the viewing area is smaller, but it is the same shape in ratio as the canvas.
3. I have squared up the canvas exactly the same way as the "sight-size" canvas, with half-way and quarter-way marks, and marked the mirror also with half-way and quarter-way lines with a felt pen, except the squares on the mirror will be smaller.
4. So now I am painting exactly what it is in the mirror, but only bigger.

Continue with the demonstration as follows:

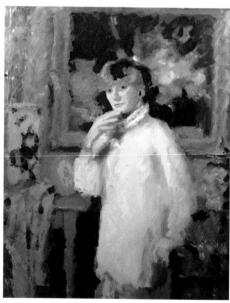

6. The shock of the darks
I added stand oil to the turpentine and established the darkest darks and the lightest lights. Those sudden darks always look a shock at first, but don't lighten them until you have added some mid-tones, then you can decide whether to lighten them or leave them alone.

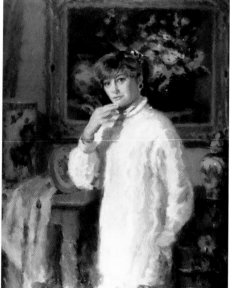

7. Avoiding dwelling on one area
Back to the face, the nose especially needed more work, but I had spent enough time there — DON'T WORK ON THE ONE SPOT TOO LONG. I got going on the rest of the canvas and completed it before going back to the face. With the rest of the canvas completed, I could stay on the face for as long as I liked, or even put the painting away and have another look in a couple of months.

3. Here we go — first marks on the canvas
You can see the divisions marked on the canvas which were scaled up from the same marks on the mirror.

4. The head measured correctly
The head was life-sized, just over my hand span, which measures 21.5cm (8$\frac{1}{2}$''). (You may want to refer to page 98 for a refresher on measurement.)

5. Simultaneous development
I brought up the whole canvas at the one time. You can see I was working up the face exactly the same as in the face chart on page 104, with the iris established in the eye socket shape.

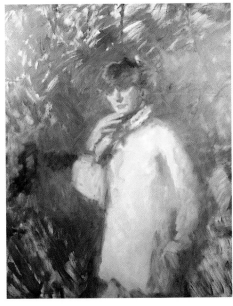

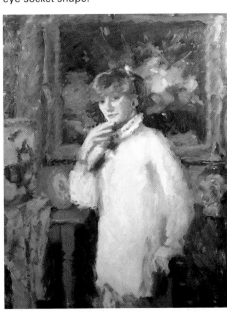

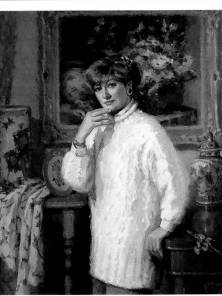

"Self portrait winter 1992", 107 x 91cm (42 x 36'')

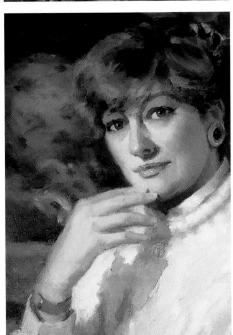

Detail

Detail of the background still life

129

Flowers and faces in one painting. This combination presents you with a juggling act. You have to not only stage-manage the point of interest but decide which you will paint first — the sitter before they lose interest, or the flowers before they die?

The floral portrait — flowers and faces combined

A commissioned portrait means a likeness is required. Not a vague study in a half light or a fanciful characterisation, but a clear representation of the physical features, requiring that the colour of the eyes and probably most of the face be seen.

A floral painting is a decorative subject, usually colourful, and is usually more eye-catching than a landscape or portrait.

To put flowers and a face in the one painting causes a conflict of interest because only one of these can emerge as the centre of attention. There are two strategies for dealing with this problem.

The problem

When you're painting a portrait, as soon as the block-in has been completed the usual method is to immediately get on with painting the face because although the sitter may be able to return many times (but not always) a degree of interest can be lost after the first few sittings.

5 key points

1. Avoid creating two centres of interest.

2. Create careful eye-paths and tie-ins to support the centre of interest.

3. Select flowers that are readily available and can be replaced if they wilt while you are blocking in.

4. Don't work from photographs of the flower arrangement or the sitter.

5. Never work on one spot for too long.

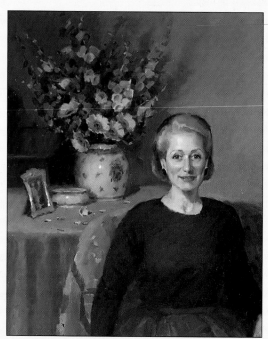

Detail of large painting

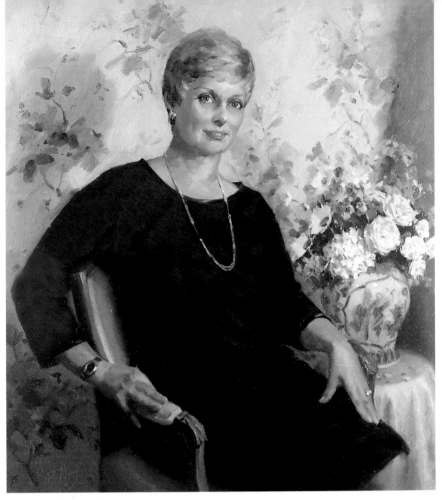

Here are the two different approaches I used for setting the flowers in these two "floral portraits". You may be able to devise better solutions.

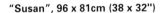

"Susan", 96 x 81cm (38 x 32")

Strategy 1
In this portrait of Susan I set the flowers out of the direct light to lower their tonal range.

Strategy 2
I used flowers of a darker tonal value and placed them so that they rounded off the lower corner and supported the portrait of Beverley.

"Beverley, 122 x 91cm (48 x 36")

When to begin work on the flowers

However, when you are painting a floral portrait using fresh flowers, the situation is reversed and you are pressured to paint the flowers before starting on the face.

Here's how to manage this juggling act
If flowers have been included in a portrait, then obviously the flowers are not going to last until you are ready to paint them properly, but you do need the flowers there while you bring the canvas up to the point where you are ready to work on them; as everything on the canvas is relative and the whole subject must be judged and evaluated as one unit.

What you have to do is keep replacing the flowers as they die off while you work on bringing the whole canvas EXCEPT THE FLOWERS to a point where you can place one final bowl of flowers and bring them to completion, regardless of whether or not the face has been finished.

Make sure you set up flowers which are readily available, for instance, in this demonstration the flowers were all from my garden and I knew the same ones would be there when I wanted to pick a fresh bunch. In Beverley's portrait on the previous page, the flowers came from the florist, but they were mid-season and I was able to replace them when the time came for the flowers to be painted.

So, when a portrait with flowers is being painted, WHEN DO YOU BEGIN WORK ON THE FLOWERS? I'll show you my method in the following demonstration. The sequence starts at the point when the block-in has been completed, and tided up a little. The final vase of flowers has been set, the model is sitting, now this is the way to go.

The groundwork for the floral portrait has been completed, the darkest darks have been established and there is enough information in place on the sitter to enable work on the background and the flowers to go ahead. Two bowls of flowers have come and gone and now the final arrangement of garden flowers is in place. These flowers will be painted over the thin layer of mid-tone which was laid down to reduce the glaring white patch while I made my tonal evaluations on the block-in.

Priority switches to the flowers
Thankfully it is NOT HOW YOU START BUT HOW YOU FINISH that counts because the face is horribly unlike the sitter and I am very keen to do some work on it, but the first priority is to capture the transient flowers.

I knew the first bowls of flowers would die while I blocked in the sitter, so I didn't paint any of them, I just left the area with a bit of a neutral wash.

When the canvas had been brought up to the stage where I was ready to begin work on the flowers, I then arranged the bowl of flowers that I wanted to paint and began work on them.

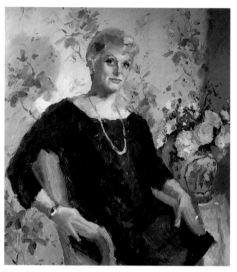

You have to paint real flowers
The floral background material has been completed and work has begun on the final bowl of flowers. At this stage, both the flowers and the face are at the same level of development, but there is no time to do any work on the face, but you still need to press on and complete the flowers.

If for some reason you cannot complete the flowers, do NOT take a photograph and work from that, or finish them from your imagination, just throw the whole lot out. Rub back the canvas with turpentine, set up another bowl of flowers, and begin again.

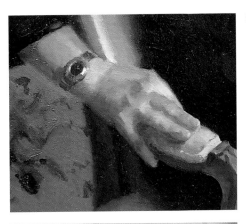

Detail

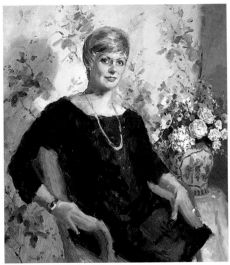

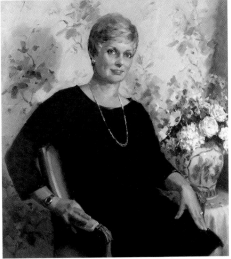

Detail

Detail

Never work on one spot for too long

Now the vase of flowers has been completed, and a big drama has arisen. Susan arrived with a new, very short haircut; something to do with a cat and a tin of housepaint up a ladder! As I have said before, with every difficult painting there is always one good drama — the more important the painting is, the more the dramas occur. I understand this occurs in most fields of endeavour.

I have done a bit more work on the face, but it is still not "there". NEVER WORK ON THE ONE SPOT TOO LONG or you will finish up with tunnel vision and keep repeating the mistakes. The next job is to complete the rest of the canvas, then have another fresh look at the face which I can give my full attention to as the flowers and background have now been completed.

"Susan", finished

If someone had turned up to sit for you for a portrait, and was the classic blond in a black dress — how would you have set it up?

I happen to know Susan loves flowers and that her house is light and bright and pastel, and is as busy as an airport.

I set up around her a Colefax and Fowler English chintz and the flowers were chosen from my garden so they could run seamlessly into the background material. I put the vase of flowers on a stool with a drape of a sympathetic shade and tone.

We tried lots of jewellery, and no jewellery, and settled on a gold chain to break up the large area of solid black.

Detail

Detail

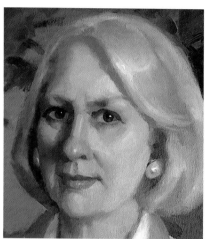

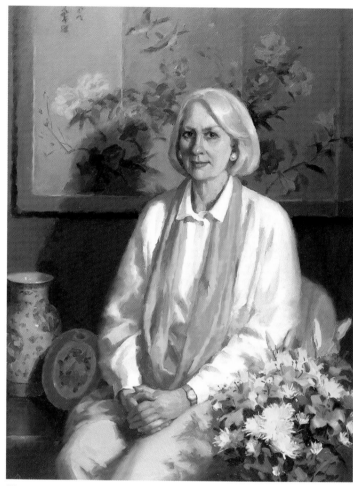

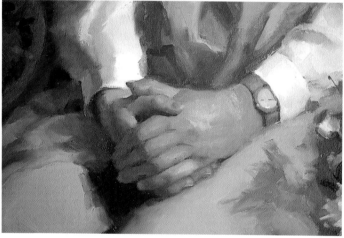

Nothing changed to suit the colour scheme

Beverley's watchband was an orange-tan, nothing was changed on the canvas to suit the co-ordination, you paint ONLY what is set up there in front of you. If the watchband had jarred or not suited, I would have asked the sitter to take it off. If the design required it, I would put something else there instead.

"Beverley, 122 x 91cm (48 x 36")

Beverley is the secretary of the Victorian Artists' Society in Melbourne, and her calmness always calms me down when I am in full flight.

When you are setting up a portrait, somewhere along the line the sitter's own body language appears. Beverley sat calmly like this while I tortured her with the usual artist's request, "Just one more minute and we can have a break", then about an hour later the sitter goes numb and falls off the chair.

Hint

Never work from artificial flowers

Artificial flowers will never settle or nestle like the real thing, neither will they glow or throw rich shadows like the real thing. You just have to work around their tendency to fade quickly and that alters the dynamics of the way you would do the usual portrait painting.

134

The out-of-focus flowers on the background screen, although not exactly "matching" colours, are similar to the vase of flowers and add a tie-in to all the busy areas below. If the backdrop had just been one plain colour, it would have looked like the canvas had been cut in half, with all the mayhem at the bottom and nothing at the top. So the flowers on the screen are tie-in colours, and they also do the job of carrying the eye about the canvas.

The most obvious tie-in here is the yellow/orange flowers and the orange scarf.

The screen edge takes the eye gently down to the porcelain which uses similar colours to the flowers and the screen, and very low in tonal range, so they don't attract too much attention, but quietly carry the eye back to the hands and vase of flowers.

Tie-ins and carry-the-eye areas
If you wish to put a lot more than just the sitter in a portrait, then a gaudy mess of unrelated colours really could take the eye away from the point of interest; but if the tie-in and the carry-the-eye areas are sympathetic relatives of the foreground, these support the point of interest rather than detract from it.

What creates those inescapable eyes?

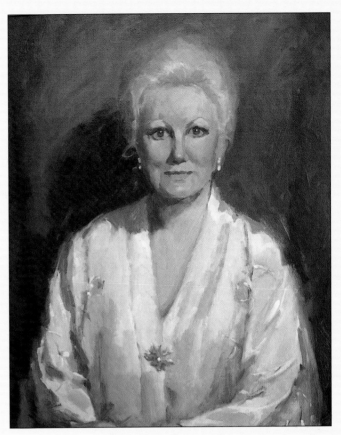

"Lee", 76 x 61cm (30 x 24")

The question often arises "how do you get the eyes to follow you around the room?" Many portraits give this appearance. It is simple — if the sitter has been painted looking directly at the artist, the result is that the sitter appears to be looking at the viewer. No matter what angle you view the picture, even if it is squashed up from practically side on, the eyes will still be looking directly at the viewer. They can't move and look away from you, they are locked in.

This happens too in a photograph, but the portrait is approximately life-sized and because the photograph is usually small it is more noticeable on the painting.

The same thing happens if a room full of people are watching the news on television. The newsreader looks directly down the barrel of the lens, and everyone in the room feels they are the only person the newsreader is speaking to. Simple really.

Cloth in all its variety

Many people have trouble painting cloth, they either overwork it or forget that it follows the shape of what lies beneath.

I suppose you could say there's only so much you can do with a bunch of flowers on a bench — surely there has to come a time when you run out of ideas and are in danger of being slick and dull from working the same old subjects. If you are still in love with a favourite vase or blue gum leaves you can happily paint them until they cart you off like Monet who said on his deathbed, "But I haven't got it right" after a lifetime of painting waterlilies. I am still working with copper pieces and vases that I have had since the day I picked up a paintbrush.

However, there are some things that I have painted over and over and I simply cannot face them any more. Sometimes I set up something that reminds me of these subjects and I just sink inside and either don't paint the subject or re-arrange it with a new vase or a new interesting piece of material.

I find small paintings are the most difficult to do anything original with because there isn't the room to create an interesting and poetic set-up, it is just a vase of flowers planted in the middle of the canvas. The larger canvas gives you

more scope to zing the eye here and zing the eye there or waltz it around the canvas and use a bit of something new to set you off painting with excitement.

Unfortunately, with a lovely vase of flowers there seems to be the universal problem of what to do with all the spaces beneath. We've seen it and done it a million times, a dish at the front or a dish at the back (or both) and a bib here and bob there.

The tweaked cloth solution

One of the best methods of breaking a line, carrying the eye or just filling in a space without introducing another dish, vase, jar or bottle is to simply tweak or crease the backdrop or front drop material to the direction or depth that suits the subject. A pinch creating a little bit of a shadow can break the line, a big drag and scrunch gives deeper darker fold shadows and reflected lights that can give interest to an area that needs something but you don't know what.

I have a pile of chintz pieces from decor shops, some of these were bought on sale and some I have had to pay full

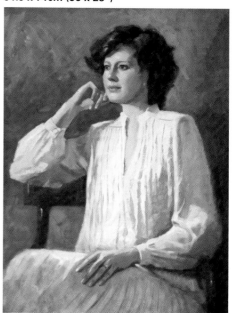

"Mrs Lizzie Bridgman"
91.5 x 71cm (36 x 28")

price for. However, I also have a pile of interesting tea towels and dinner napkins, and the pile is getting bigger. I belong to the "shop-'til-you-drop" brigade and can fossick for hours before I come home with one serviette for $2.50 which will give me enough inspiration to set me off on a four-foot painting.

Establish anchor points early

Many people have trouble painting cloth, they either overwork it or forget

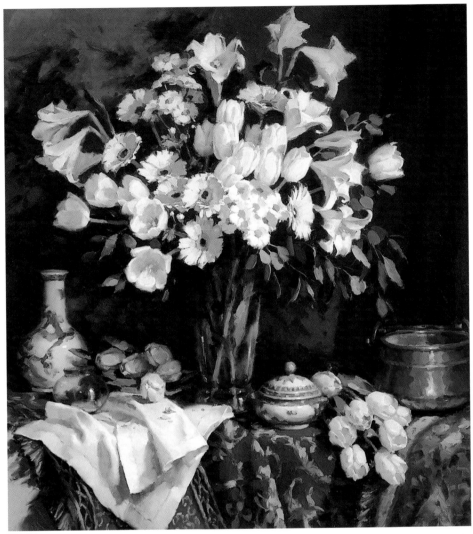

that it follows the shape of what's beneath it. Basically it is the same as any other subject and should be approached the same way, that is with your eyes squinted, observing your subject (and canvas) from your standpoint and observing how it relates to the rest of the subject, establishing a mid-tone, then working in your lights and darks. If there is a pattern or check, establish anchor points early and the pattern in the shadow area

will need to be as dark in ratio. Don't go using your brushes from the light side of the pattern on the dark side of the pattern.

If you are painting what you observe to be there from your standpoint, hopefully what arrives on your canvas will resemble stiff linen, chintz, soft silk or heavy tapestry. Do not aim for a likeness. If you are accurate the likeness should arrive all by itself. This is all great practice to draw on for the

costume portrait — a judge wearing his silk robes or a woman in a patterned dress.

While setting up the following demonstration I was in search of something for the left bottom corner and my eyes landed on the tea towel on the kitchen rail. It was just what I wanted so in it went. You can see how it develops along with the rest of the canvas. Notice how it is placed to break the straight line of the bench, give a bit of interest to an awkward area, and round off the corner to take the eye around the painting again. As you can see this painting could not take another ornament or another flower: Also have a look at the hard edge on the shadow side, and the soft lost edge on the right hand side; lost edge, found edge.

Portrait and still life paintings seem to have become rather more casual in style over the decades, gone are the rampant displays of silks and velvets that the artist can get lost in. It is very satisfying to get lost in a little bit of cloth here and there, so have a go at it and see if you solve that problem area and have a little fun with a fold or two.

Patterns

If you are painting cloth with a pattern like this, don't bring out every detail, just develop one area and the eye and brain will do the rest.

Detail

Just one rose developed on the right, halfway up, and a half explained one on the left and the whole tapestry is intimated.

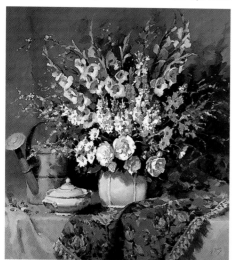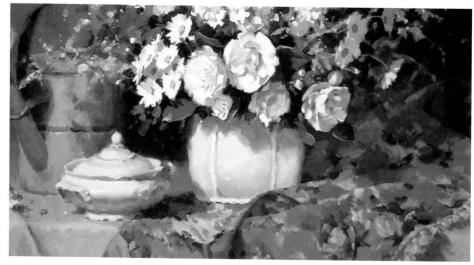

DEMONSTRATION

Have a little fun with a fold or two!

Consider the whole

Think of the canvas as one unit of tone/colour, lost and found edges and proportion. You do not paint every section of the canvas a bit at a time, so that all you have are isolated areas which are really just a collection of objects.

Compare the tone of the cloth and the tone shadow

At this stage turpentine has been used for the medium and work has begun on placing the shadows.

WHILE YOU HAVE A BRUSH IN YOUR HAND SEE WHERE ELSE YOU CAN USE IT. The brush with the mid blue has been used in several areas of the canvas, so you do not just work up one object, you move across the whole canvas.

Just light and dark and lost and found

Now while the pink brush is in your hand see where else you can use it — ECONOMY OF EFFORT in action here. I did say that this demonstration is about painting drapery — well so it is. The drapery gets treated the same as anything else, as a pattern of lights and darks, lost and found edges.

Detail of the cloth
Notice the lost edges and found edges, and the brushwork against the form.

"Don't go using your brushes from the light side of the pattern on the dark side of the pattern."

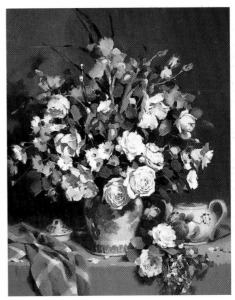

The darkest darks go in
I added stand oil to the turpentine and established the darkest darks across the canvas. Flowers and a cloth and a teapot began to appear, without any particular area being worked up ahead of anything else. When you're working with checks place your anchor points early.

Work on the flowers next
I worked up the transient flowers again. While I had a brush in my hand I looked where else I could use that colour. In this case I worked on the pink flowers while they were still fresh. The cloth had to wait.

"All from my Garden", 76 x 61cm (30 x 24")
Notice how it the cloth was placed to break the straight line of the bench, give a bit of interest to an awkward area, and round off the corner to take the eye around the painting again.

As you can see this painting could not take another ornament or another flower: Also have a look at the hard edge on the shadow side, and the soft lost edge on the right hand side; lost edge, found edge.

Cloth in all its variety — lace, checks, stripes and tassels!

Stripes

Be careful when you are painting stripes. Although they can be as detailed or as broad as you like, make sure they don't splay away from each other — keep them on their tracks as they go around the bends.

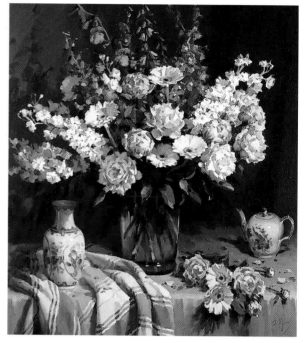

Drapery — the artist's best friend

One of the best methods of breaking a line, carrying the eye or just filling in a space without introducing another dish, vase, jar or bottle is to simply tweak or crease the backdrop or front drop material to the direction or depth that suits the subject. A pinch creating a little bit of a shadow can break the line; a big drag and scrunch gives deeper darker fold shadows and reflected lights that can give interest to an area that needs something, but you don't know what.

Folds

Frequently the area in the front of the vase can be awkward spot to handle. It is where the spotlight hits, and the area is well lit and attracts too much attention the classic spot for a dish. Well I couldn't have a dish here with the very interesting coffee pot and planter, so I moved my bench so I could work from an angle, and pinched a couple of well-placed folds in the material to break down the big blank attention-grabbing area. This is called "Camellias and Rose Hips" 51 x 61cm (20 x 24'').

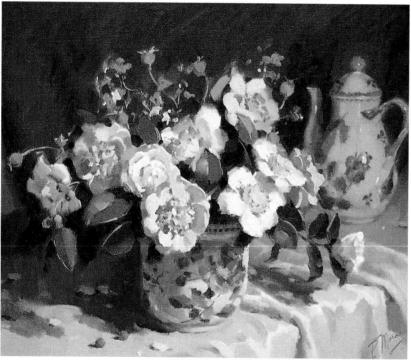

Checks

This checked cotton cloth has a duller finish than the silks but note the diminishing size of the checks. To measure these, count how many of the horizontal stripes go into the vase — seven here to the base of the vase.

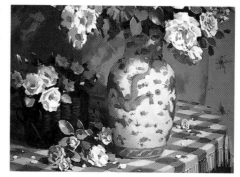

Lace

This lace bib was not painted as white paint over a dark block-in. With the eyes screwed up the mid-tonal value of the area was placed, then the lightest lights and darkest darks were painted. The darks and lights were worked together. Again the pattern consists of "lost and found" edges. This detail is from my portrait of Judge Frank Walsh on page 103.

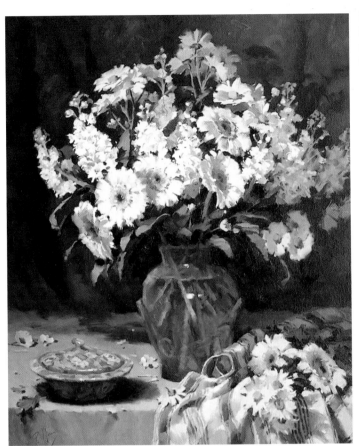

Uniform patterns

It is easier to cope with a uniform pattern if you scrunch up the material so that a meticulously painted long stripe doesn't drag the eye away from the flowers.

Detail of cloth

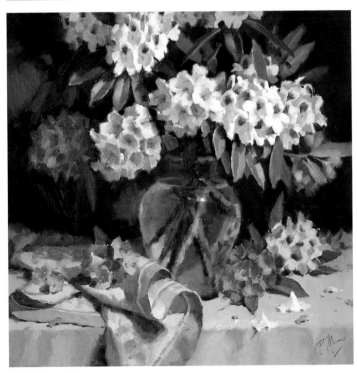

White linen and dark shadows

This appears as crispy white linen, and it is. The point of interest in this area is the middle corner of the napkin, where the lightest light sharp edge has been placed beside a supporting dark tone. Make sure when you place dark shadows that they don't look too sudden, and attract more attention than the object.

Stiff linen

This stiff linen cloth has quite a different appearance from scrunchy soft cotton, and the simple roll leads the eye back around these large flower heads.

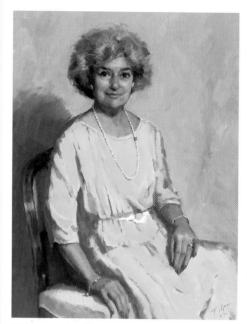

Silk crepe de chine

The material in the dress was pure silk crepe de chine. The dull sheen was painted by placing a pure wash of Cadmium Lemon and Cadmium Yellow over the white primed canvas USING THE CANVAS AS A LIGHTENER and then the other tones were brought in.

This sized canvas is known as the "Kit-cat" size, a popular dimension used around 1715 for portraits of members of the Kit-cat Club in London. (see sidebar.)

This painting, "Portrait in Yellow", 91.5 x 71cm (36 x 28"), is of my late mother.

Detail

"Express the maximum by means of the minimum, Velasquez, Velasquez, Velasquez!"

These were the words of Carolus-Duran, the teacher of John Singer Sargent, who seems to be everybody's favourite tonal painter. Stick with the big brushes for as long as you can, but don't ignore the nuances. Here, some smaller brush marks have been placed in a broadly established area, to carry the message that the bodice has pleats. PAINT WHAT YOU OBSERVE TO BE THERE AND NOT WHAT YOU KNOW TO BE THERE.

Chiffon pleats

This portrait , "Mrs Lizzie Bridgman", 91.5 x 71cm (36 x 28") is also a "Kit-cat" sized canvas. The soft, slightly see-through chiffon was painted by the flesh-tones being placed lightly and the cloth colour being worked at the same time. The shadows of the folds were not painted with a loaded oily brush, but brought in softly, going AGAINST THE FORM as much as I could before bringing in a few lines with the form in at the end. This was one of five paintings I submitted to the Alice Bale Overseas Study Award the year I won it in 1982.

Detail

142

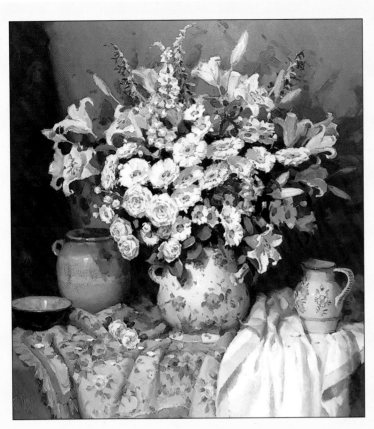

Working with an economy of effort

Like the dictum, "developing your visual memory", which I have never been able to do, "working with an economy of effort" seems like just another technical problem that the oil painter doesn't need. So what does it mean?

It means WHEN YOU HAVE A BRUSH IN YOUR HAND, SEE WHERE ELSE YOU CAN USE IT. It could just be an artistic version of the factory "time and motion" method, except there is an underlying motive. It encourages the artist to think of the canvas as one unit of tone/colour, lost and found edges and proportion.

You do not paint every section of the canvas a bit at a time, so that all you have are isolated areas which are really just an enumeration of objects.

"Spring Freshness with Antique Wares", 122 x 112cm (48 x 44")

The artist is the humble servant of "visual truthfulness" — you can set up or select your subject with passion, but observe and paint OBJECTIVELY. The trouble is that blocking-in a fiddly subject like this one can knock the star-dust right out of your eyes, but as the real estate agents say — position, position, position which means a lot of rub, rub, rub.

Tackling a satin skirt

The first picture shows the block-in of a satin skirt. Pure colours of Alizarin Crimson and Cadmium Red were applied, then the darks were brought in, leaving the highlights clear and bright and the darks clean and rich. Although the actual skirt was more muted than this, it is better to be able to knock something right back, than to clean up the mud later.

The second picture shows how the more subtle tones and colours of the silk satin were painted over the bright block-in.

143

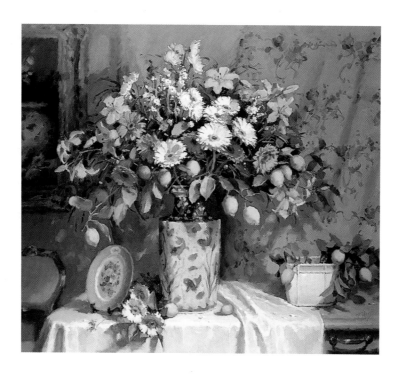

Back where I began

Tonal painting classes cover all subjects — still life, flowers, nudes, portraits and landscapes — because it doesn't matter what the subject is, it is the APPROACH that matters.

Learning to paint was one of the happiest times of my life. I especially loved the landscaping trips, ten days in the countryside painting up a storm. It didn't matter whether we had good or bad weather, we always had a good time, however, it didn't mean that my preference was painting the landscape. I now paint more flowers than anything else. The subject matter which first drew me towards painting and eventually to take lessons, was the portrait.

There is something about the traditional oil portrait that commands respect. it seems to be in a class of its own. As a teenager my first sight of prints of the 18th century portraits by Fragonard, Gainsborough and Watteau, with their rampant silks, mad hairdos and surface polish, sent my head spinning. I'm sorry to say it was the surface glamour and frivolity that drew me in but, as it turned out, when I eventually saw the originals they were absolutely wonderful and my enthusiasm was not entirely misplaced.

John Singer Sargent was fascinated, as he put it, "by the surface of things" and I have to admit that I am too, but as it is the objective observation of the surface patterns which produces the painting I cannot see that as a bad thing.

I do not try to look into the soul of the sitter; their clothes, hairdo and body language all speak for themselves and what I do is try to truthfully represent what is in front of me onto the canvas, and all I know is that something very special happens.

I learned an enormous amount from working on the self portraits, from becoming more accurate with measurements to getting the skin colours cleaner. I have painted relatives and friends and they have tortured me by being late, wriggling and not taking me seriously, but the benefits outweighed the difficulties.

Boy, do I remember some of them — I threw the brushes at my mother because she kept drifting off her spot and talking, but if I hadn't been a painter I would have done the same thing. So there they are, the oil portraits on the wall, most of them not particularly good, but a marvellous moment in an era which will never come again.

To take the terror out of attempting a portrait, think of this: "A portrait is just a still life with more flesh colours", an exercise in solving the visual problems of tone/colour, proportion, and lost and found edges.

Now I end where I began — once you understand the framework of how to place on the canvas the visual truth before you, then it is practice with a purpose, experience, experience, experience!

Now — GO OUT AND PAINT A THOUSAND PORTRAITS AND A THOUSAND FLORALS.

P. Moran